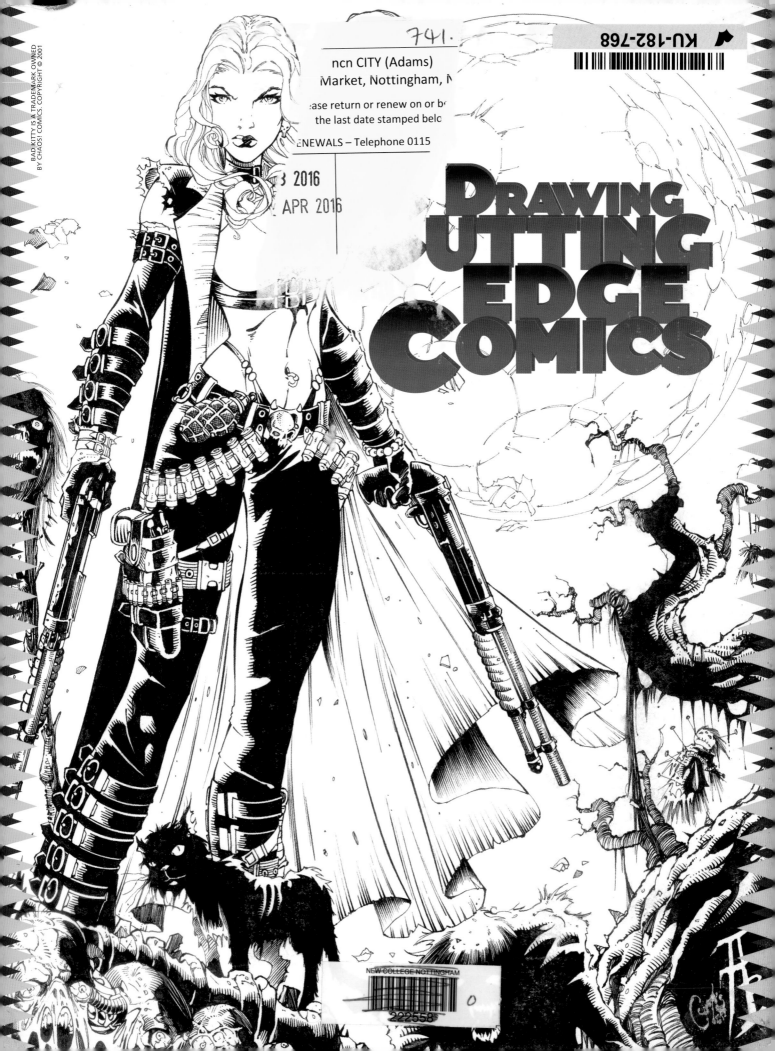

DRAWING CUTTING EDGE COMICS

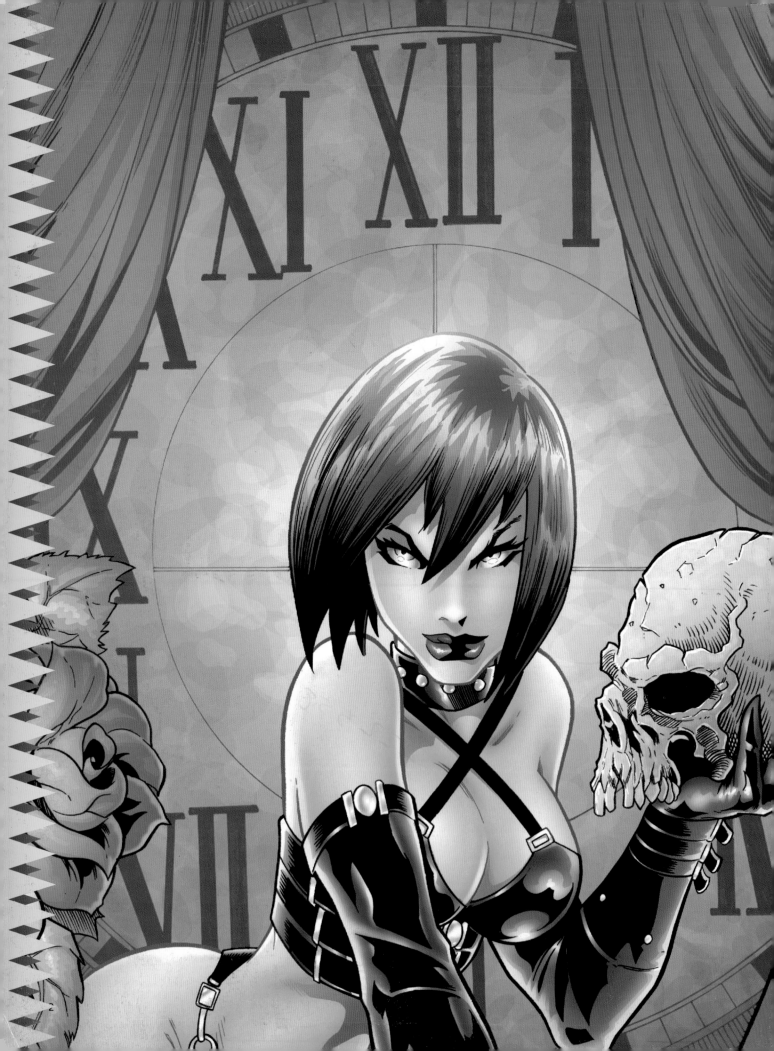

Drawing Cutting Edge Comics

Christopher Hart

WATSON-GUPTILL PUBLICATIONS
NEW YORK

To all trailblazers, present and future!

ACKNOWLEDGMENTS

Many thanks to Brian Pulido of Chaos! Comics for a great interview and the wonderful cutting-edge images.

A gazillion thanks to Renae Geerlings, managing editor at Top Cow Productions, for coordinating an amazing amount of things at the same time. Just awesome. And thanks to everyone at Top Cow for making it work. I'm always a big fan.

My thanks also to Peter Sanderson for his historical expertise.

Also, thanks to Chad Solimon, who arranged everything with uncommon precision. And thanks to Mike Francis, for steering everything in the right direction from the start.

My deep appreciation, as always, goes to Glenn Heffernan, Harriet Pierce, Candace Raney, Alisa Palazzo, Bob Fillie, Ellen Greene, and everybody at Watson-Guptill for all their great work and support.

FRONT COVER AND PAGE 1

From inked version to final color, these images depict the evolution of a cover for Bad Kitty, one of the latest female characters to join the Chaos! cosmos. Pencils: Adriano Batista, inks: Curtis Arnold, color: Drew.

PAGE 2

Chastity, the youthful but deadly vampire assassin, has gone through many looks over the years; her latest is in the style and spirit of manga. Pencils: Adriano Batista, inks: Rich Koslowski, color: Kason Jensen.

Senior Editor: Candace Raney
Project Editor: Alisa Palazzo
Designer: Bob Fillie, Graphiti Design, Inc.
Production Manager: Ellen Greene

First published in 2001 by
Watson-Guptill Publications,
an imprint of the Crown Publishing Group,
a division of Random House, Inc., New York
www.crownpublishing.com
www.watsonguptill.com

Library of Congress Cataloging-in-Publication Data
Hart, Christopher.
 Drawing cutting edge comics / Christopher Hart.
 p. cm.
 Includes index.
 ISBN 0-8230-2397-4
 1. Comic books, strips, etc.—Technique. 2. Drawing—Technique. I. Title.
 NC1764 .H358 2001
 741.5—dc21 2001026932

Manufactured in China
9 / 08

CONTRIBUTING ARTISTS:

Marlo Alquiza (inks): 84–88
Bill Anderson (inks): 98–99, 100–104, 106–113
Darryl Banks: 5, 100–104
Talent Caldwell: 82
Brian Denham: 80
Christopher Hart: 4, 24, 26–41, 64–67, 105, 137–139
Dave Hoover: 5, 126–135
J. J. Kirby: 5, 42–51, 94–97
Mike Leeke: 98–99, 106–113
Grant Miehm: 76, 78, 84–88
Dan Norton: 5, 62, 68–75
Mark Pacella: 114–115, 117–125
Dan Panosian (inks): 115
Al Rio: 5, 8–23, 25, 52–61, 116
Billy Tan: 79
R. V. Valdez: 81
Nate Van Dyke: 83
Joe Weltjens: 5, 63, 77, 89–93

COLORISTS:

J.J. Abbott, Brimstone: 5, 8–9, 24–25, 42–43, 52–53, 57, 59–62, 65, 68–76, 94–104, 114–115, 126–127, 137–139
Joe Weltjens: 5, 63, 77, 89–93

Contents

INTRODUCTION 7

THE BASICS WITH AN ATTITUDE 8

ANATOMY FOR COMIC BOOK ARTISTS 24

THE BIG GUYS 42

EXTREME ALLURE 52

EXTREME CHARACTER DESIGN 62

DISCOVERING YOUR PERSONAL STYLE 76

THE POWER OF PERSPECTIVE 98

DESIGNING THE PAGE 114

CROSSING OVER TO TELEVISION ANIMATION 126

GETTING AN AGENT TO REP YOUR WORK 136

RIDING THE EDGE: AN INTERVIEW WITH BRIAN PULIDO 140

INDEX 144

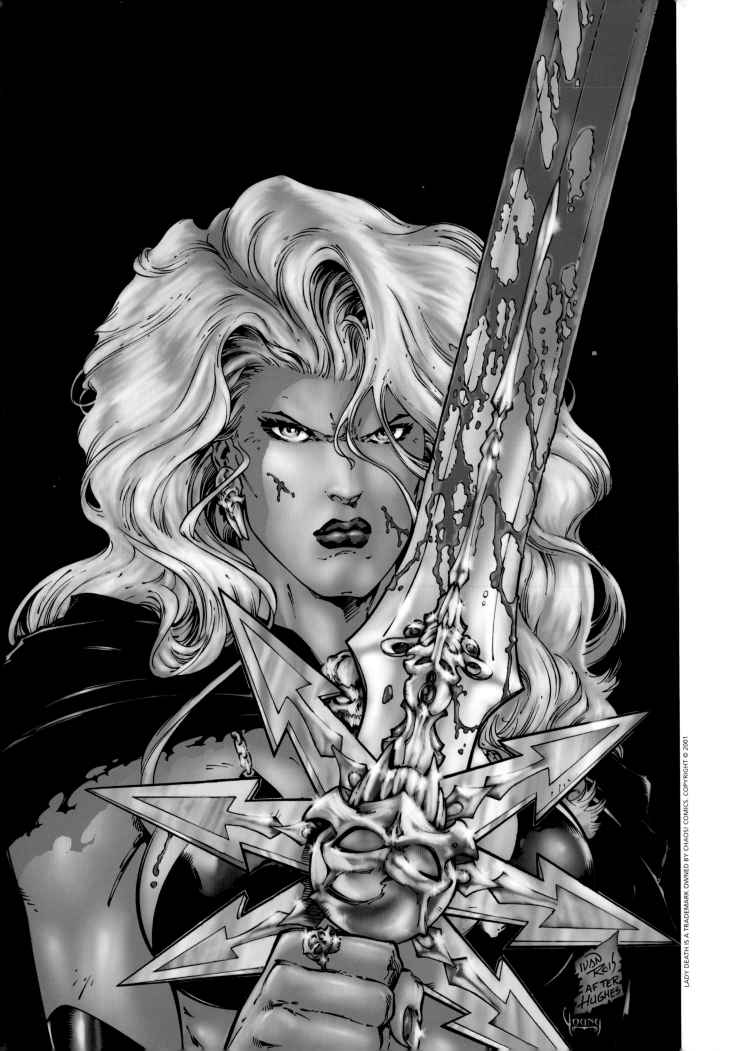

Introduction

I've written many books on drawing techniques, specifically in the area of comic book illustration. But I've never written one like this before. This has been a particularly ambitious undertaking that has required a great deal of planning, energy, and focus. It's not a book about how to draw. It's a book about how to draw *better.* It's a master guide that, when followed, can rocket your skills not just to the level of proficiency, but beyond—to the cutting edge.

There's something new in comics. Have you noticed it? Everything is more extreme. The heroes are grittier. The women are sexier. The big guys are bigger. The pages and panels are designed for maximum impact. You're not going to find the square-jawed, milk-drinking heroes of years gone by on these pages. You won't find the girl next door, either. She ran off with the antihero and raised a little hell along the way.

Have you been frustrated by other books about how to draw comics? Has the following happened to you? You read through the first few chapters, only to realize that you're still a little unsure of how to draw the super-defined muscle groups that are so pronounced on today's comic book characters. If you can't clearly draw all of the muscle groups, you can't draw today's comics. It's not your fault. You've been left hanging. But when you finish reading the chapter on anatomy in this book, not only will you have all the answers you need, you'll also learn how to draw the kind of ripped, awesome look that will put your characters on the cutting edge.

You'll learn how to draw all of the hottest character types in comics today, from trendy heroes to lady assassins to awesome giants, warlocks, and more. You'll learn how to create extreme sex appeal in your female characters, where something as subtle as a tilt of the head or a lift of the shoulder adds mountains of sensuality. The section on character design reveals shortcuts for churning out tons of original characters in half the time. And, you'll learn the state-of-the-art secrets the pros use to combine comic book genres for wild, new looks. You'll also learn how to use amazing colors, featuring advanced techniques. And since comics aren't just about drawing but also storytelling, this book contains the comic book artist's bible for layout and design. It will show you exactly how to tell a story that'll grab hold of your reader and never let go.

Are we done? Hardly. In an extensive interview, Brian Pulido, president of Chaos! Comics, reveals his thoughts on where he believes comics are heading now and in the future. In addition, some of Top Cow's amazing artists demonstrate how they spin original character designs—just for this book! You're also going to read an exclusive interview with comic book agent Doug Miers, who will tell you exactly how you can get an agent and exactly what one can do for you and your career.

Who's on your side? You got that right. Now stop wasting time reading this introduction and let's get started.

With her pale skin and pasty eyes gone, Chaos! reinvented their most famous diva, Lady Death, making her human for a series called Alive. Pencils: Ivan Reis, inks: Joe Pimentel, color: Roy Young.

The Basics with an Attitude

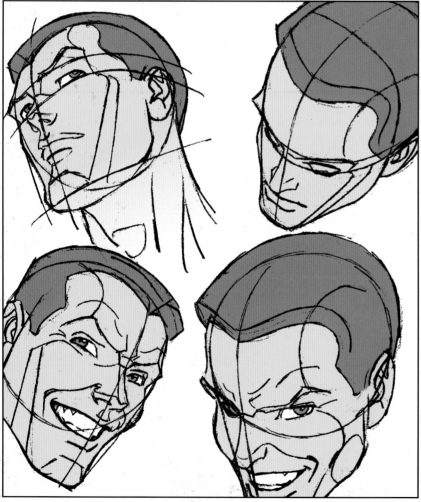

Whether you're just starting out or have already acquired considerable drawing skills, how you begin a drawing determines the way it ends up. Without a solid foundation, no building can stand. This is especially true for cutting-edge comics. As you push the envelope ever further, it becomes even more important to lock in the basics—this will free you up to make sharp stylistic choices without distorting the underlying image.

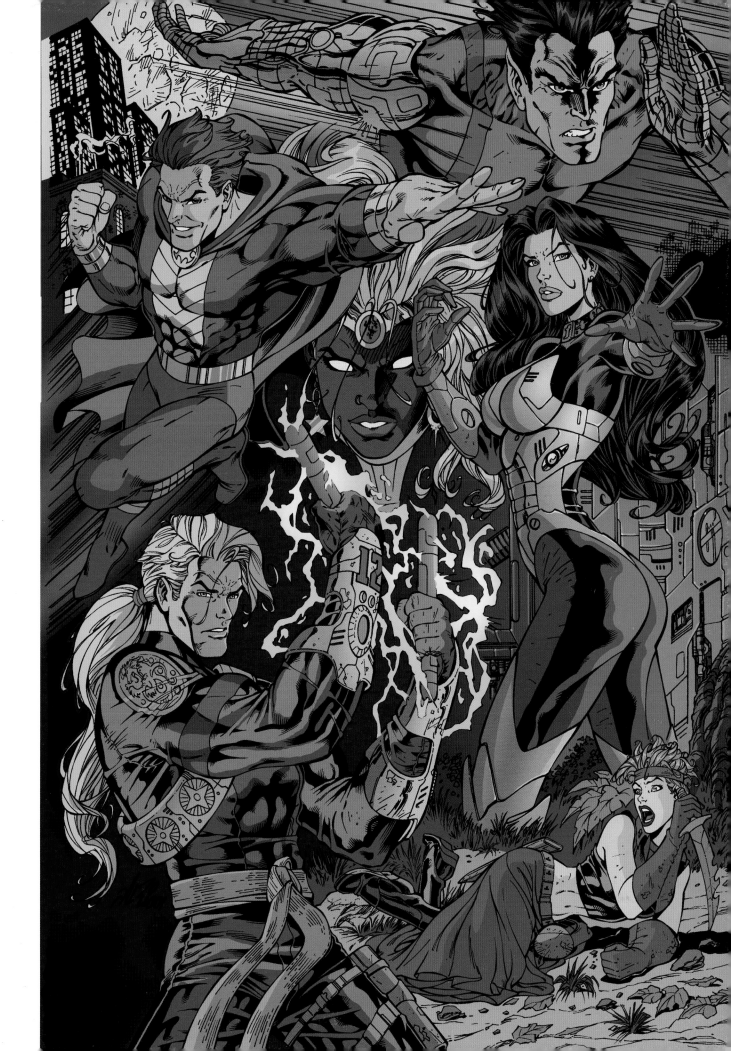

The Modern Comic Book Head

Today's comic book hero is cool and self-assured. Those square-jawed, do-gooder types with two-ton eyebrows that you find in other how-to-draw books? Dump 'em. They're ancient history. Today's good guy has a little bit of the bad guy in him. He's even a touch conceited.

Follow these guidelines and your proportions will always be correct. That doesn't mean you should be a slave to these measurements, just keep them in mind. You can even adjust the proportions to create more unique characters.

FRONT VIEW

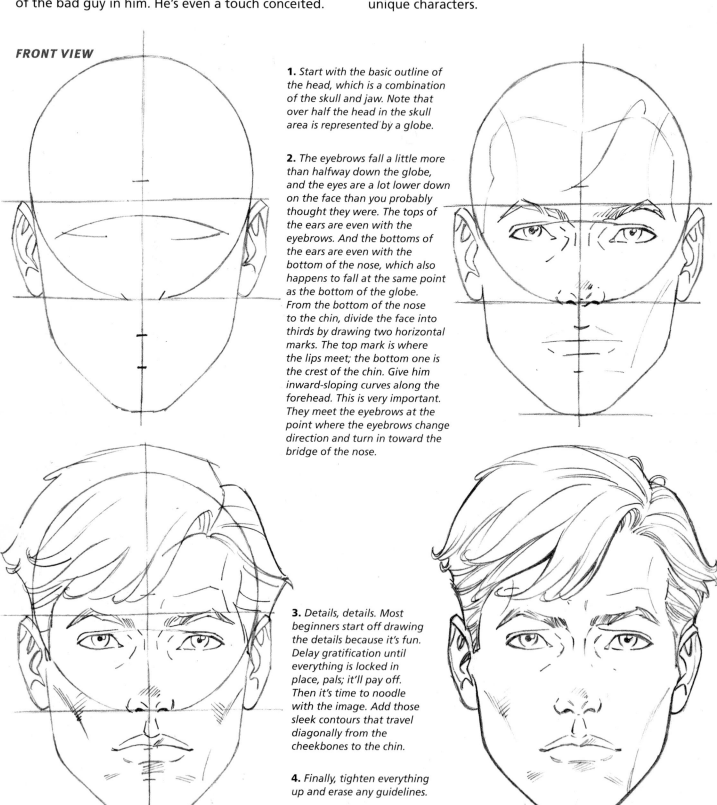

1. Start with the basic outline of the head, which is a combination of the skull and jaw. Note that over half the head in the skull area is represented by a globe.

2. The eyebrows fall a little more than halfway down the globe, and the eyes are a lot lower down on the face than you probably thought they were. The tops of the ears are even with the eyebrows. And the bottoms of the ears are even with the bottom of the nose, which also happens to fall at the same point as the bottom of the globe. From the bottom of the nose to the chin, divide the face into thirds by drawing two horizontal marks. The top mark is where the lips meet; the bottom one is the crest of the chin. Give him inward-sloping curves along the forehead. This is very important. They meet the eyebrows at the point where the eyebrows change direction and turn in toward the bridge of the nose.

3. Details, details. Most beginners start off drawing the details because it's fun. Delay gratification until everything is locked in place, pals; it'll pay off. Then it's time to noodle with the image. Add those sleek contours that travel diagonally from the cheekbones to the chin.

4. Finally, tighten everything up and erase any guidelines.

SIDE VIEW

Where did Mr. Blockhead go? He has been replaced. Our modern comic book guy has a tapered jaw and a less pronounced chin. He doesn't have to look like he chews titanium nuggets for breakfast. There's also no need for a face full of gleaming white teeth with deep creases etched around his mouth. A sleeker, simpler look is best.

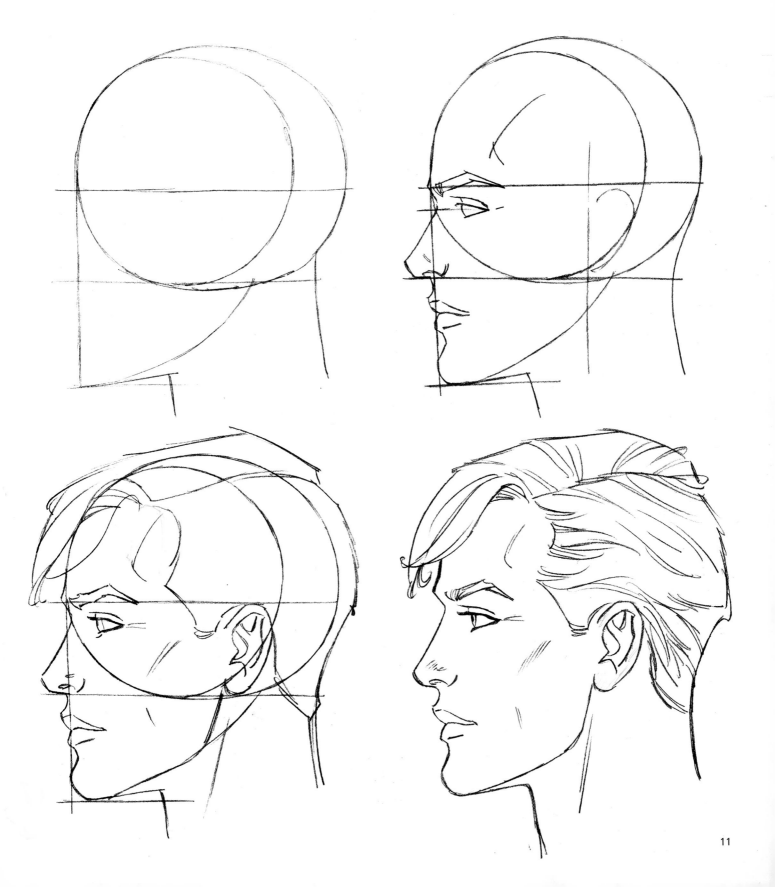

The Modern Female Head

Same deal, different head. Proportionwise and placementwise, the structure is basically the same as that of a man. You've still got the skull/jaw combo, and you tick off the horizontal guidelines in the same spots.

Now come the differences. Leave off the contour lines of the forehead in the finished drawing. Anything that articulates the bone structure of the face, such as those forehead contour lines, makes her look more masculine. The exception is cheekbones, which are very sexy on women. The forehead should look totally smooth—not a wrinkle on it. Soften the angles of her jaw and chin. Raise the outside of her eyes slightly. Fill out the lips (as if you didn't already do that!), and ease up on the bridge of the nose or omit it *entirely*.

FRONT VIEW

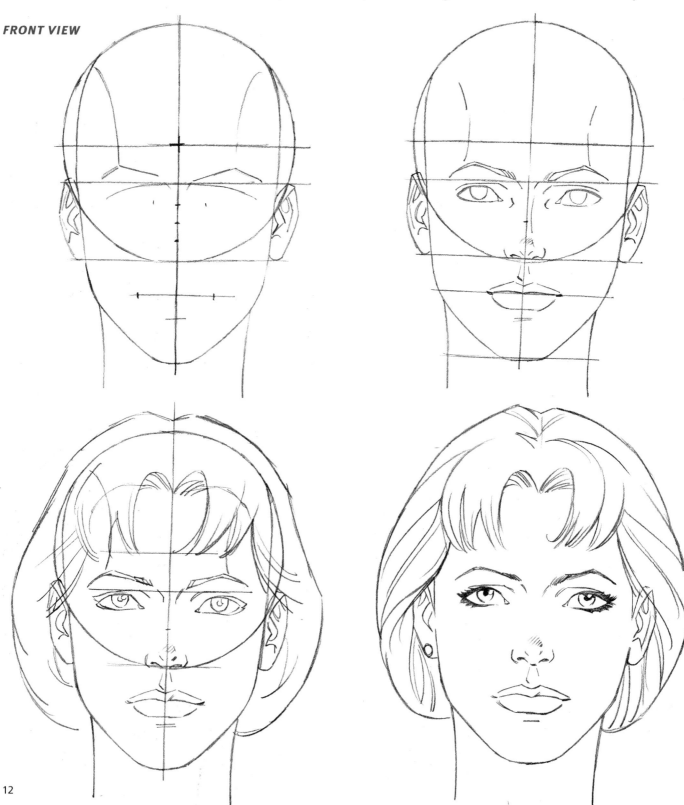

SIDE VIEW

Again, same deal as with the man. Notice the upturned nose. The upper lip has a slight overbite. It used to be that a big lower lip was sexy. Now the opposite is also considered sexy. Don't be afraid to let the forehead protrude slightly after the indent at the bridge of the nose. You don't want to make her look like Frankenstein's monster, but this protrusion is a natural part of the anatomy. If you treat it lightly, it'll look fine.

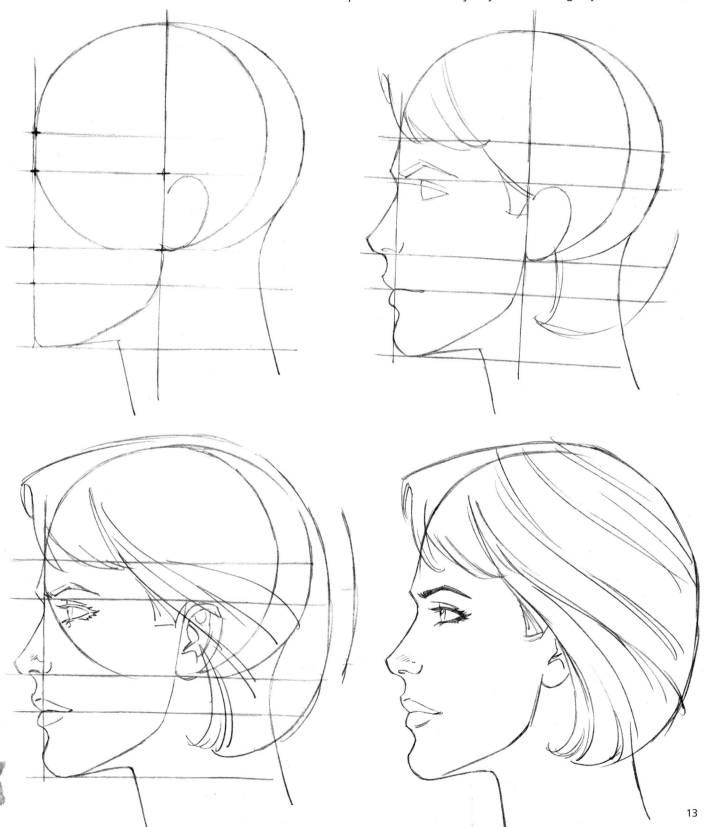

Head Tilts and Turns

What gives our modern leading man his sleek look? Primarily, it's the contour line that flows from the zygomatic arch (the cheekbone just behind the eye) down to the chin. This creates a separate plane out of the front of the face, narrowing almost to a triangle. You can see this separate, but distinct, plane in every pose, no matter which way the head tilts.

Ever wonder why all the guidelines drawn on the face are curved instead of straight? It's because the head is round, not flat. Think of the guidelines as pieces of string that wrap *around* the head, indicating where exactly to place the features.

PLANES OF THE FACE—MALE

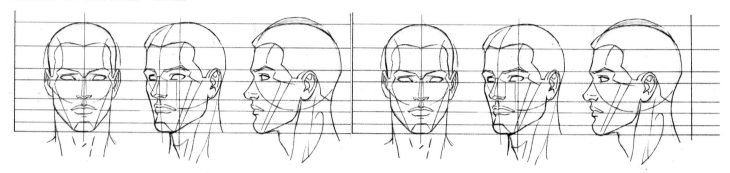

TRY THESE HEAD ANGLES

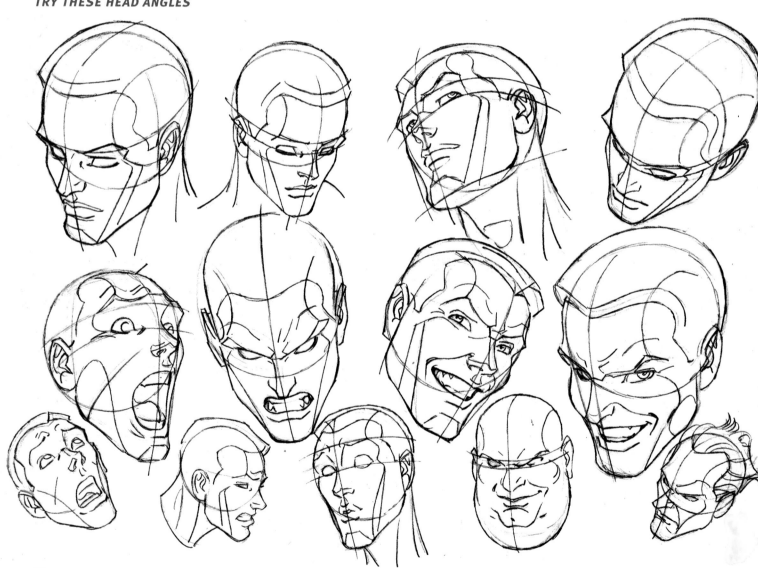

Some beginners are tempted to camouflage the heads of female characters with tons of hair. That won't work. They're not fur balls. Sooner or later, you're going to have to draw a real woman. So, check this page out! Now you'll be able to draw her from any angle.

PLANES OF THE FACE—FEMALE

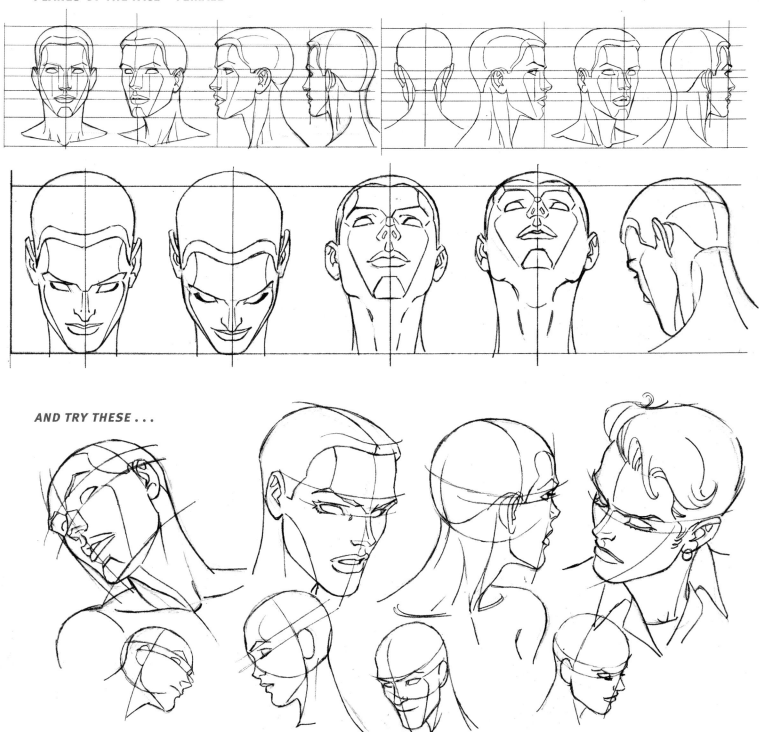

AND TRY THESE . . .

Various Angles

When I was learning how to draw, sometimes I'd get a book so bogged down with heavy-duty instruction that the author seemed to forget I wanted to draw for pleasure. So, before moving on, take a break and try practicing what you've learned so far, using these cool characters for inspiration.

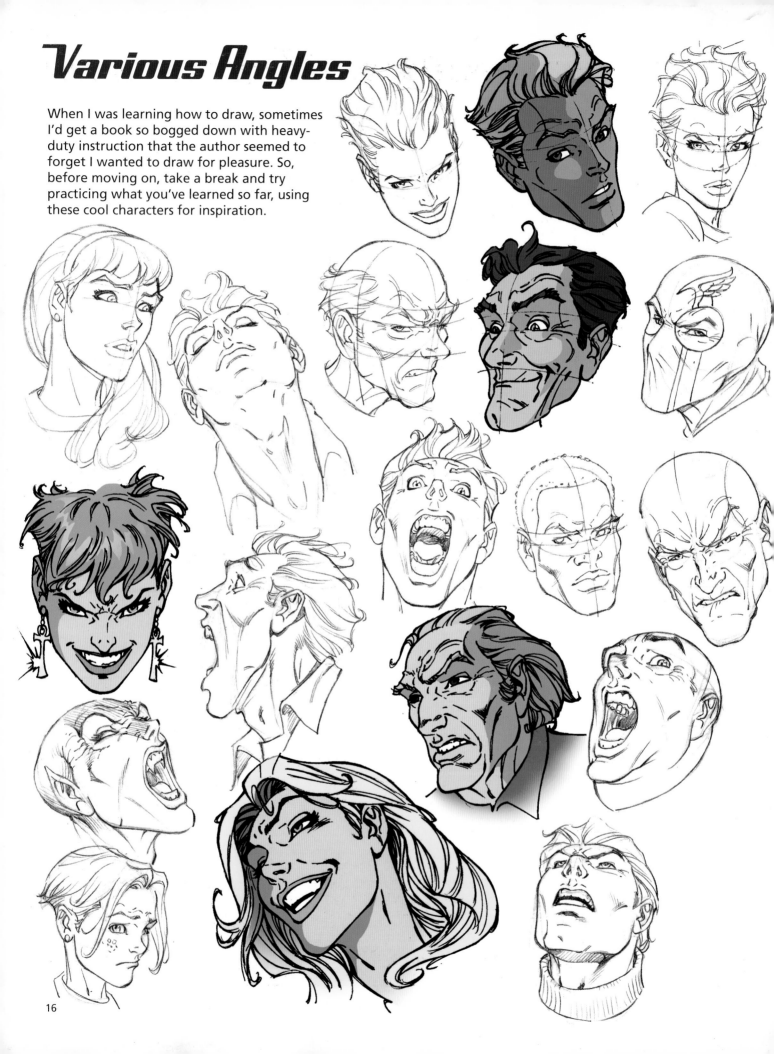

Intensity and Expressions

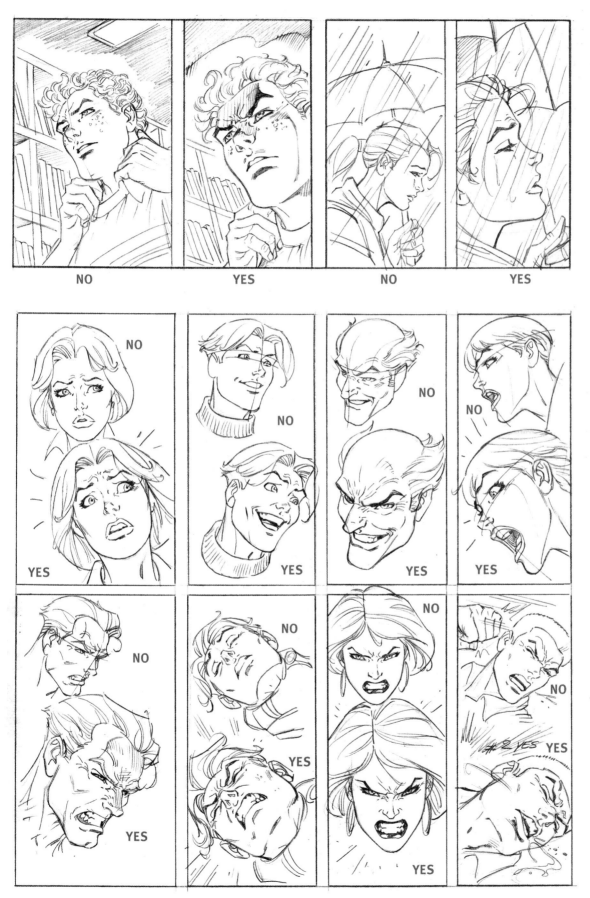

No doubt you've all read comic books in which, suddenly, the story sags. On occasion, you've skipped those pages until the images got intense again. Red flag! As an artist, you can't afford to lose your reader. The scriptwriter has written important elements into the story, which will suffer if the reader skips them. How do you solve this vexing problem? Intensity. Ratchet up the emotions of your characters beyond the norm. Grab your reader and don't let go. Make it urgent. Keep in mind that you're creating *moments.* The reader is going from moment to moment, not reading through a gently flowing story like it's a novel. Jump from jagged rock to jagged rock!

Classic Hero Body

This is a durable body type. This guy can be a hero, antihero, or leading man with no particular powers. Either way, he's athletic in appearance but not suffocating in his own muscles. He's driven by personality more than physique and physical stature. The average person is six to seven head-lengths tall. The classic comic book hero is eight to ten heads tall; this makes him appear more impressive.

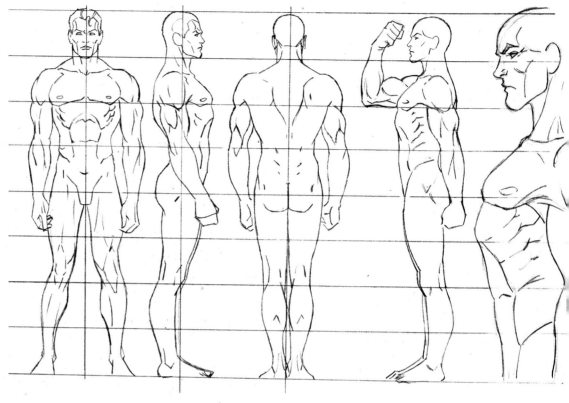

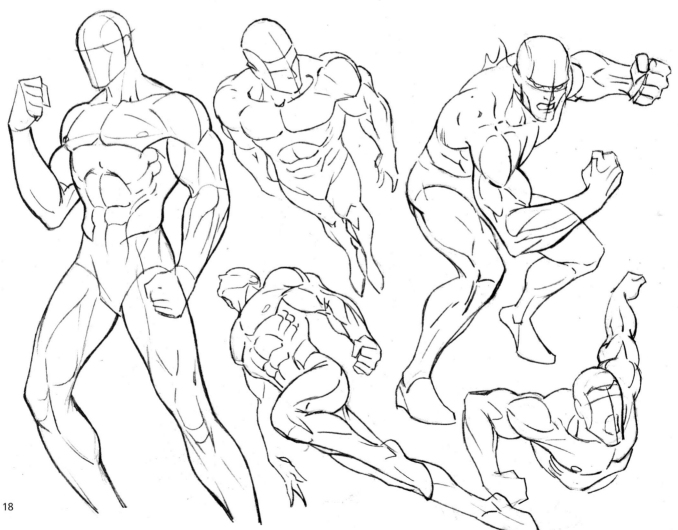

Classic Heroine Body

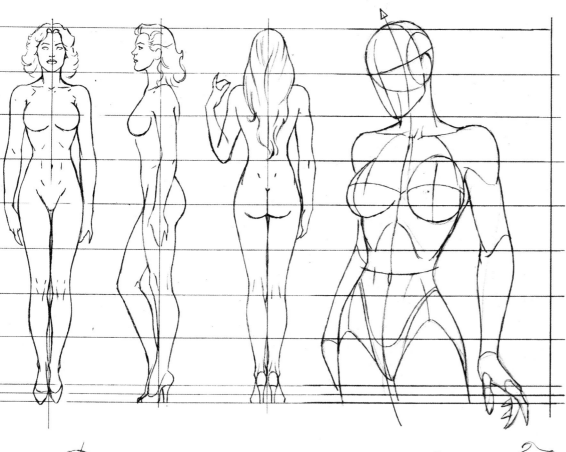

She's also eight to ten heads tall but, in most cases, will have a smidgen of extra length due to her high heels. And, don't overlook this fine point: Her shoulders should be wider than her hips. Don't be afraid to give her wide shoulders. It won't make her look masculine. In fact, it's just the opposite. Wide shoulders *and* wide hips, connected by a narrow waist, are extremely sexy. What you want to avoid is giving her thick neck muscles and large shoulder muscles. In addition, her legs can be muscular, but they should also be sleek and shapely.

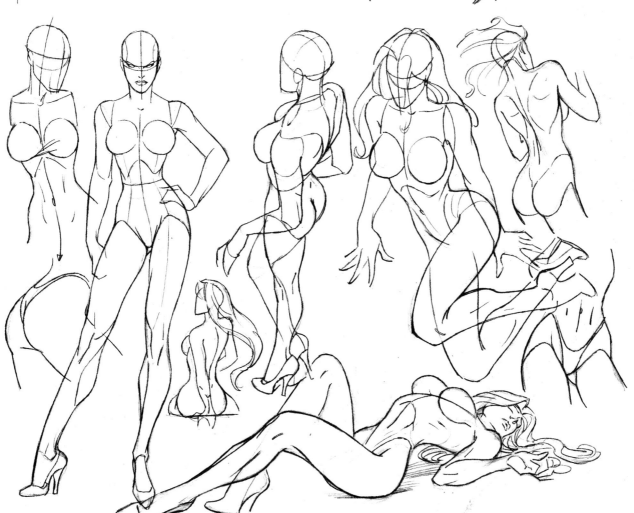

Hands

Hands can be tricky. Even if you learn how to draw a hand perfectly in one pose, you can still be stumped when you try to draw it in another pose. Hands can adopt more unique poses than any other part of the human body. The only way to learn to draw hands is to see them from every conceivable angle. Voilà!

MALE

The tops, or back hand sides, of the fingers are flat, because that area is right next to the underlying bones. It's the palm side of the fingers that has the padding. When the fingers taper, it's only the underside— where the padding is—that tapers. Beginning artists often taper the top side, as well, and the result is a fingertip that comes to a point, like a dagger. You should avoid this.

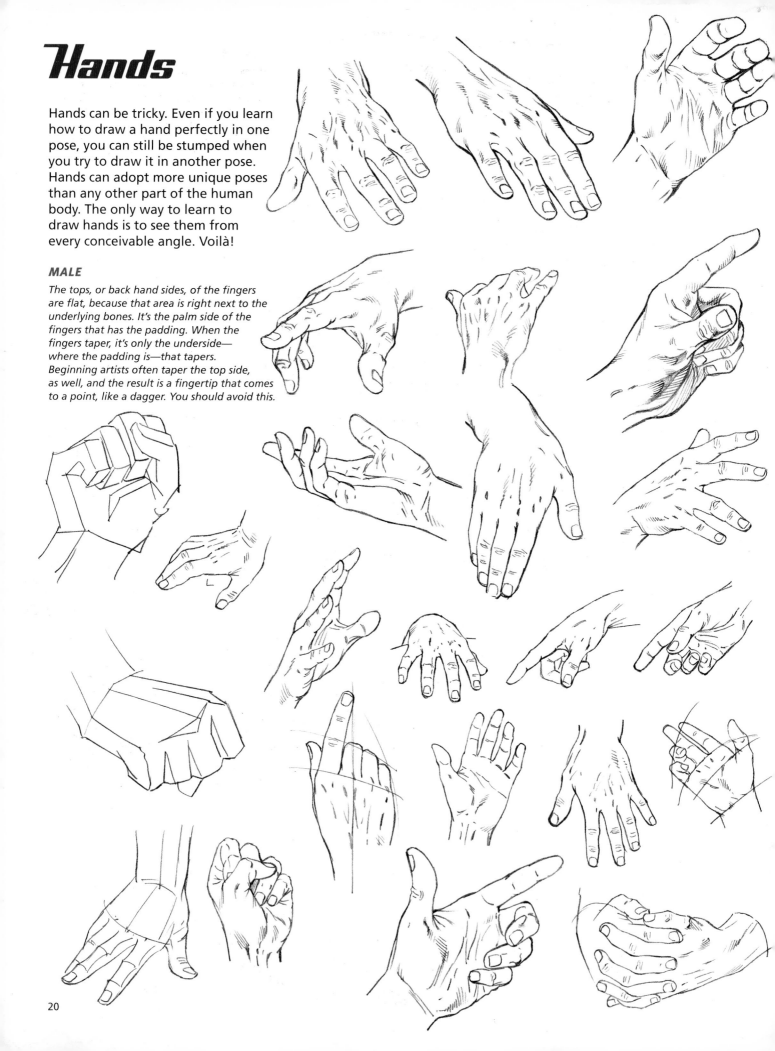

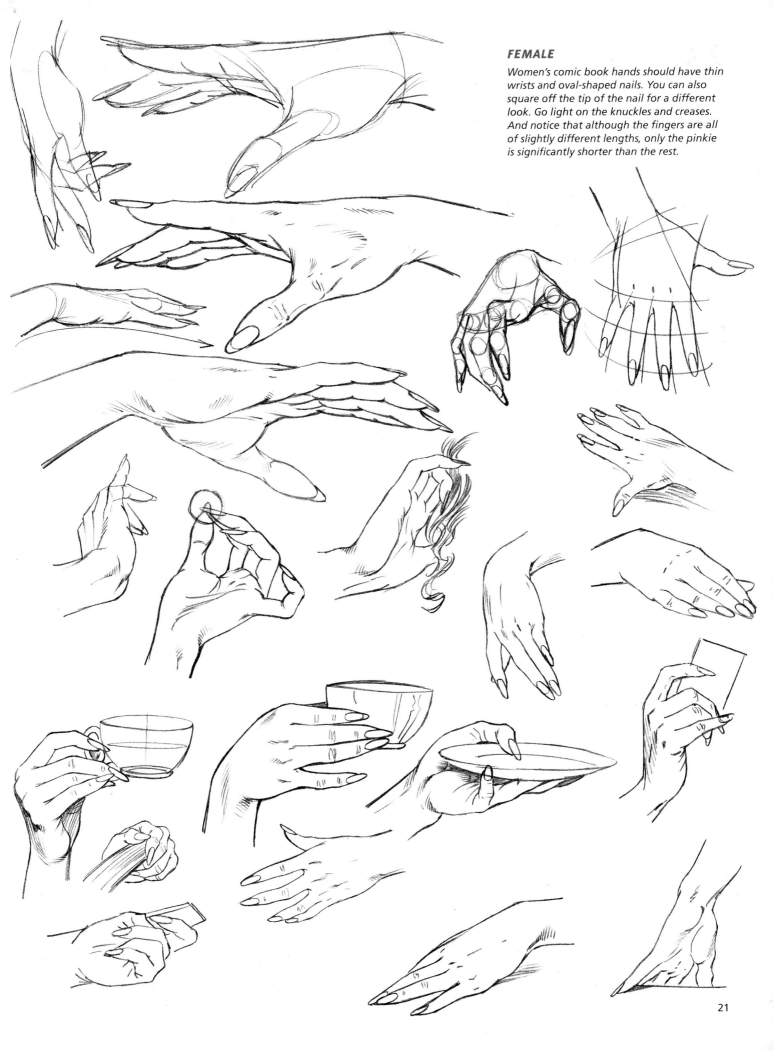

FEMALE

Women's comic book hands should have thin wrists and oval-shaped nails. You can also square off the tip of the nail for a different look. Go light on the knuckles and creases. And notice that although the fingers are all of slightly different lengths, only the pinkie is significantly shorter than the rest.

Feet

No one has ever gone into art because they couldn't wait to draw toes. At least, no one who isn't on medication. Be that as it may, if you're going to draw comics, you're going to run into every kind of scene. Babes at the beach. Fight scenes on oil drilling rigs. Underwater scuba scenes. And, what are you going to say to the editor? "I'd love to draw this book, but can I put loafers on her?" No, my friends, the time has come for you to face your fears head on, and that includes drawing feet.

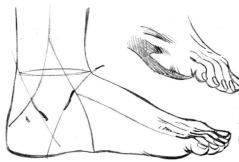

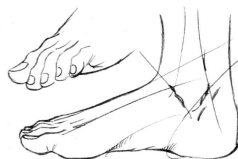

The top of the foot curves upward slightly.

The foot has two basic masses: the ball of the foot and the heel.

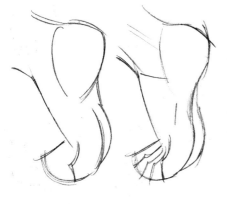
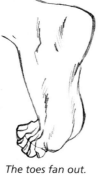
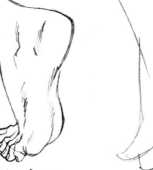

The toes fan out.

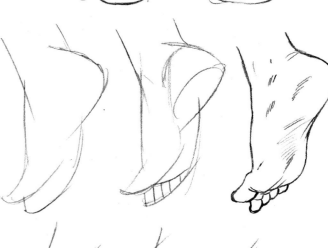

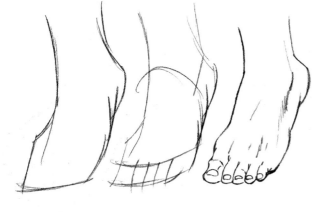

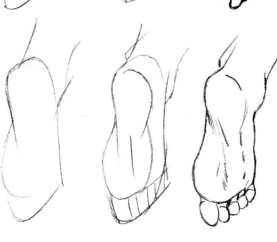

Note that the outer ankle always appears lower than the inner ankle.

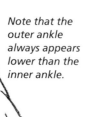

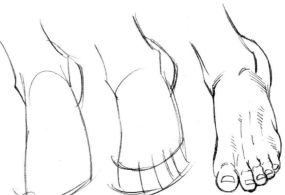

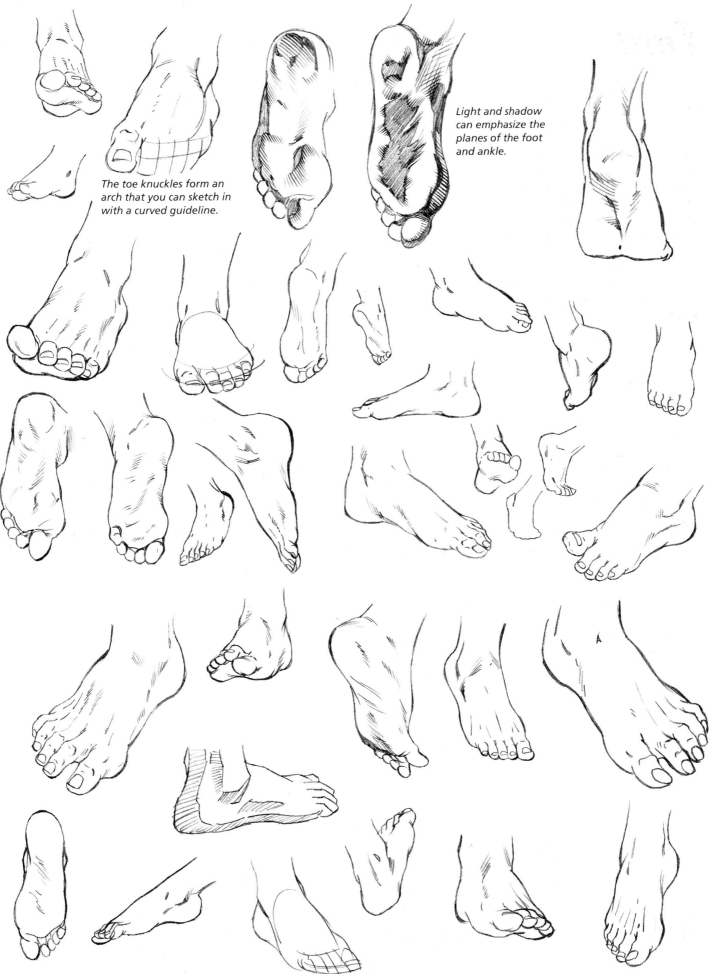

The toe knuckles form an arch that you can sketch in with a curved guideline.

Light and shadow can emphasize the planes of the foot and ankle.

Anatomy for Comic Book Artists

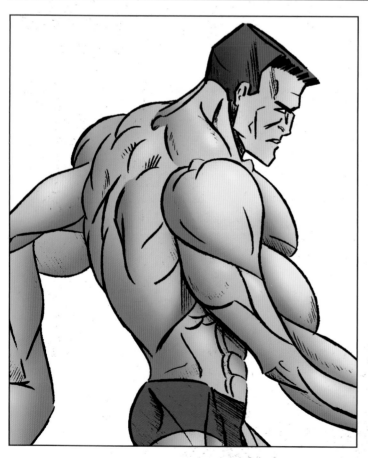

Anatomy. Ouch! Don't you hate that word? Well back up a step. Think of anatomy as your friend, except that it doesn't ask to borrow money. One of the main complaints comic book editors have about artists is that they've learned to draw by looking at comics, rather than through an understanding of anatomy and life drawing. Flashy style won't mask a lack of understanding. And, with today's emphasis on extreme anatomy, you've got to know more, or you'll fall behind.

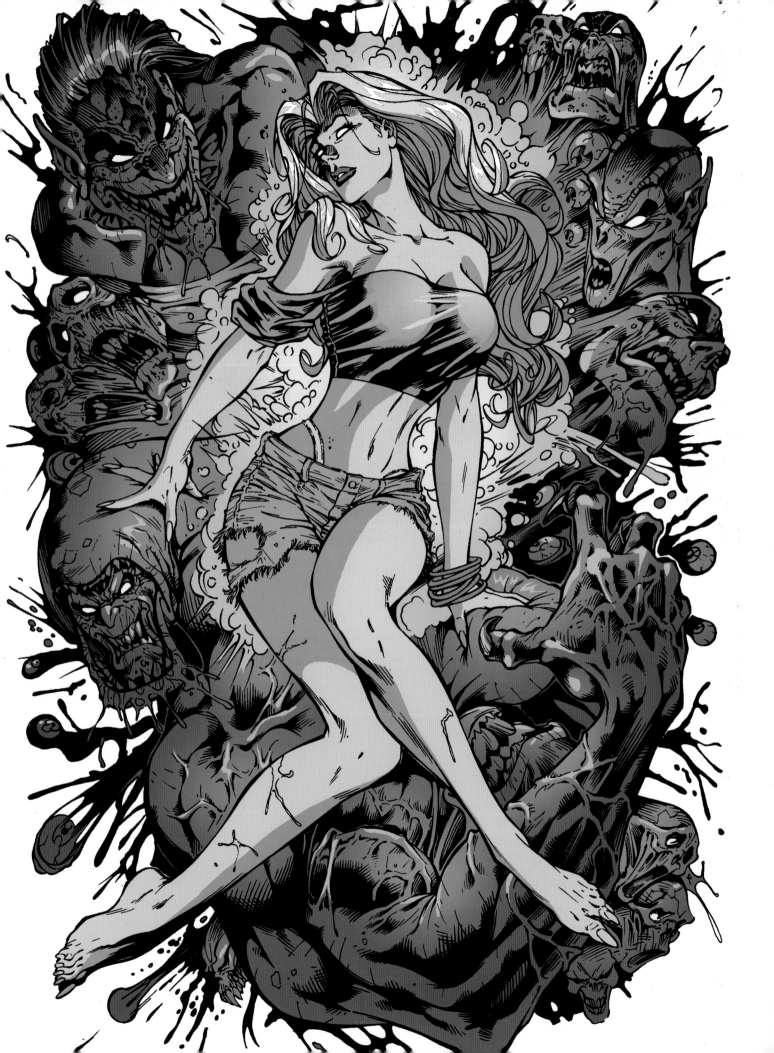

The Tough Guy's Head

On a man, the line of the cheekbone travels toward the mouth, then appears to be cut off by a vertical facial muscle called the depressor anguli oris. On a woman, the line of the cheekbone doesn't appear cut off by the depressor anguli oris.

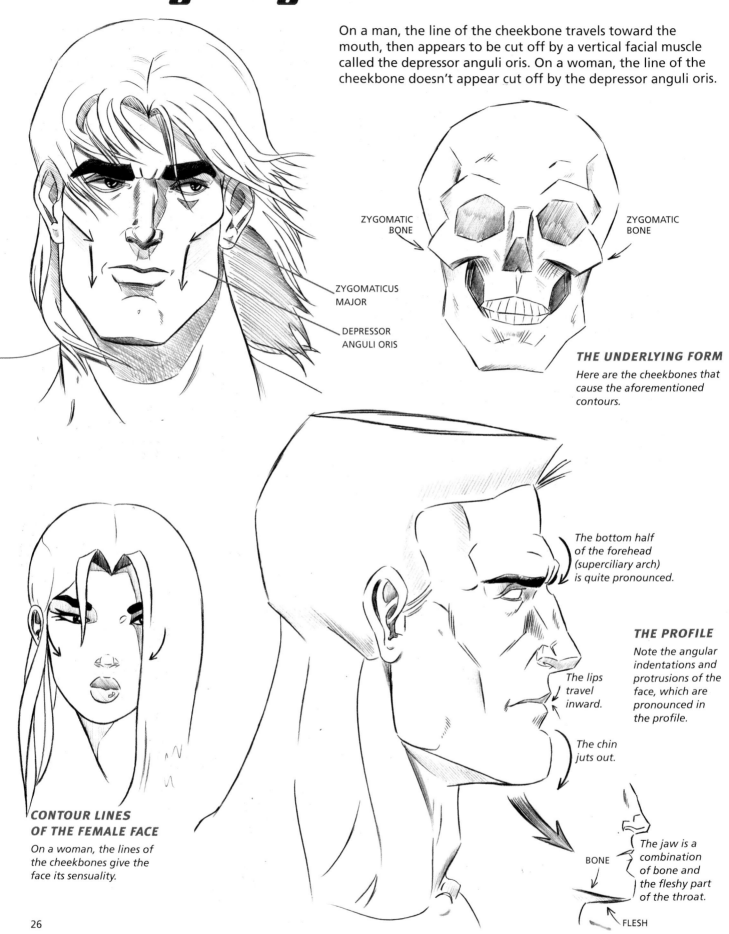

ZYGOMATIC BONE

ZYGOMATIC BONE

ZYGOMATICUS MAJOR

DEPRESSOR ANGULI ORIS

THE UNDERLYING FORM

Here are the cheekbones that cause the aforementioned contours.

The bottom half of the forehead (superciliary arch) is quite pronounced.

THE PROFILE

Note the angular indentations and protrusions of the face, which are pronounced in the profile.

The lips travel inward.

The chin juts out.

BONE

The jaw is a combination of bone and the fleshy part of the throat.

FLESH

CONTOUR LINES OF THE FEMALE FACE

On a woman, the lines of the cheekbones give the face its sensuality.

The Muscles of the Face

When I was starting out, I tried to make my comic book heads look cool—I added lots of lines to the faces that didn't mean anything. I was just guessing where the lines should go. The result was comic book heads that were too busy.

The creases of the face are an outward reflection of the inner musculature. Familiarize yourself with the muscles of the face (marked with striations), and then you won't be guessing anymore where the lines go. As a result of this understanding, your drawings will take on a new authority. And then you will rule the world! . . . Or something like that.

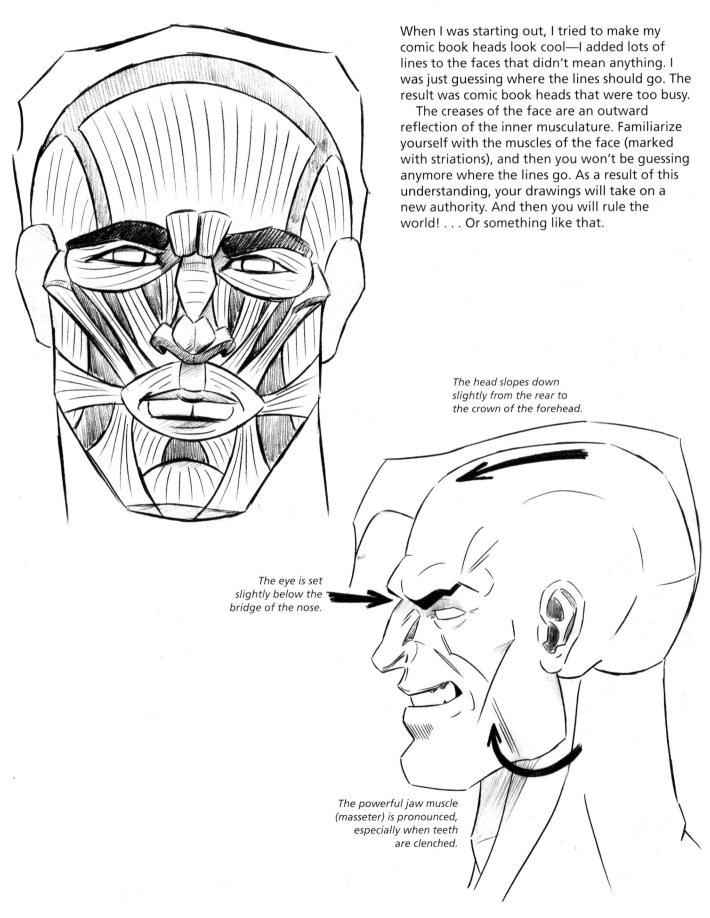

The head slopes down slightly from the rear to the crown of the forehead.

The eye is set slightly below the bridge of the nose.

The powerful jaw muscle (masseter) is pronounced, especially when teeth are clenched.

The Tough Guy's Body

Looks like this guy needs a life outside the gym. Well, he's not going to get one—not if I can help it!

The more muscles you give a character, the bumpier the body's outline becomes. Look at the speed bumps down this guy's arms, for example. The trapezius muscles (between the neck and shoulders) are first, then the deltoids (shoulder muscles), then the triceps (in the upper arms), and finally, the brachioradialis for those of you who speak fluent Latin (the forearm muscles).

It's not important that you memorize all of the different muscles but that you begin to notice, and compartmentalize in your mind, the various muscle groups. Don't be overwhelmed. If all you get at first glance is an understanding of how the upper leg muscles attach to the knee muscles, that's a great start. Take it piecemeal—chest, shoulders, calves, abdomen, forearms, hips, and so on. That's how the muscles are arranged—in groups.

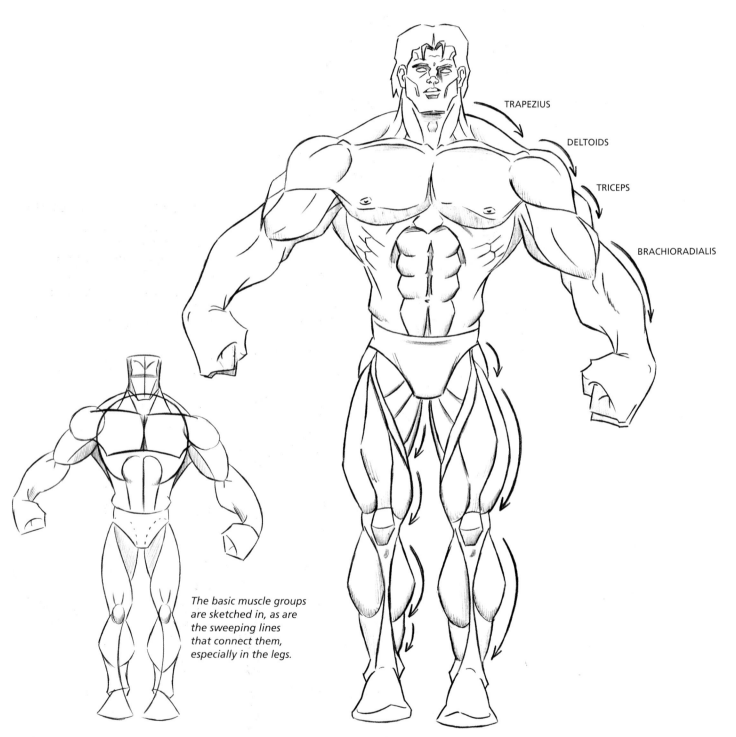

TRAPEZIUS

DELTOIDS

TRICEPS

BRACHIORADIALIS

The basic muscle groups are sketched in, as are the sweeping lines that connect them, especially in the legs.

"Hidden" Muscles

There are some muscles that only become visible in certain positions, for example when an arm is raised. When the arm is down, certain muscles are obscured. One such muscle is the teres major.

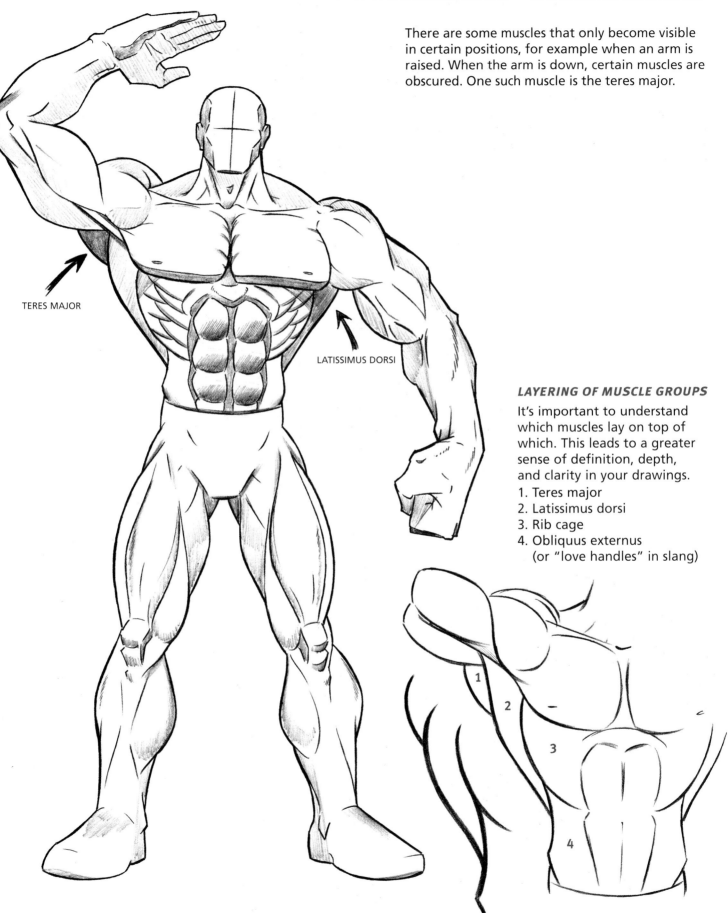

TERES MAJOR

LATISSIMUS DORSI

LAYERING OF MUSCLE GROUPS

It's important to understand which muscles lay on top of which. This leads to a greater sense of definition, depth, and clarity in your drawings.
1. Teres major
2. Latissimus dorsi
3. Rib cage
4. Obliquus externus (or "love handles" in slang)

The Back

The shoulder blades curve away from the spine. Each shoulder blade (scapula) has a narrow bone that travels across it called the spine of the scapula. The spine of the scapula protrudes deeply into the shoulder muscle, ending in a sort of indented knob. When you look at the shoulder blade in someone's back, what you're really seeing is the spine of the scapula, not the actual top of the shoulder blade itself. The illustration below shows the actual shoulder blade bone.

Notice the basic shape created in the area between the spine of the scapula and the neck. By sketching this form as a guide, you'll be able to more accurately draw the back.

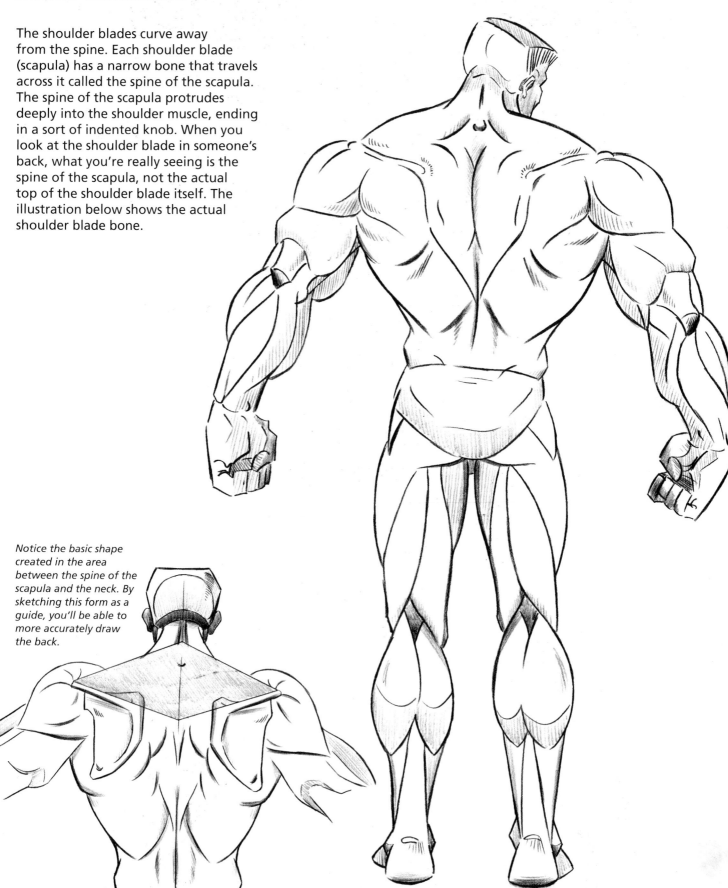

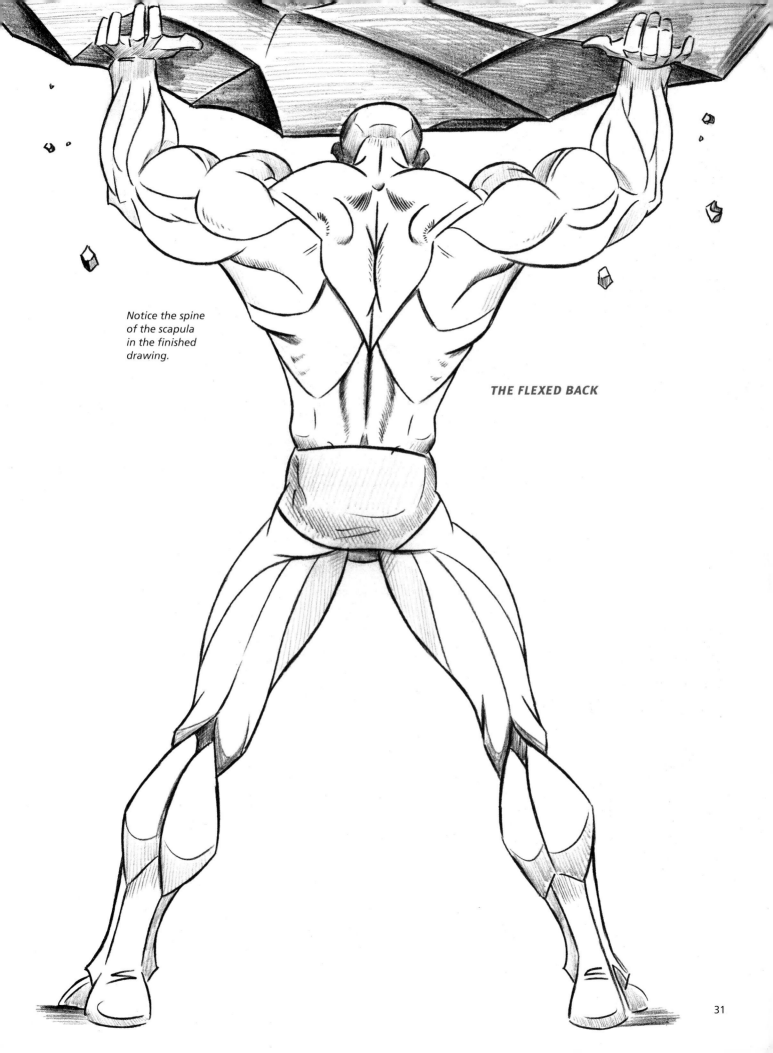

Notice the spine
of the scapula
in the finished
drawing.

THE FLEXED BACK

The Body in Profile

The important basic idea to get here is that the torso doesn't flatten out when the figure turns sideways; it retains a great deal of thickness in profile. There's a lot of mass on the back and behind the arms, especially on big characters. Notice, too, that the upper body is defined by bunches of muscle groups while the legs are defined by longer, leaner muscles.

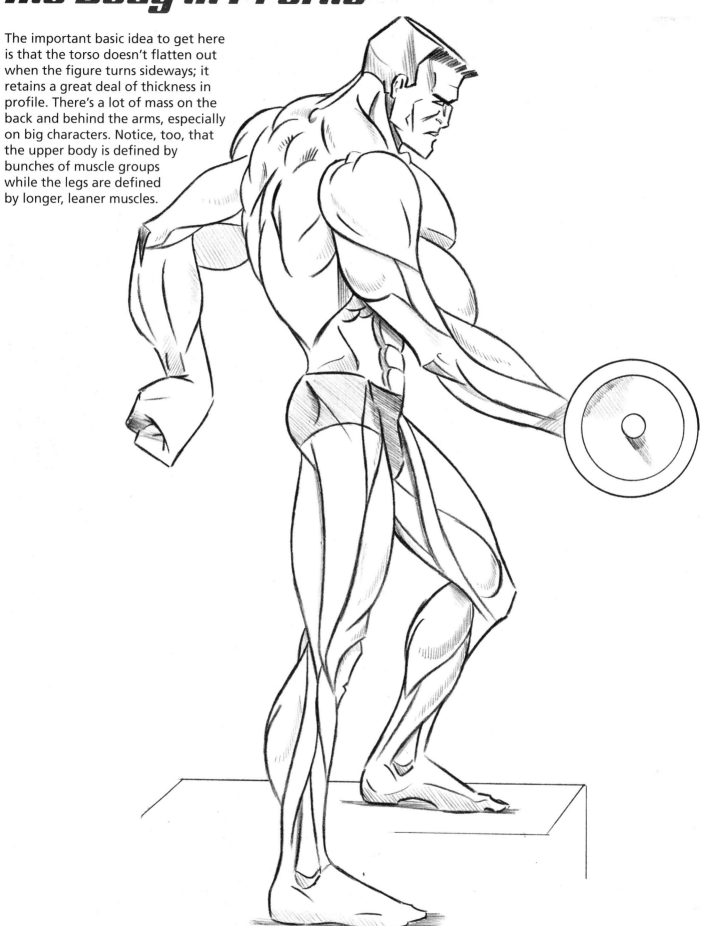

Overlooked Arm Muscles

We all know the big arm muscles: the biceps and triceps. We spent our youths in the high school weight room doing curls, remember? But there are important muscles that go in between the biceps and triceps, and you've got to indicate them or you won't draw a convincing arm. Want to know their names? Brachialis, coracobrachialis, and triceps brachii. Okay, so maybe you don't want to know their names. Like I say, names don't make you a better artist. Just take a look at the illustrations, and you'll quickly get up to speed.

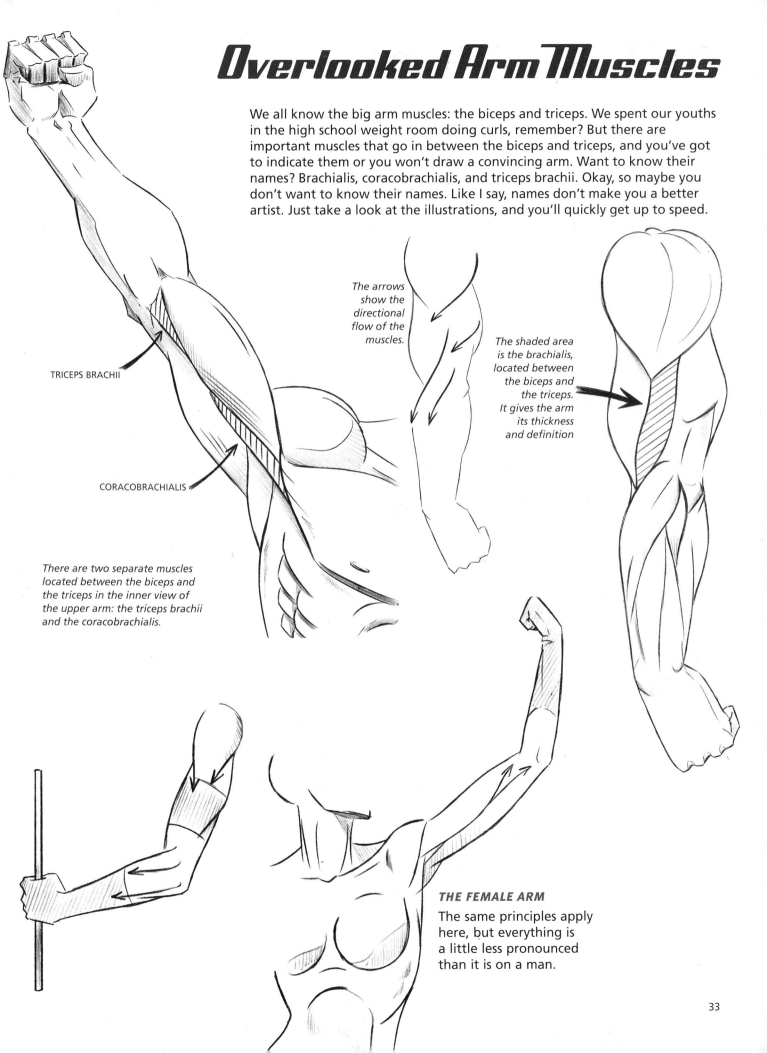

TRICEPS BRACHII

CORACOBRACHIALIS

There are two separate muscles located between the biceps and the triceps in the inner view of the upper arm: the triceps brachii and the coracobrachialis.

The arrows show the directional flow of the muscles.

The shaded area is the brachialis, located between the biceps and the triceps. It gives the arm its thickness and definition

THE FEMALE ARM

The same principles apply here, but everything is a little less pronounced than it is on a man.

Drawing the Angles

Good drawings require tough decisions. Trying to fake it when you're not sure will lead to drawings that lack conviction. Here is a method you can use to force yourself to be decisive in your drawings. Do your initial sketch using straight lines only—no curves allowed. If you make a mistake, it's okay. Just keep in mind that you are striving for a clear statement with each line. To finish, adjust the final drawing by smoothing out the hard angles.

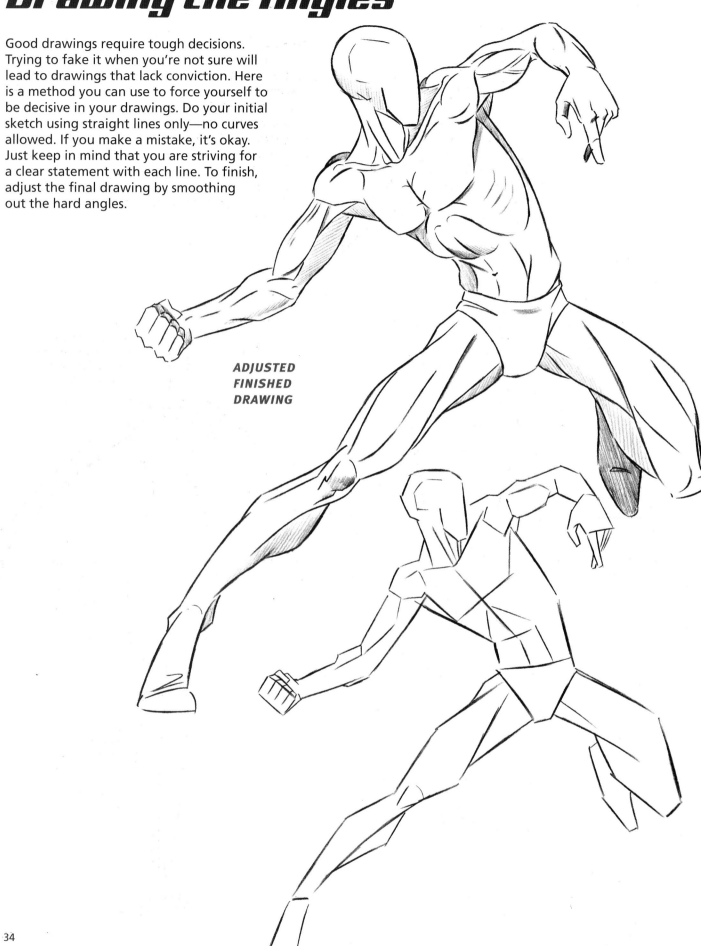

**ADJUSTED
FINISHED
DRAWING**

The Female Form

Instead of combining individual muscle groups as you would with the male body, you'll have more success constructing the female form by joining the basic overall body areas together. Is it easier? Not necessarily. Subtlety can be just as difficult to draw. You can go overboard in drawing a bad guy, making his arms too big or his back too wide, but he'll still look like he can bend cars with his pinkies. But if you bungle the proportions of a beautiful woman, she loses her attractiveness and you're sunk. They key is balance. Keep everything about her in balance.

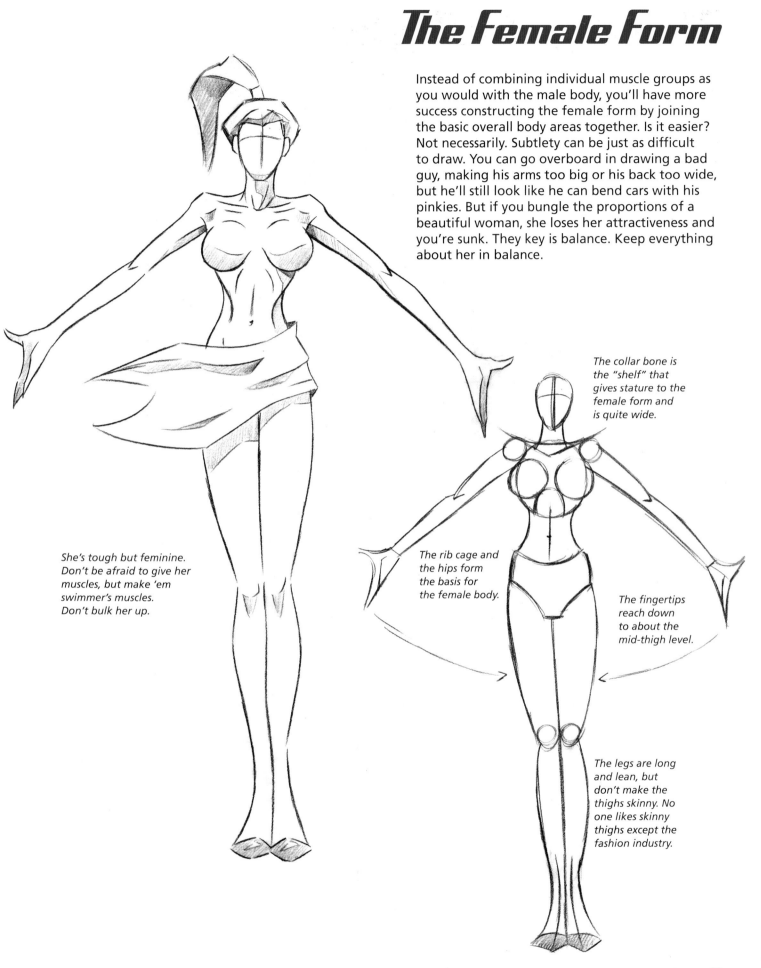

She's tough but feminine. Don't be afraid to give her muscles, but make 'em swimmer's muscles. Don't bulk her up.

The collar bone is the "shelf" that gives stature to the female form and is quite wide.

The rib cage and the hips form the basis for the female body.

The fingertips reach down to about the mid-thigh level.

The legs are long and lean, but don't make the thighs skinny. No one likes skinny thighs except the fashion industry.

The Torso

We generally assume that the light source in any scene comes from above, whether in the form of sunlight or interior lighting. Of course, comic books are famous for dramatic sidelighting or bursts of light coming from below. But as a rule of thumb, a woman's upper body creates the following cast shadows.

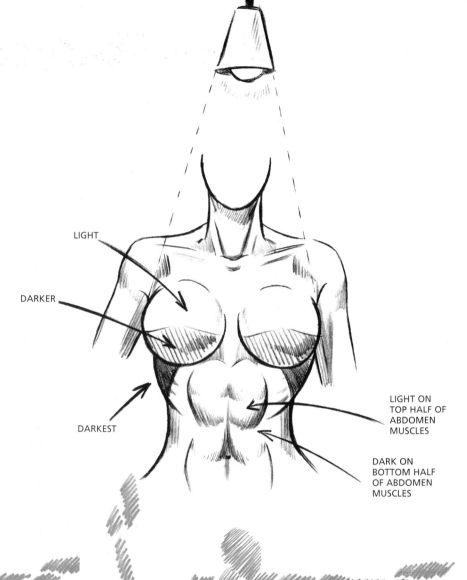

LIGHT

DARKER

DARKEST

LIGHT ON TOP HALF OF ABDOMEN MUSCLES

DARK ON BOTTOM HALF OF ABDOMEN MUSCLES

ROTATION

The upper body is capable of a nice bit of rotation, and because of that, you can play with alternative positioning before settling on a final pose. By simply repositioning the front features of the torso, you can change the direction of a pose.

Upper Body Contour Lines

There are three basic, vertical contour lines on the anterior side of the female torso. Each travels downward. They give the body dimension by breaking up what would otherwise be an undelineated mass.

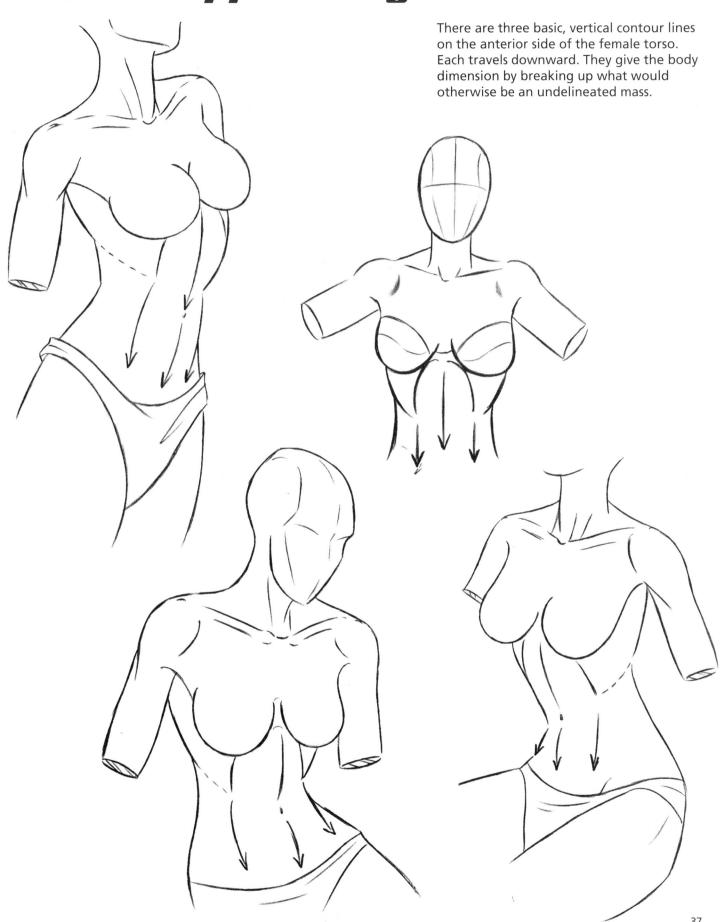

The Female Body in Profile

Without the arms, the graceful curves of the female form in profile become overwhelmingly evident. It's the back, not the front of the torso, that displays long, flowing lines. Notice the continuous hills and valleys of the back, particularly at the hips. In addition, the rib cage and hips tilt in opposite directions at a significant angle. The greater the tilt, the sexier the pose. Note, also, the sweep of the legs, which changes direction at the knee.

OUT

IN

OUT

UP

IN

DOWN

OUT

OUT

IN

Dramatic Twisting

You can give your poses that extra something by twisting the torso and hips in opposite directions. This gives the figure a dynamic quality but can also make for trickier drawing. Unless you're very comfortable drawing the figure, the overall flow of the body can become disrupted in the areas where the figure shifts directions.

To unify the pose, start by sketching a center line. This is an imaginary line that runs down the center of the body, no matter what direction the body is facing. By keeping track of where the center is, you'll keep the body's alignment from going out of whack. Many professional illustrators and most professional animators continue to sketch the center line on all complex poses throughout their careers.

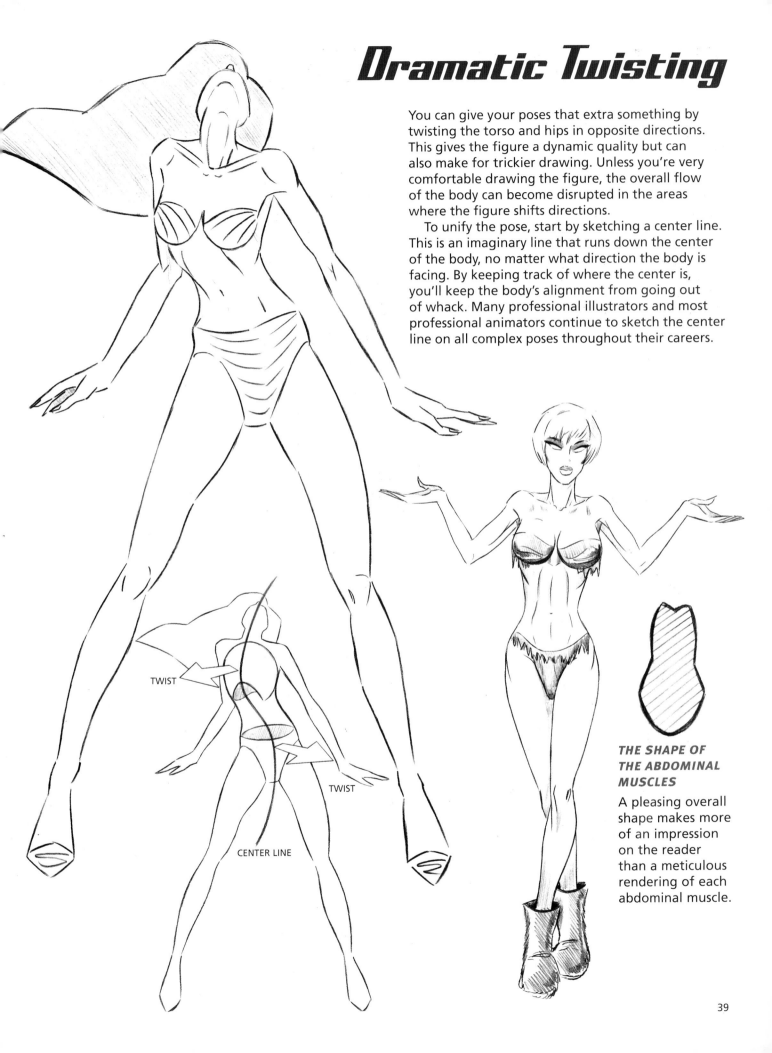

TWIST

TWIST

CENTER LINE

THE SHAPE OF THE ABDOMINAL MUSCLES

A pleasing overall shape makes more of an impression on the reader than a meticulous rendering of each abdominal muscle.

The Female Back

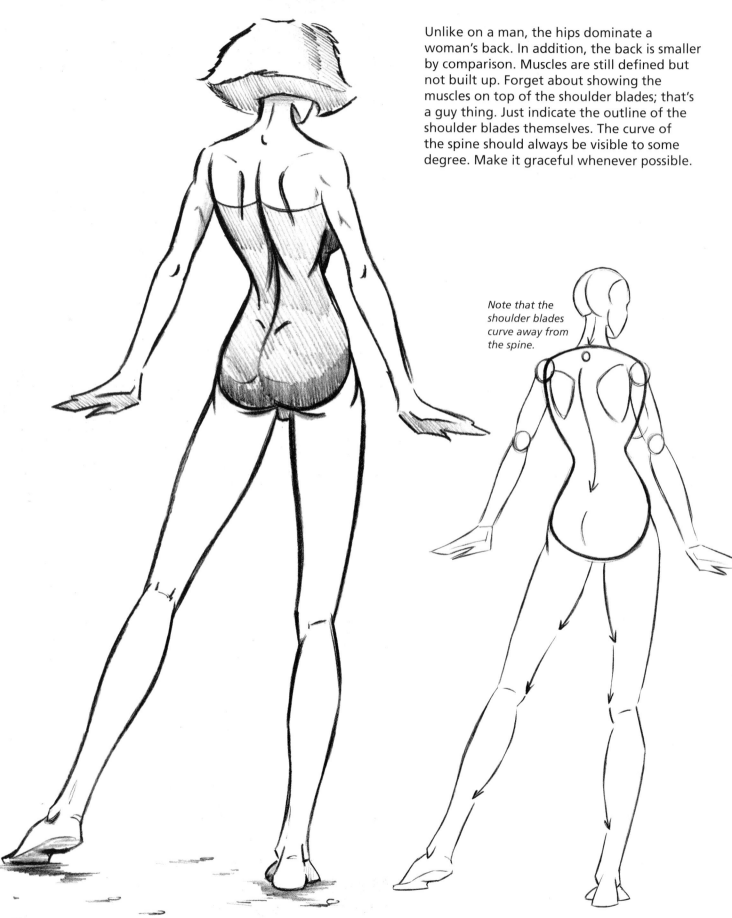

Unlike on a man, the hips dominate a woman's back. In addition, the back is smaller by comparison. Muscles are still defined but not built up. Forget about showing the muscles on top of the shoulder blades; that's a guy thing. Just indicate the outline of the shoulder blades themselves. The curve of the spine should always be visible to some degree. Make it graceful whenever possible.

Note that the shoulder blades curve away from the spine.

Legs

Keep in mind these fundamental shapes and ideas as you create your own characters.

BASIC HIP SHAPE

A single contour line travels from the inner thigh to the inner calf, giving a lean and long look. On a woman, this is a better way to show leg muscles than by bunching them together.

The exterior joint of the knee is higher than the interior joint of the knee.

Note the angle of the hips (the arrow): here, the weight-bearing leg pushes the hip up, causing the hip on the right to round out; the relaxed leg steps away from the body for balance, creating an indentation in the hips to the left.

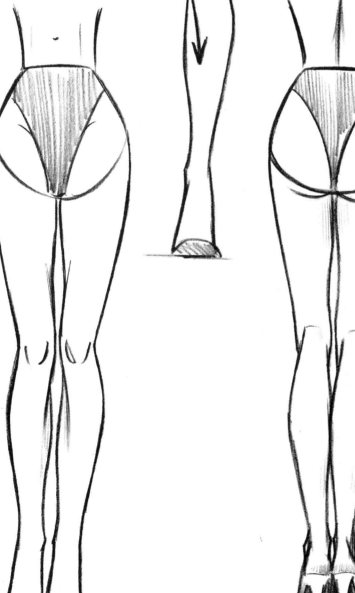

The glutes (butt muscles) dip below the hips in the back view.

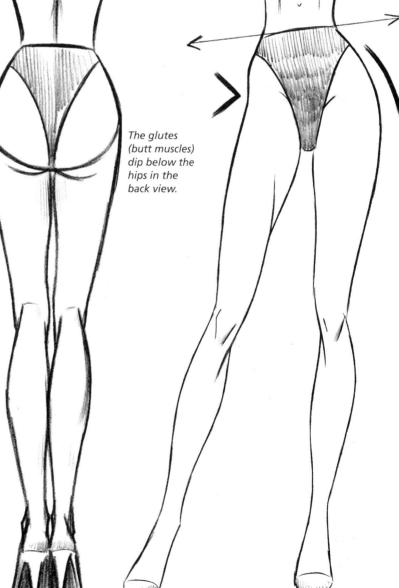

The Big Guys

Today's comic book big guys go *way* beyond the norm. They are astoundingly impressive. Massive. Awesome. They're the next stop on your way to the cutting edge. ■ When you pump up your guys to maximum size don't touch the size of the head. Only the body grows. The head remains exactly the same. The contrast between the tiny head and the ultra-massive body is an *insane* look that translates into raw, unbridled power. This contrast also makes the character look even taller, because our eye judges the height of a character in terms of how many heads tall it is. The more stacked heads it takes to make up the length of a character, the taller that character will seem. Look at the wimpy guy on the opposite page and the transformation he undergoes after being whacked by a bolt of pure energy. It transforms him into a hero and then way beyond—into a comic book giant.

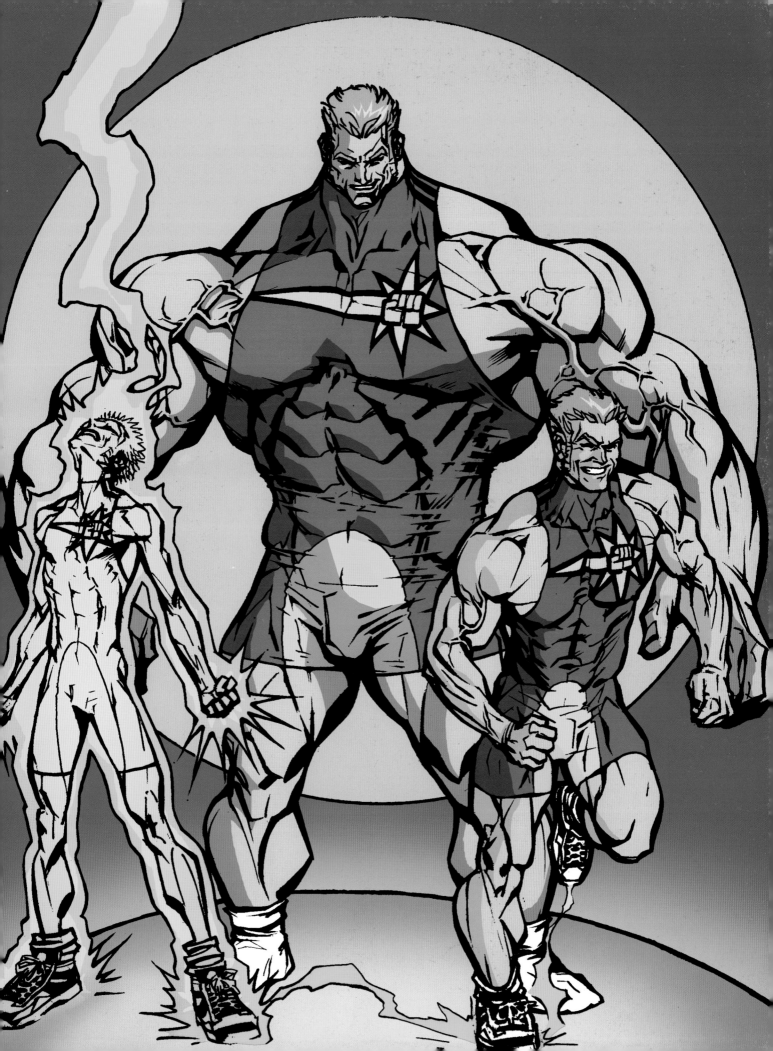

Extreme Veins

Visible veins make muscles look like they're going to explode. Extreme vascularity found its way into the public consciousness by way of professional bodybuilders, such as Arnold Schwarzenegger. It's a cutting-edge look. You don't have to—nor should you—show all of the veins all of the time. Pick and choose.

Notice that the major arteries and veins crisscross one another like latticework, and are most plentiful on the neck, inner shoulders, arms, and inner thighs. They are less apparent on the upper chest, lower abdominals, hips, and inner calves—and almost nonexistent on the rib cage, trapezius, and middle of the chest.

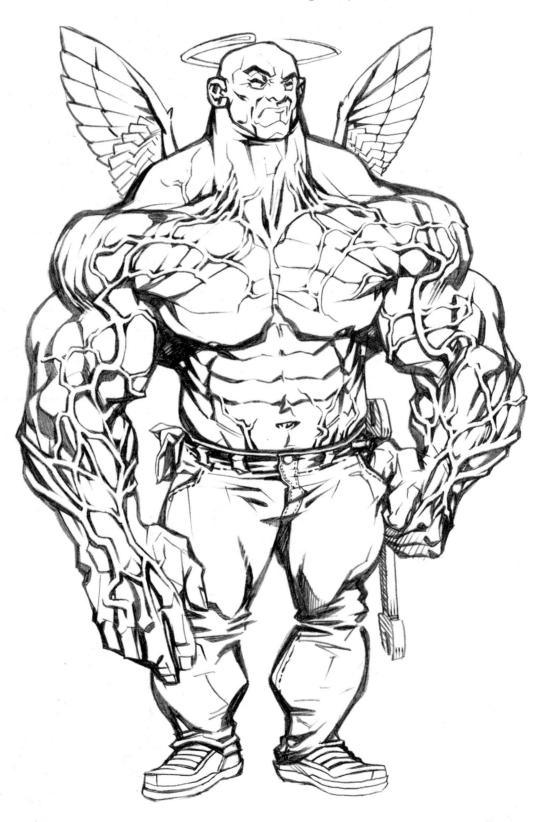

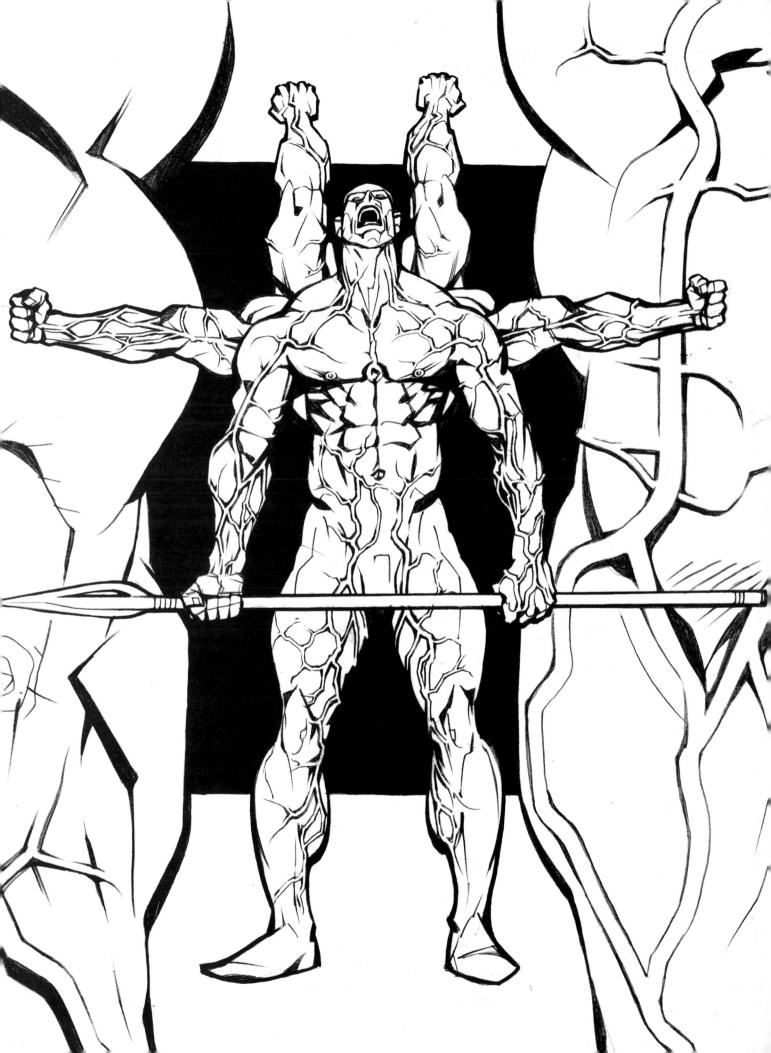

Strange Creatures

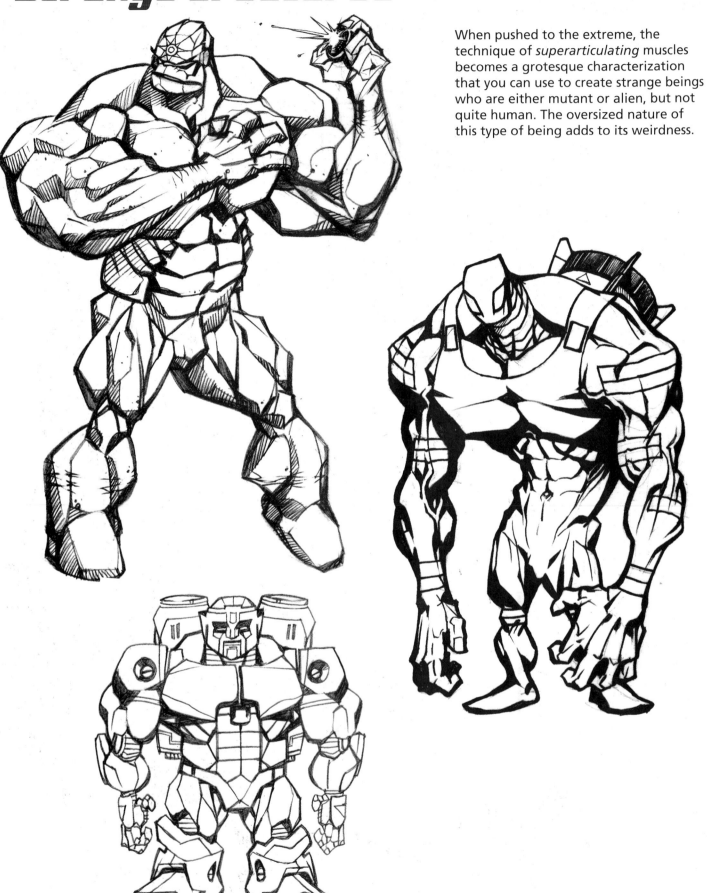

When pushed to the extreme, the technique of *superarticulating* muscles becomes a grotesque characterization that you can use to create strange beings who are either mutant or alien, but not quite human. The oversized nature of this type of being adds to its weirdness.

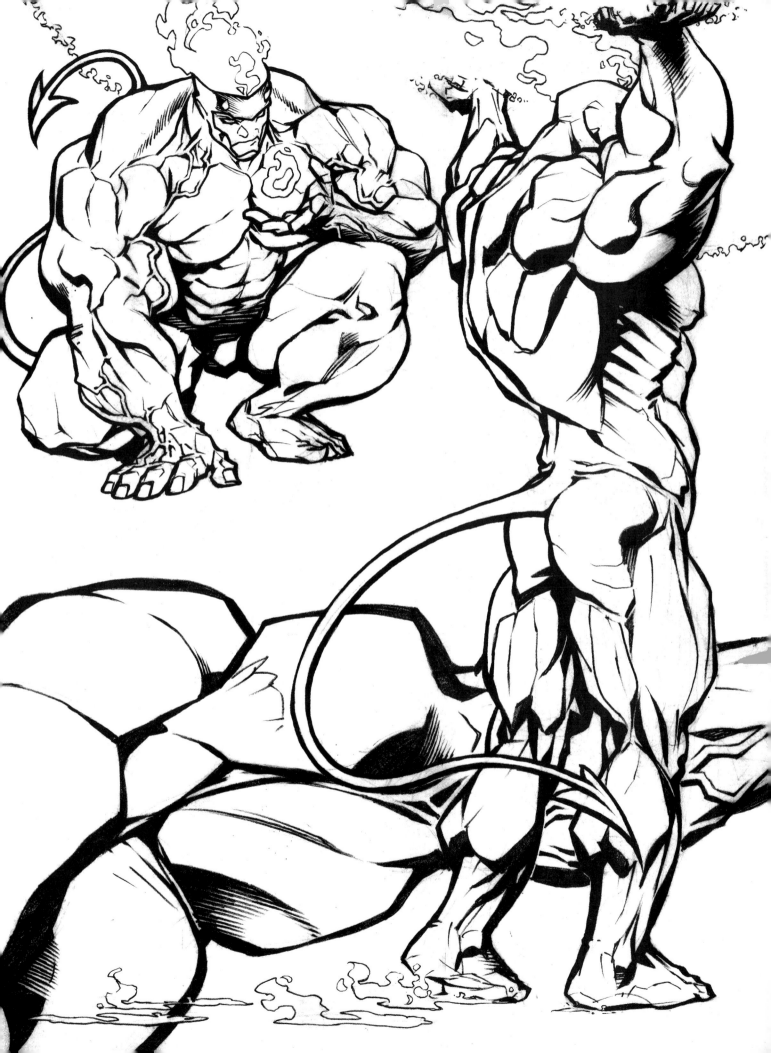

Muscle-Bound Freaks

You can draw any character in a cutting-edge style. That's one of the cool features of comics: They break boundaries, pulling the reader in tow. But the crucial question is, Why have these characters taken on their strange forms? It's up to you to invent a history (or "backstory," as it's called in Hollywood) for them. A compelling history is absolutely essential. It creates the mystery, tragic legend, and purpose of a character. Without the backstory, all you've got is a picture.

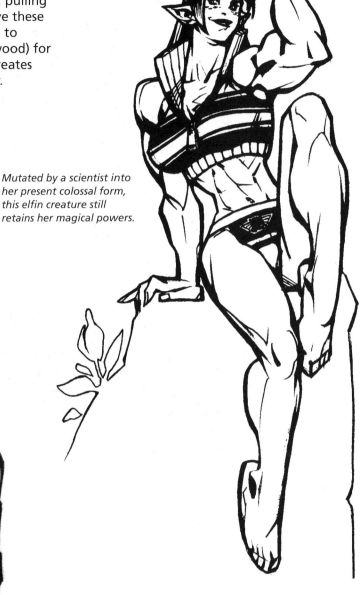

Mutated by a scientist into her present colossal form, this elfin creature still retains her magical powers.

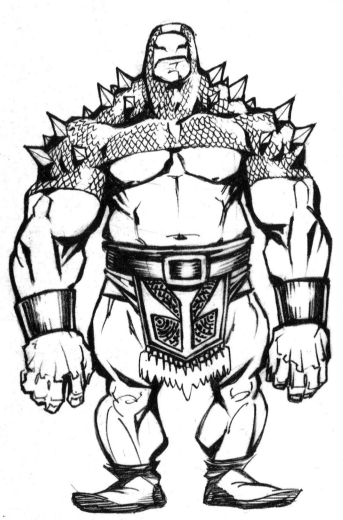

This prince was cursed by a jealous princess who could not win his affections. He must live his life out as an ogre servant in her castle.

STRETCHING AND CONTRACTING (OPPOSITE)

Muscles pull apart or bunch together, based on a specific action. If a character reaches for something, the muscles stretch and lengthen. If a character pulls something toward itself, the muscles contract and bunch together. For example, look at the tattoo on the back of this colossal figure. When the arms pull forward, the back muscles stretch, and as a result, the tattoo widens into an oval shape (opposite page, top). When the shoulder blades crush together, the back muscles bunch up, and the tattoo contracts, becoming taller, thinner, and more circular (opposite page, bottom). The figure facing the reader stands up straight, lengthening his torso and smoothing out his chest and abs.

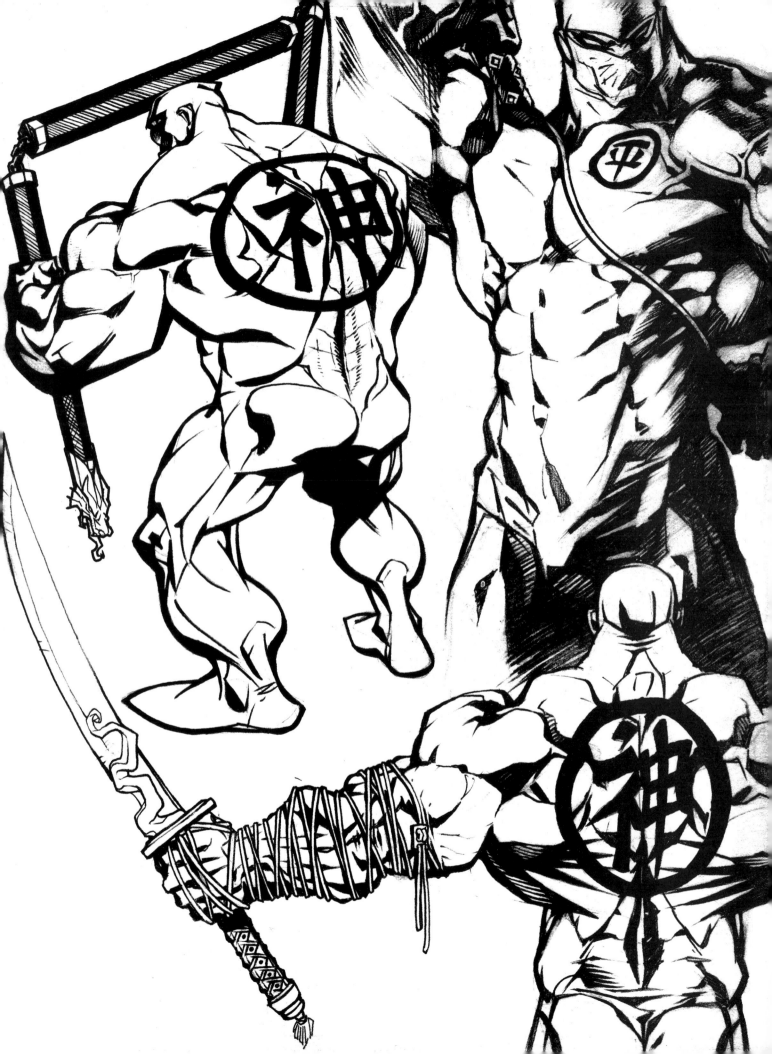

Wild Things

Even creatures that appear more animal than human are usually represented by using human brute anatomy. Again, the keys to these characters are exaggeration, articulation (definition of the muscle groups), and basing the body on a strong sense of form and structure. Approach your drawings as if you were a sculptor instead of an illustrator. Carve out each muscle group with definition and precision.

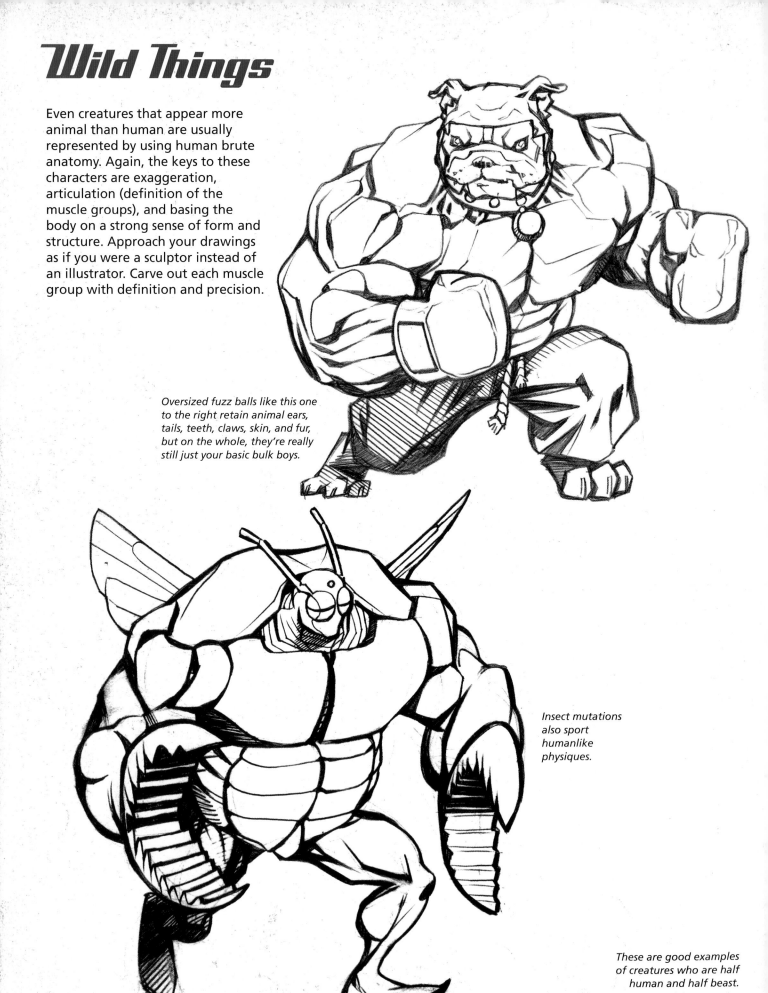

Oversized fuzz balls like this one to the right retain animal ears, tails, teeth, claws, skin, and fur, but on the whole, they're really still just your basic bulk boys.

Insect mutations also sport humanlike physiques.

These are good examples of creatures who are half human and half beast.

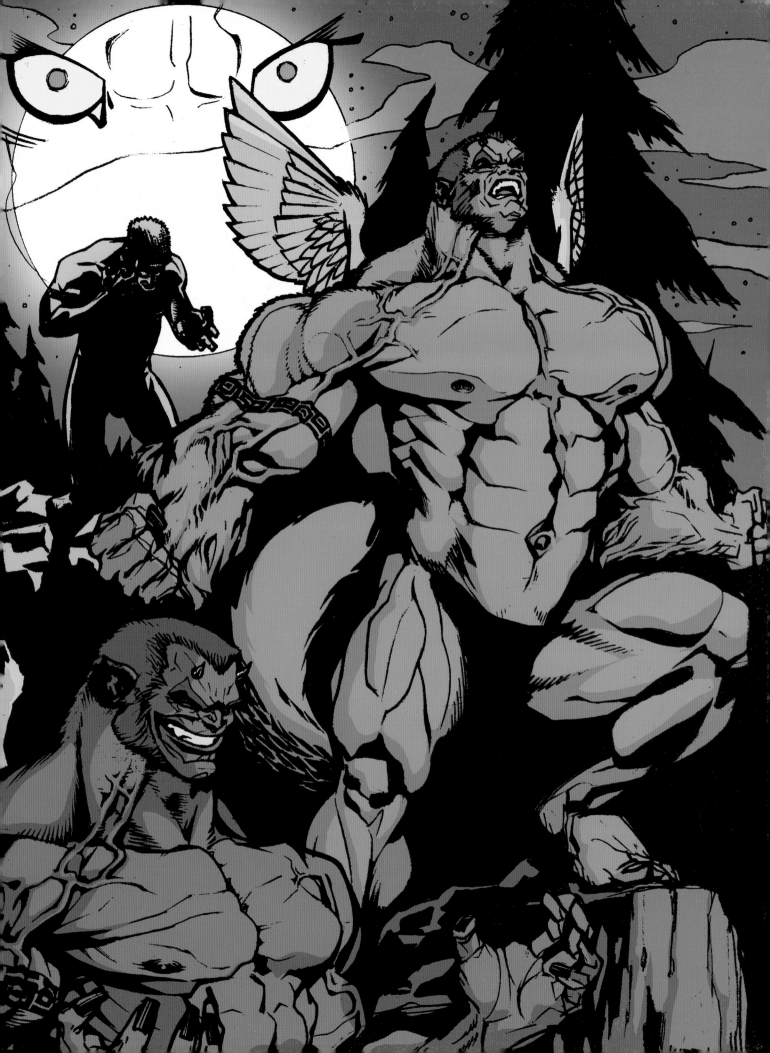

Extreme Allure

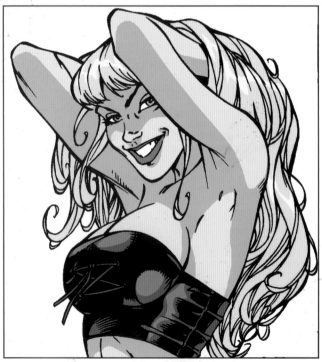

For this chapter, we'll be concentrating solely on the latest techniques used by the top pros to create the most attractive-looking ladies on the planet. Then, if you want to stick 'em in space suits to fight aliens, be my guest. Not all of today's comic book artists can draw fantastically seductive women, but those who do are always in demand.

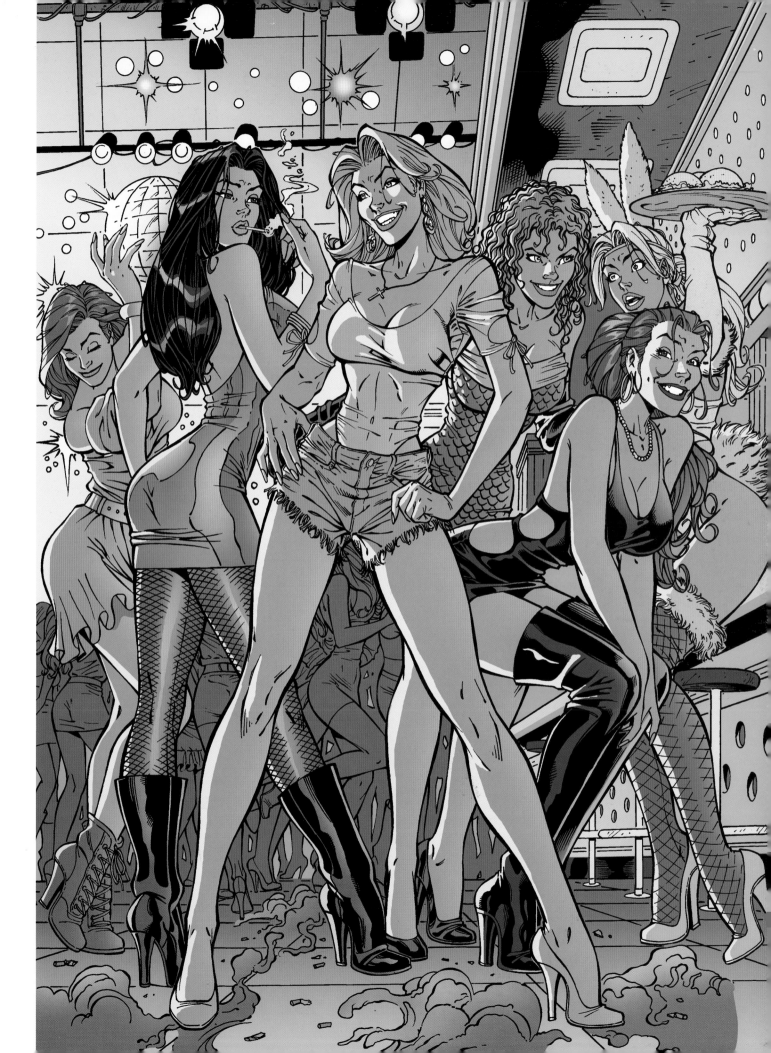

Sexy Eyes

IRIS
PUPIL
WHITE

Divide the eyeball into three parts: white, iris, and pupil. Notice that the eye is completely spherical. You can draw lines around the eye, as if it were a globe, to help you visualize it as round and three-dimensional (left).

The eyes are, by far, the most important feature of a comic book woman's face. If the eyes lack impact, you're done. Pack it up, and send somebody else to pinch-hit, because you can't save it after that. So, let's take a look at the basic principles of drawing the eye.

The diagram shows the volume of the eyeball.

The arrows show the direction of the supraorbital arch.

As you first draw the eyelids and eyelashes, continue to lightly indicate the outline of the eyeball itself, as in the sketches at left. This will help you get a feel for the volume of the eye and how much room it takes up on the face.

Unless you understand what's underneath the eyelids, you're likely to think that the eyeball is almond shaped, due to the eye's external appearance. It isn't. The eyeball is round. Try drawing the examples you see on this page, but try drawing them without faces at first. You'll get a lot more practice that way than if you were to draw an entire face with each set of eyes.

The arrows show the direction of the eyebrows and eyelashes.

DETERMINED

ATTENTIVE

DOUBTFUL

DREAMY

ASSERTIVE

INTENSE

HESITANT

PAINED

RESTING

AFRAID

LOST IN THOUGHT

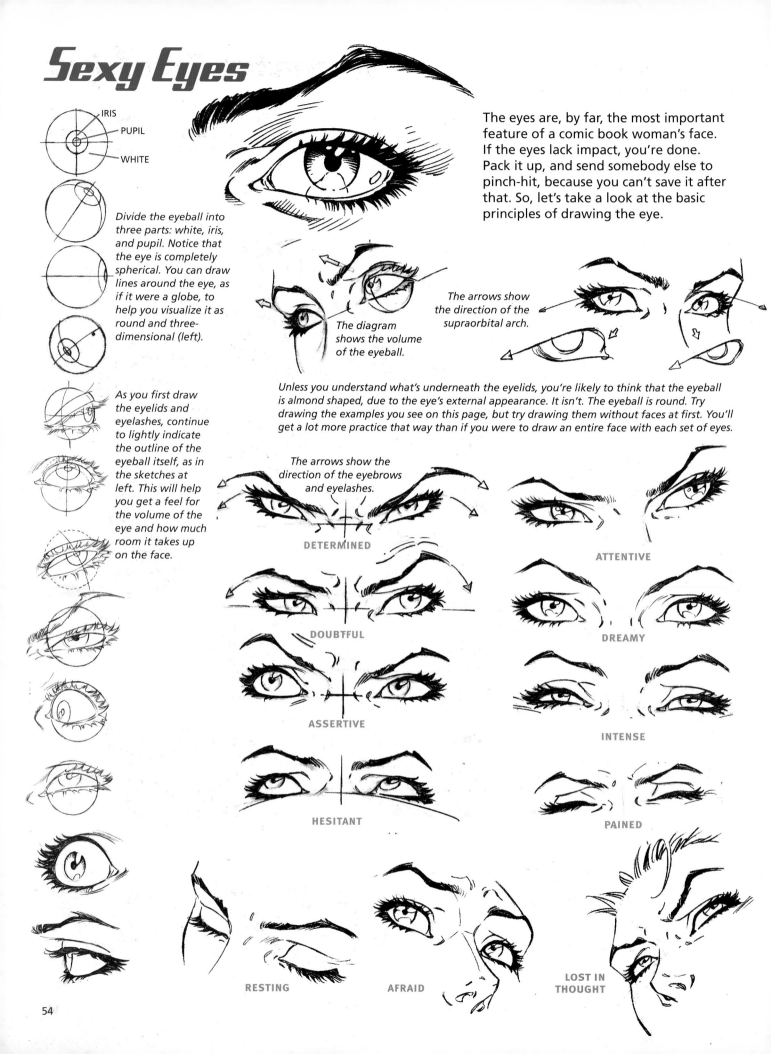

Irresistible Lips

Let's take a look at the feature that most supports those alluring eyes: the lips. After the eyes, the mouth is the most important feature in creating a seductive comic book woman.

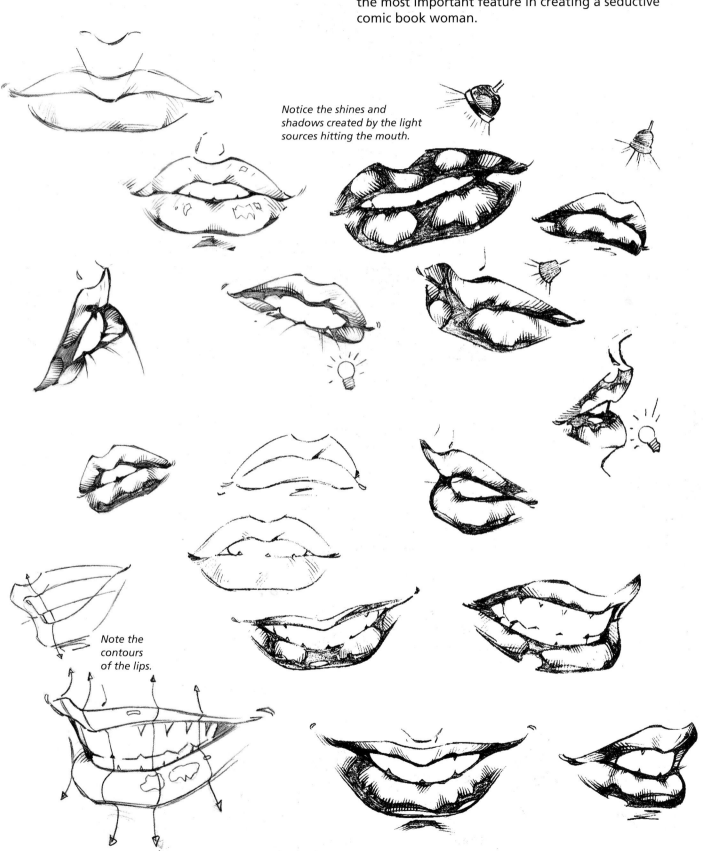

Notice the shines and shadows created by the light sources hitting the mouth.

Note the contours of the lips.

Not Just Another Pretty Face

Try out these attractive characters.

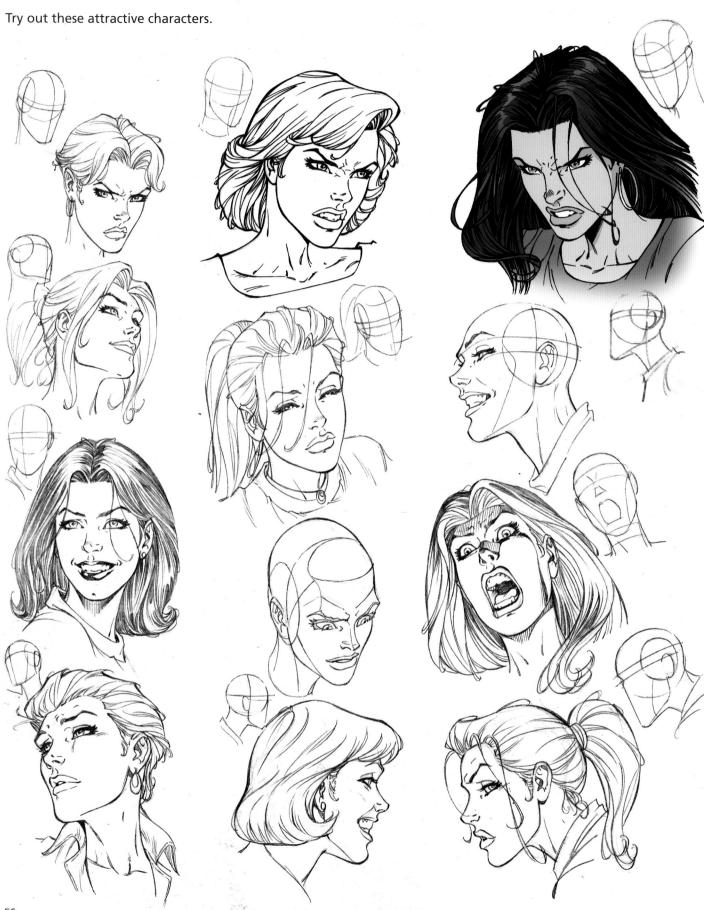

Turning Pretty into Sexy

There's more to sexiness than mere prettiness. There's that "special something" that will make you walk barefoot over busted glass just to ask for her phone number. The next few pages are going to show you how to get it. No, not her phone number—that quality in your drawing.

Start with a pretty character. She's great looking but seems unaware of her own beauty. In comic books, that's what prevents her from being as sexy as she could be.

Let her hair flow, cascading carelessly around her face. Her eyelids are a bit heavier, and her mouth is slightly opened, relaxed.

In the final stage of the transformation, she has eyes with heavy lashes. Her mouth is opened a little bit more, her head tilts back slightly, and her shoulders are raised. She's alluring, seductive, and irresistible.

A NOTE ABOUT HAIR

On the far right is the old-fashioned method of drawing hair—filling in an entire black mass with a few highlighted areas. On the near right is the cutting-edge method—articulating each individual strand.

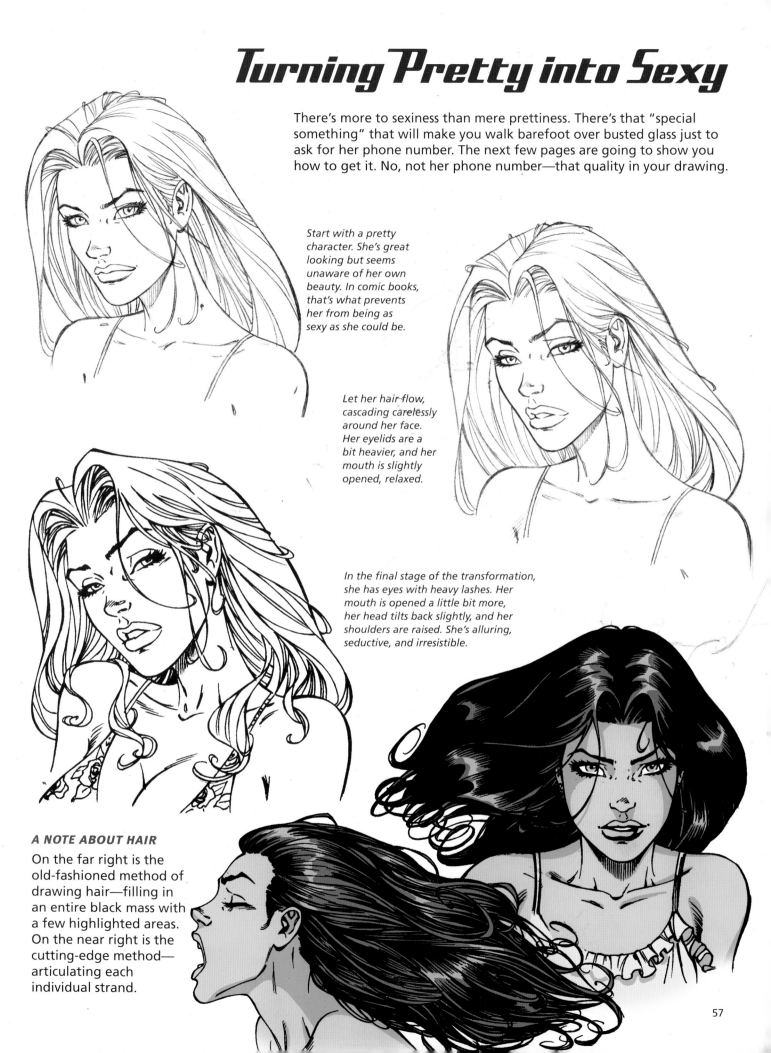

57

Transforming a Regular Woman...

Body language and costume can add allure to a character's persona.
By merely altering the posture and clothing of a female character
just slightly, you can turn a mortal man into a pool of quivering Jello.

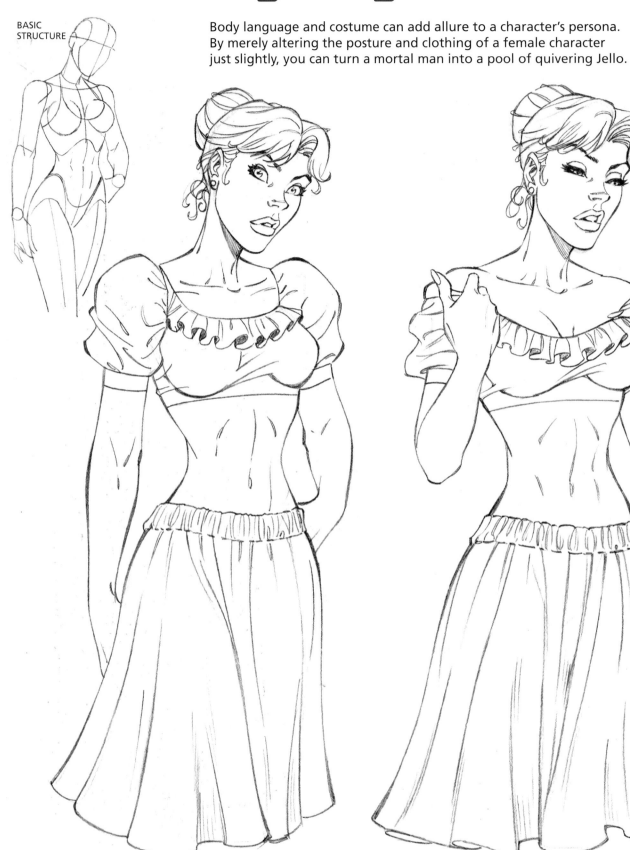

*Pretty straightforward.
She's a looker all right, but
there's no sensuality here.*

*Here the blouse sleeves are drawn
lower to reveal the neckline and shoulders.
Much more attractive.*

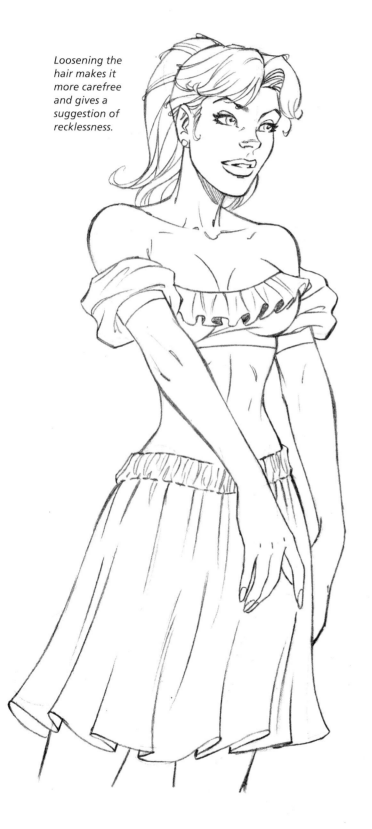

Loosening the hair makes it more carefree and gives a suggestion of recklessness.

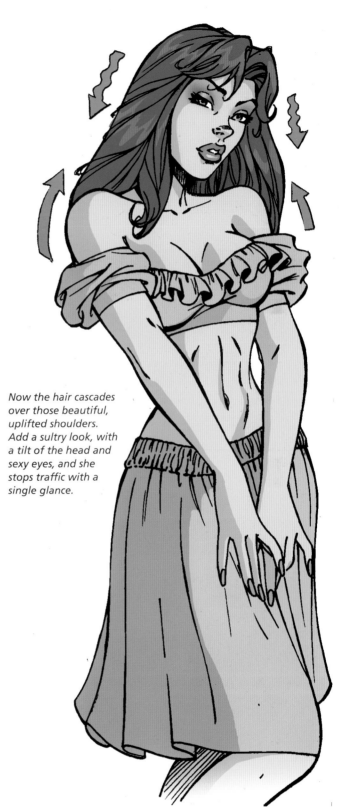

Now the hair cascades over those beautiful, uplifted shoulders. Add a sultry look, with a tilt of the head and sexy eyes, and she stops traffic with a single glance.

Sexy Clothes and Costumes

Choosing the right clothes for a character is essential because clothes are the first thing your reader sees. If the clothes are too loose and hang on a woman like a potato sack, they hide the body language. Here are some suggestions for dramatic, formfitting, revealing clothes.

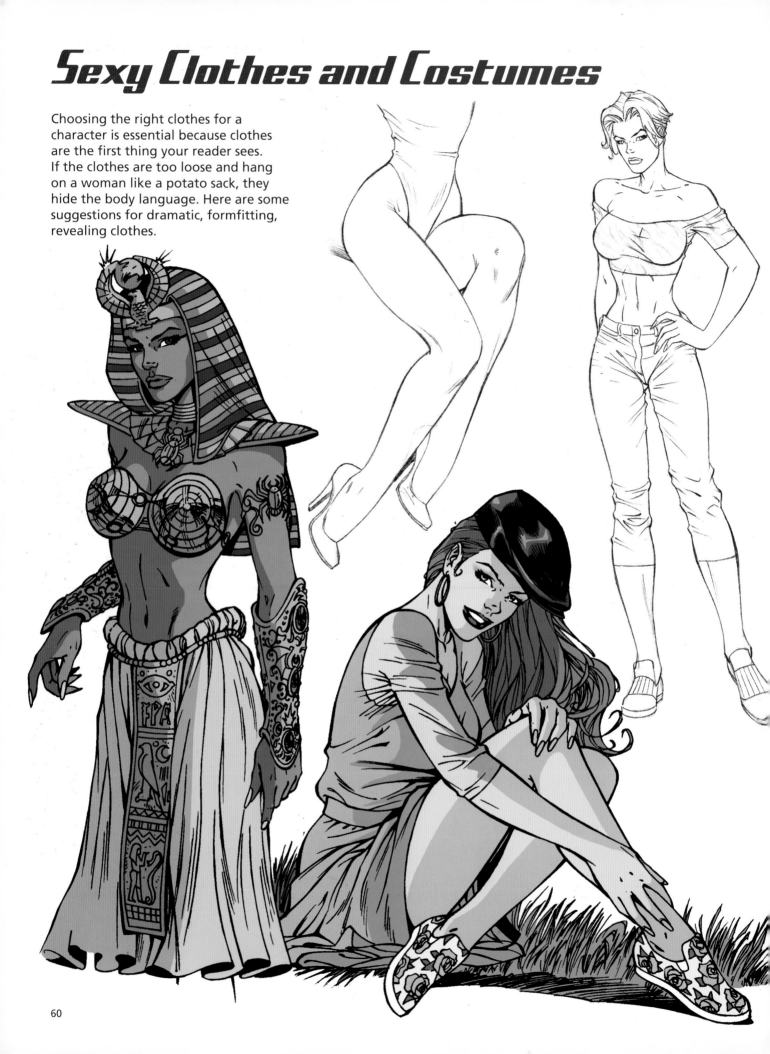

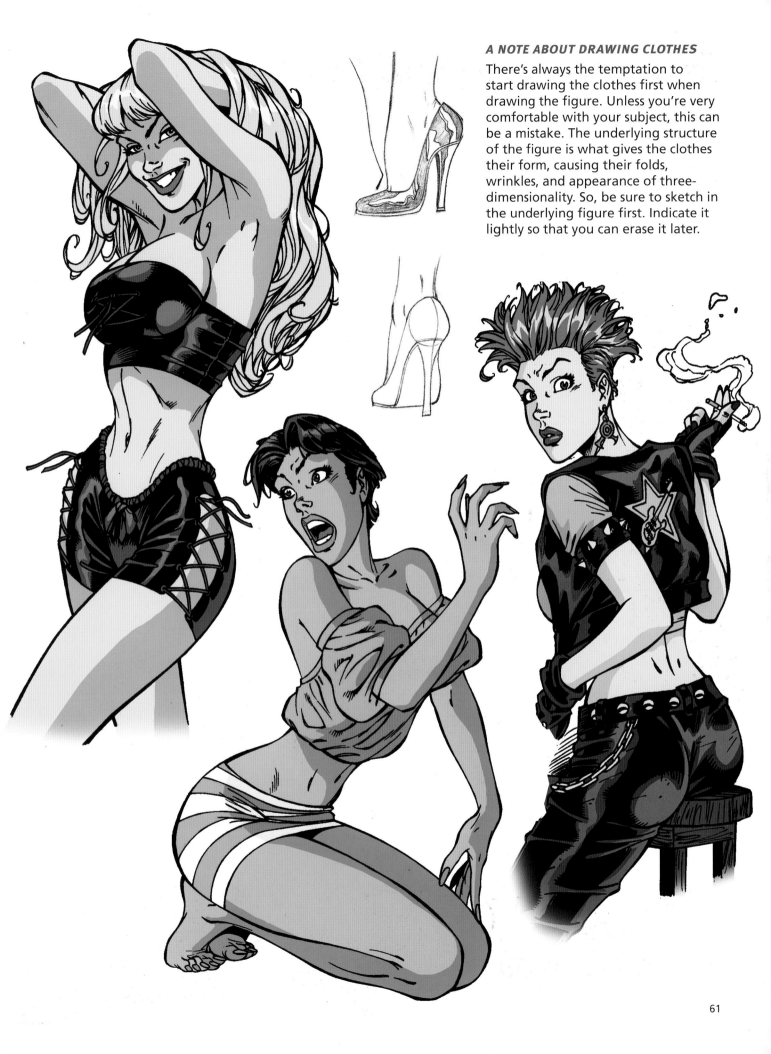

A NOTE ABOUT DRAWING CLOTHES

There's always the temptation to start drawing the clothes first when drawing the figure. Unless you're very comfortable with your subject, this can be a mistake. The underlying structure of the figure is what gives the clothes their form, causing their folds, wrinkles, and appearance of three-dimensionality. So, be sure to sketch in the underlying figure first. Indicate it lightly so that you can erase it later.

Extreme Character Design

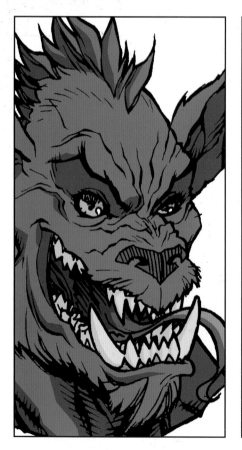

Today's comics are all about pushing the envelope. Nowhere should that be more evident than in the design of your own characters. You've got to squeeze every ounce of juice out of them. Let's start by looking at some ordinary features and see what we can do when we approach them with an eye toward the cutting edge.

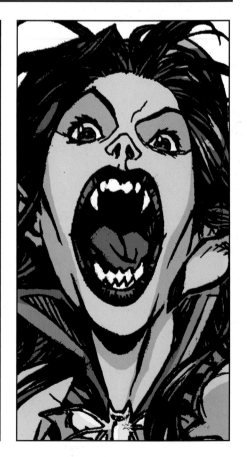

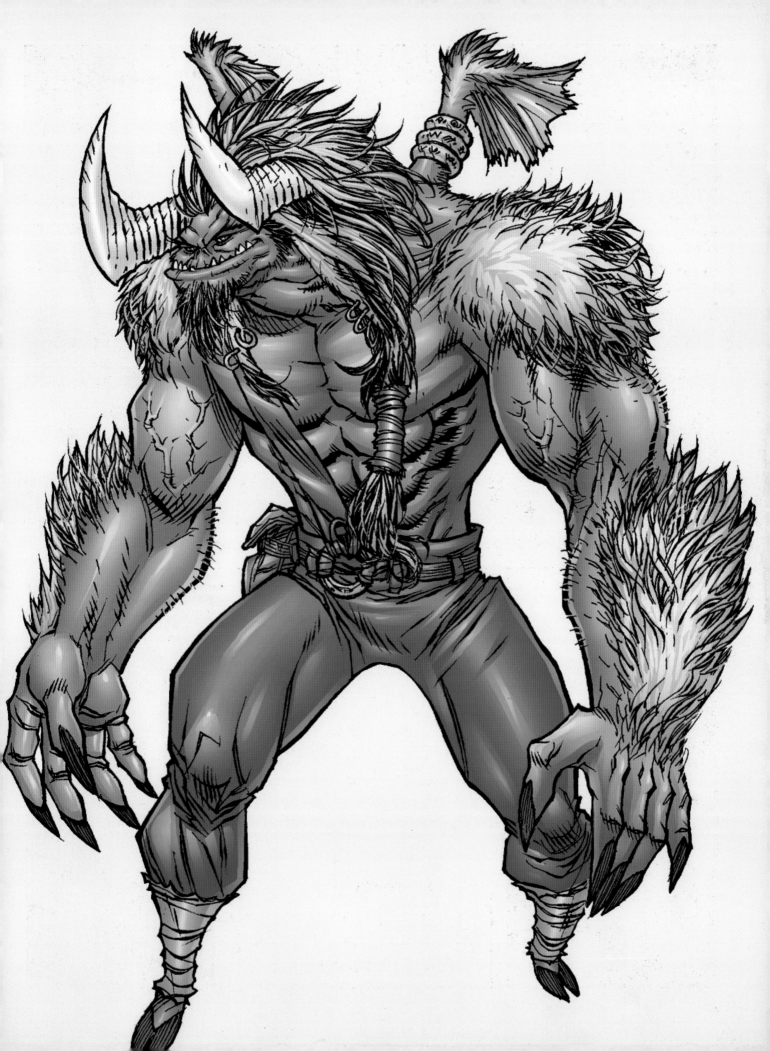

Eyes

It has been said that the eyes reflect the soul. If that's true, then a cutting-edge character must have cutting-edge eyes. To achieve this, sharpen the shape of the eyes and eyebrows. And on your female characters, intensify the eye lashes.

ORDINARY—MALE

Not bad. Feels good. Feels solid. But lacks drama and a slashing style.

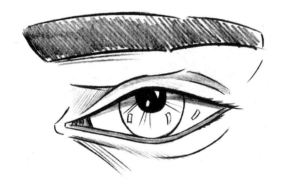

ORDINARY—FEMALE

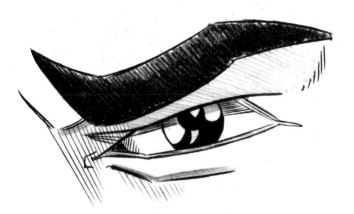

CUTTING-EDGE—MALE

Looks cool, sharper. But wait! It's not as anatomically correct as the ordinary eye, is it? No, it's not. So sue me. The dramatic effect is more important than accuracy.

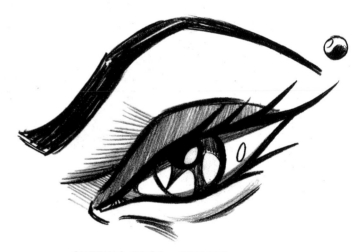

CUTTING-EDGE—FEMALE

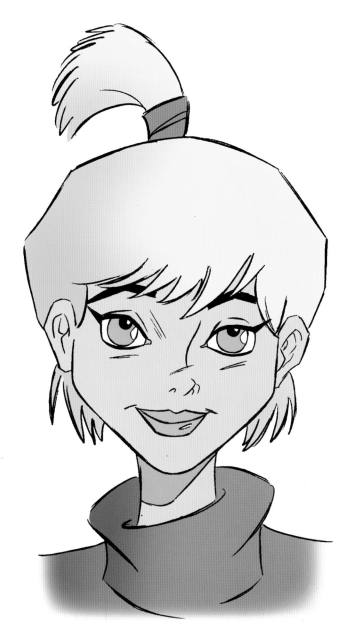

REGULAR

Nice, plain, not a ton of personality. The type of gal who'll let you copy her homework.

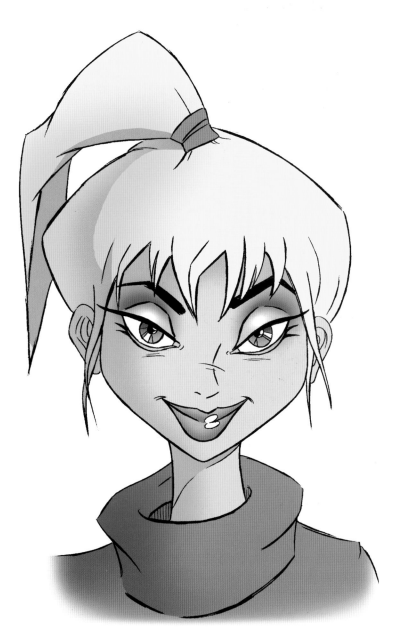

TWEAKED

Now she has something going on behind the eyes. But, it's more than just the eyes. It's the hair, lips, nose—it's everything. Everything has been changed *just a little*, but together, it all adds up to a significant difference. It's all a bit sharper.

The Eye/Nose Faceplate

Many great characters never get fully realized due to artist fatigue. You might draw three detailed variations of a character's head, run out of time or inspiration, and settle on one—even though none of them really thrills you. And, if your choice doesn't thrill you, it probably won't thrill your reader, either. However, there's another method for designing characters that will make you more prolific.

A face's personality is derived principally from the eye/nose area, and if you were to focus solely on that spot, you could run through many more variations in the same amount of time. Sketch new eyes and noses until you've found the look you like. Once you've got that, then you can go ahead and fool around with altering the basic head shape. You don't need to throw out your old method of working, but add this technique to your repertoire.

ORIGINAL EYE/NOSE COMBINATION

VARIATIONS

66

Overall Design

When creating a cast of characters, the rules change. Each character must look different from the others. If your idea for different characters is different-shaped noses, then all of your characters will look the same, just with different noses. You need to start with a different overall theme for each character and allow that concept to dictate the types of features you use.

ANGULAR

Here's a pinched face that narrows to a point. As a result, all the features are pointy, tight, and angular.

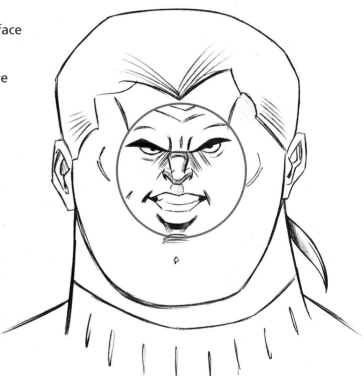

GATHERED

This guy's theme is having all his features gathered centrally in his massive head. The shape of his features doesn't really matter so much as their placement.

EXPANDED

Staggering the placement of the features and creating unusual distances between them, results in a unique character.

SHORT FOREHEAD

LONG NOSE

LONG UPPER LIP

MEDIUM CHIN

Character Types

Sometimes, you have to think in terms of star power. Visualize your character starring in a story. What role would he or she play? What *type* would he or she be? Cast your lead characters as if they were movie stars and you were the casting agent, make-up artist, and costume designer.

Your characters need to fit a certain type; they can't be kind of this and kind of that. Make a decision. Audiences need strong types to lead them through a story. Here are a few.

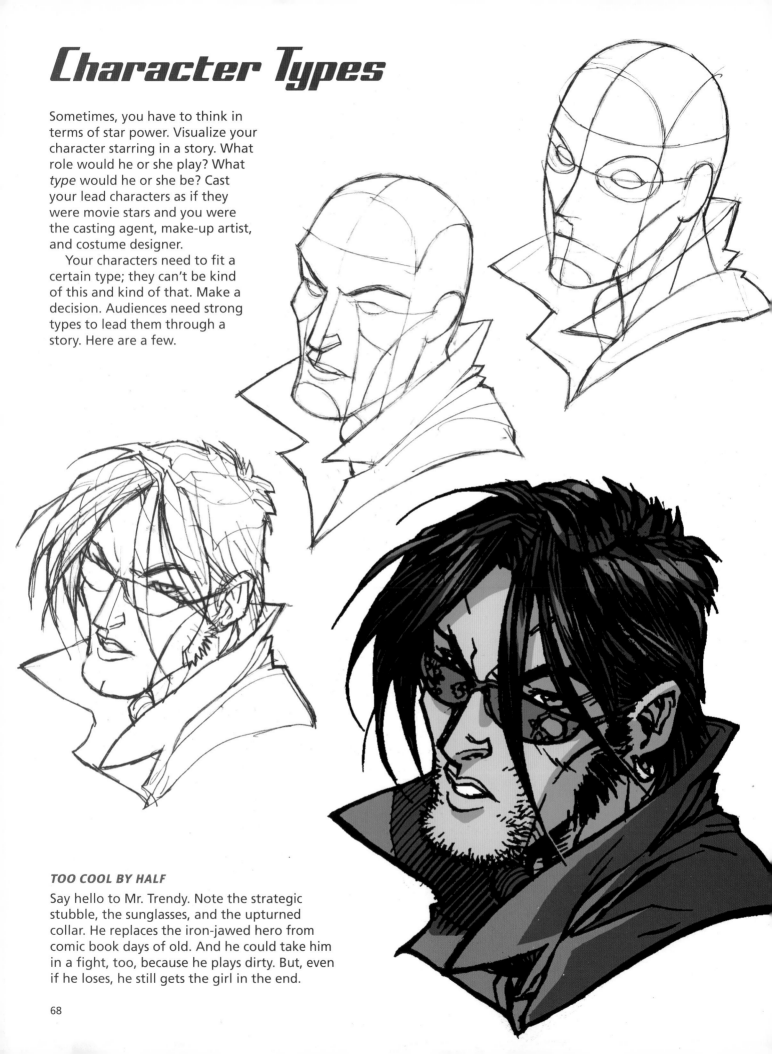

TOO COOL BY HALF

Say hello to Mr. Trendy. Note the strategic stubble, the sunglasses, and the upturned collar. He replaces the iron-jawed hero from comic book days of old. And he could take him in a fight, too, because he plays dirty. But, even if he loses, he still gets the girl in the end.

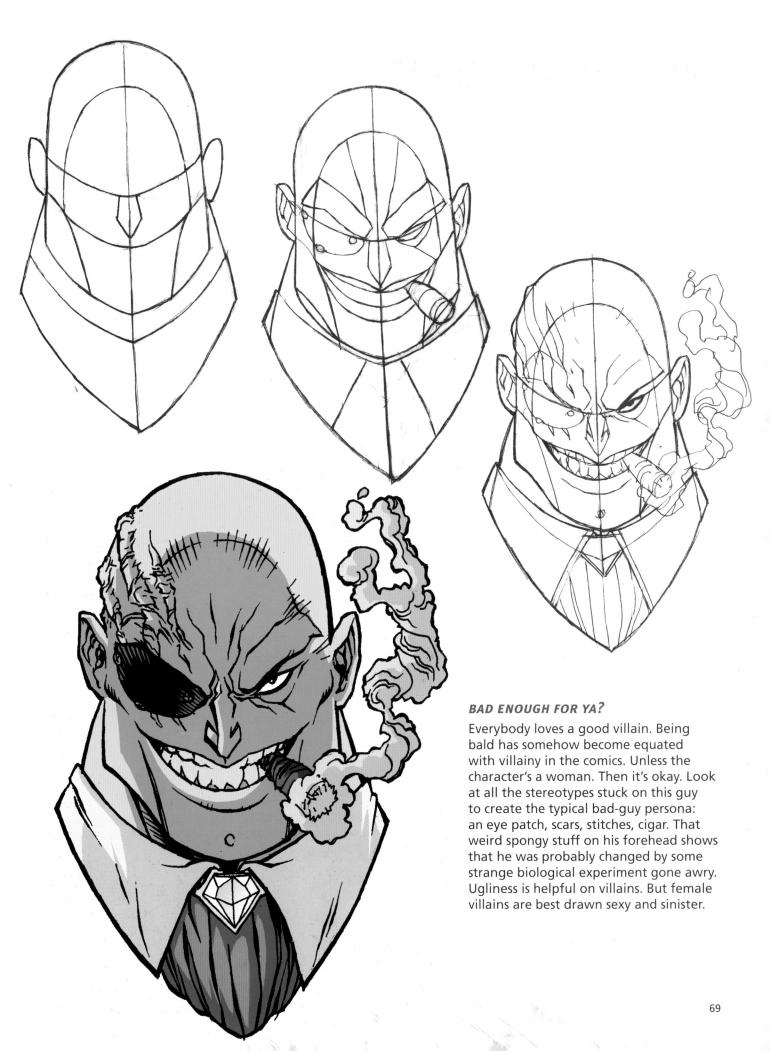

BAD ENOUGH FOR YA?

Everybody loves a good villain. Being bald has somehow become equated with villainy in the comics. Unless the character's a woman. Then it's okay. Look at all the stereotypes stuck on this guy to create the typical bad-guy persona: an eye patch, scars, stitches, cigar. That weird spongy stuff on his forehead shows that he was probably changed by some strange biological experiment gone awry. Ugliness is helpful on villains. But female villains are best drawn sexy and sinister.

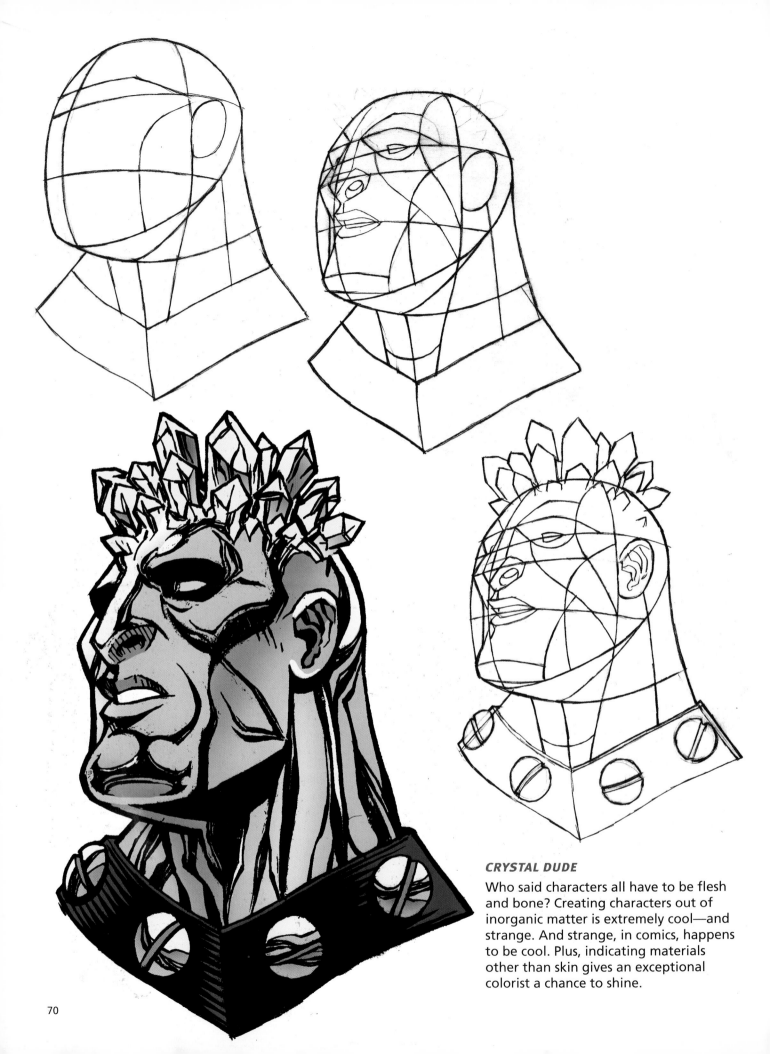

CRYSTAL DUDE

Who said characters all have to be flesh and bone? Creating characters out of inorganic matter is extremely cool—and strange. And strange, in comics, happens to be cool. Plus, indicating materials other than skin gives an exceptional colorist a chance to shine.

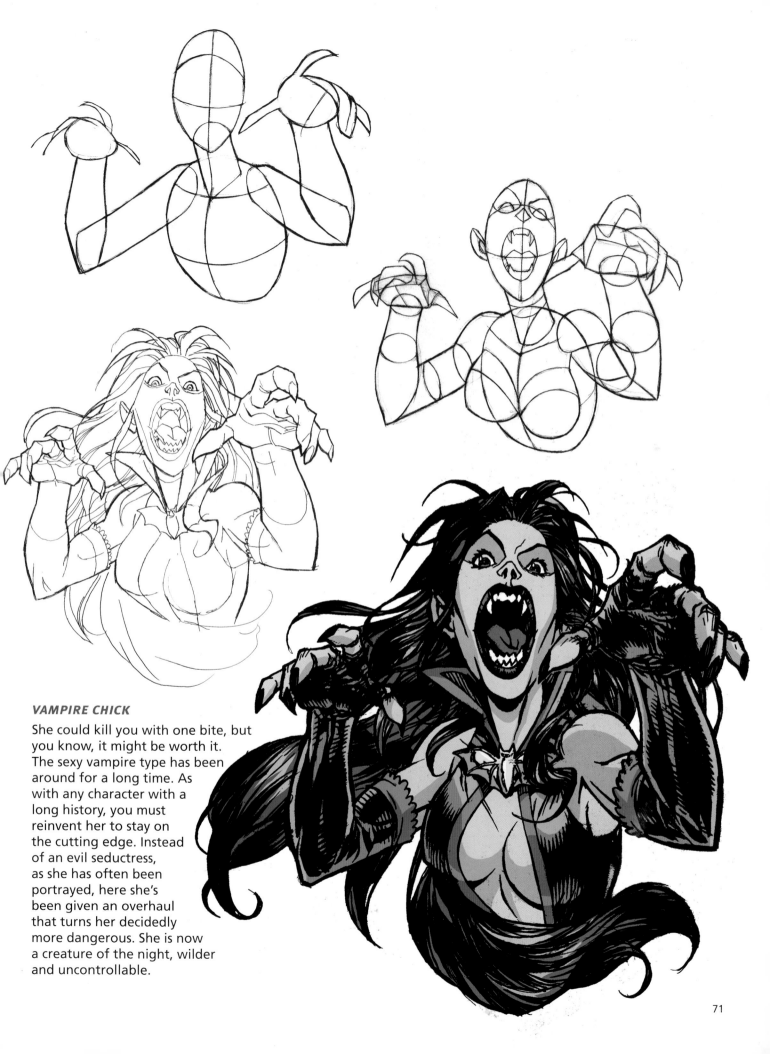

VAMPIRE CHICK

She could kill you with one bite, but you know, it might be worth it. The sexy vampire type has been around for a long time. As with any character with a long history, you must reinvent her to stay on the cutting edge. Instead of an evil seductress, as she has often been portrayed, here she's been given an overhaul that turns her decidedly more dangerous. She is now a creature of the night, wilder and uncontrollable.

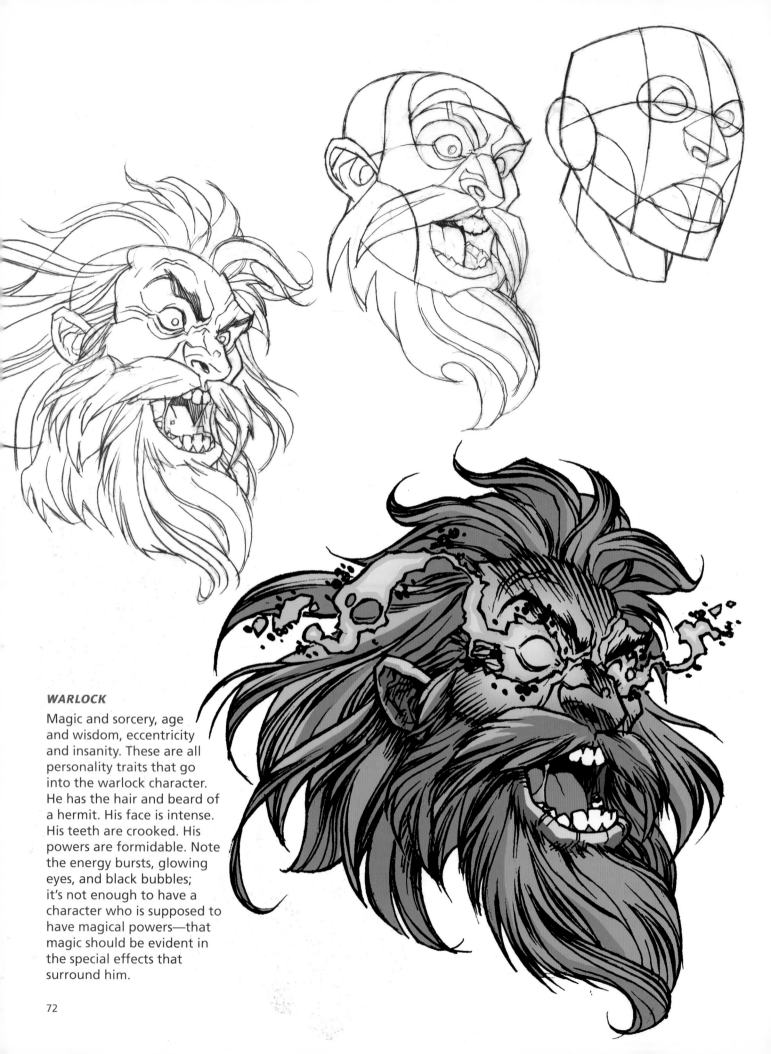

WARLOCK

Magic and sorcery, age and wisdom, eccentricity and insanity. These are all personality traits that go into the warlock character. He has the hair and beard of a hermit. His face is intense. His teeth are crooked. His powers are formidable. Note the energy bursts, glowing eyes, and black bubbles; it's not enough to have a character who is supposed to have magical powers—that magic should be evident in the special effects that surround him.

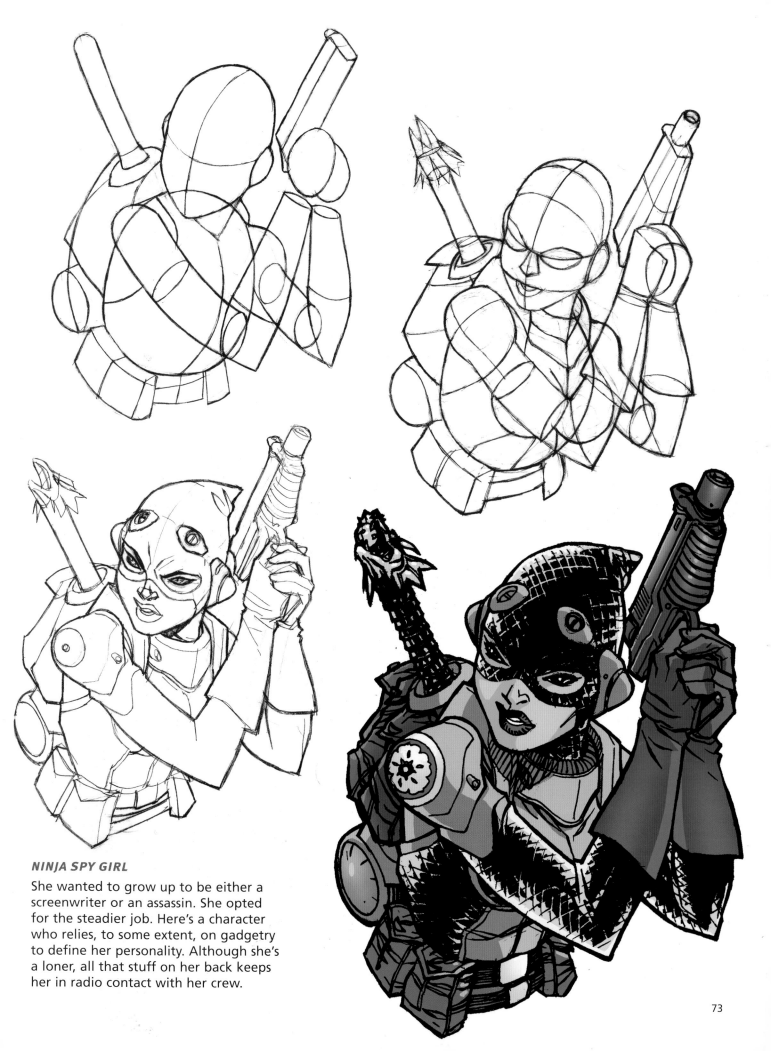

NINJA SPY GIRL

She wanted to grow up to be either a screenwriter or an assassin. She opted for the steadier job. Here's a character who relies, to some extent, on gadgetry to define her personality. Although she's a loner, all that stuff on her back keeps her in radio contact with her crew.

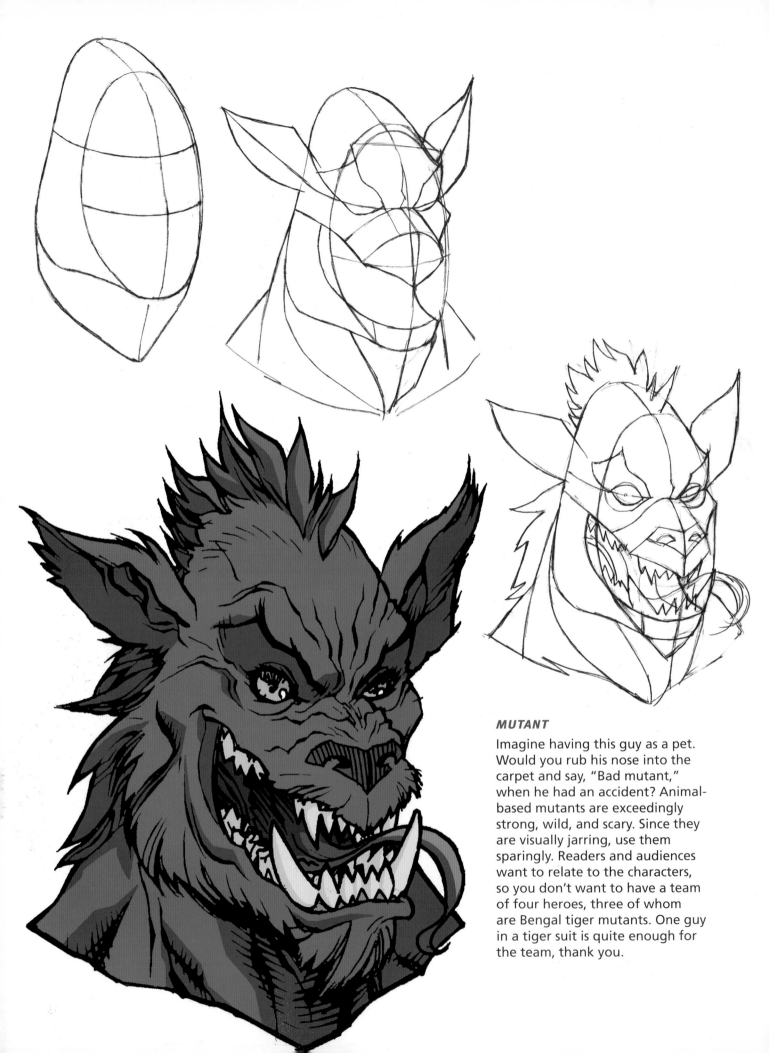

MUTANT

Imagine having this guy as a pet. Would you rub his nose into the carpet and say, "Bad mutant," when he had an accident? Animal-based mutants are exceedingly strong, wild, and scary. Since they are visually jarring, use them sparingly. Readers and audiences want to relate to the characters, so you don't want to have a team of four heroes, three of whom are Bengal tiger mutants. One guy in a tiger suit is quite enough for the team, thank you.

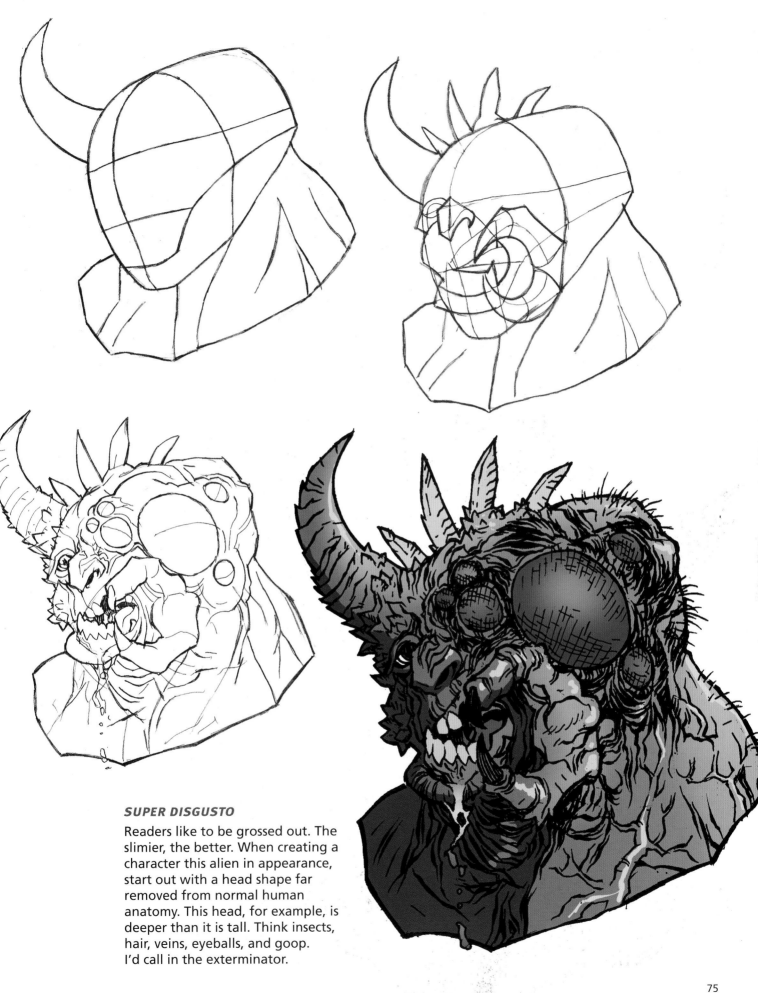

SUPER DISGUSTO

Readers like to be grossed out. The slimier, the better. When creating a character this alien in appearance, start out with a head shape far removed from normal human anatomy. This head, for example, is deeper than it is tall. Think insects, hair, veins, eyeballs, and goop. I'd call in the exterminator.

Discovering Your Personal Style

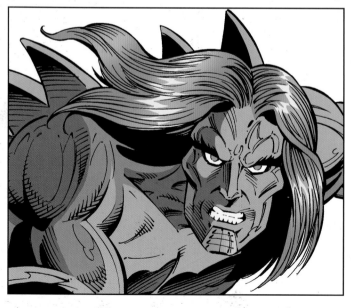

At some point, all artists are concerned with developing a recognizable style of their own, something that distinguishes them from the pack. This section illustrates how different artists use their own vision to interpret the same character. The results are all quite different, as each artist's individual style is clearly defined.

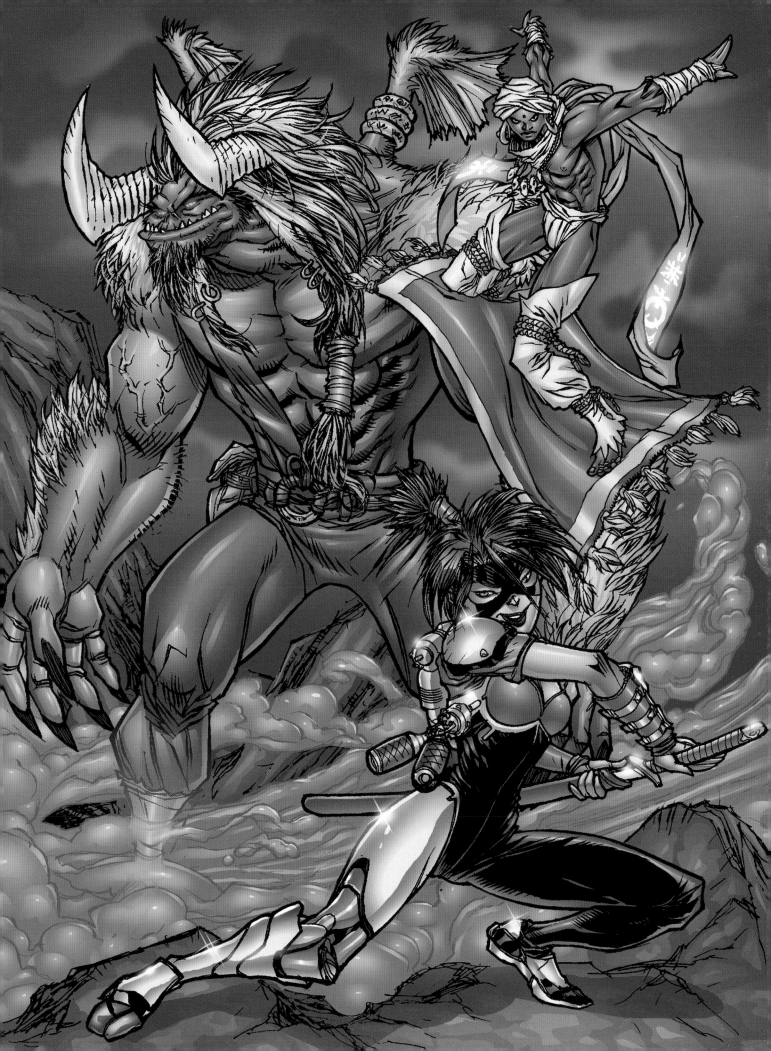

The Starting Point

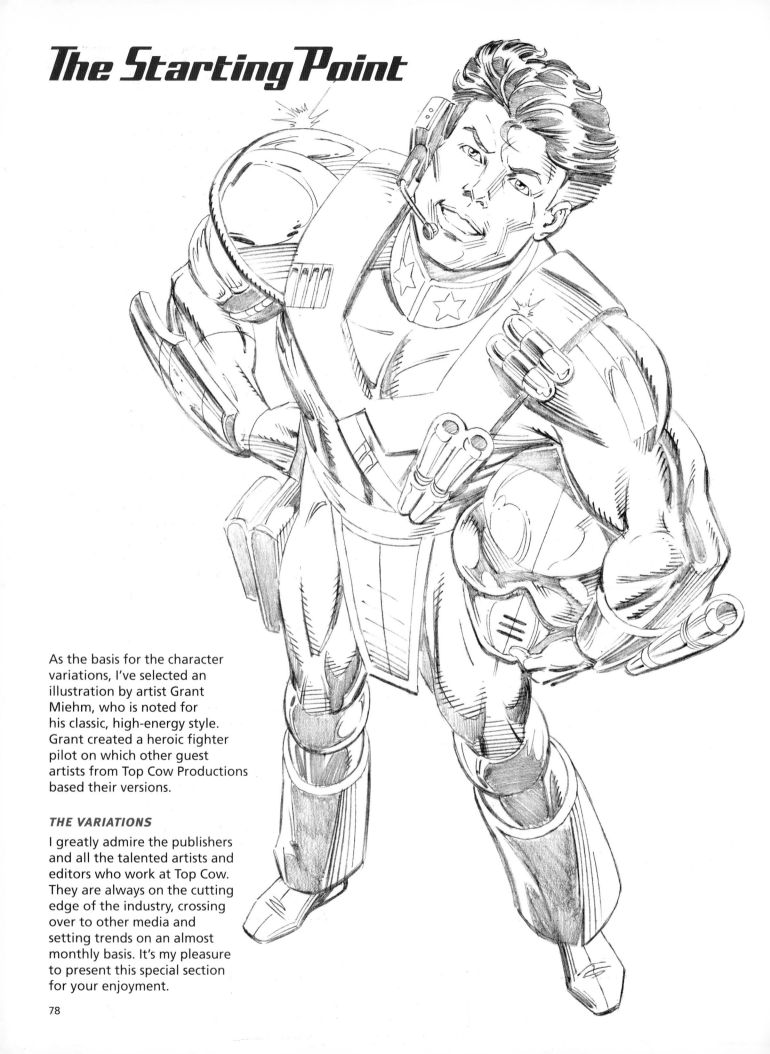

As the basis for the character variations, I've selected an illustration by artist Grant Miehm, who is noted for his classic, high-energy style. Grant created a heroic fighter pilot on which other guest artists from Top Cow Productions based their versions.

THE VARIATIONS

I greatly admire the publishers and all the talented artists and editors who work at Top Cow. They are always on the cutting edge of the industry, crossing over to other media and setting trends on an almost monthly basis. It's my pleasure to present this special section for your enjoyment.

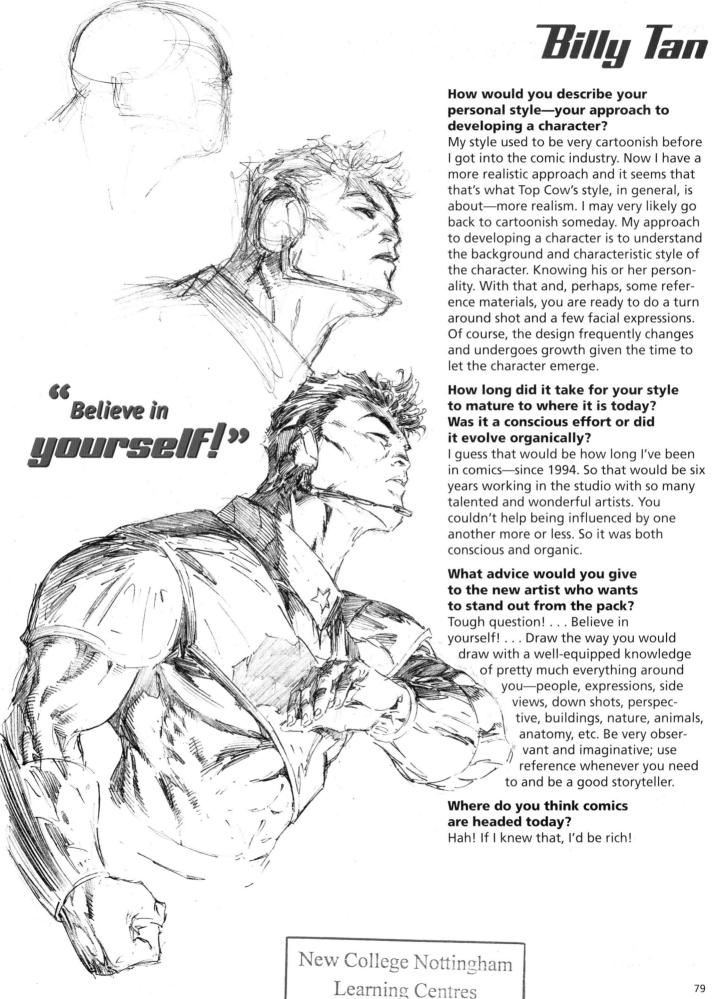

Billy Tan

How would you describe your personal style—your approach to developing a character?

My style used to be very cartoonish before I got into the comic industry. Now I have a more realistic approach and it seems that that's what Top Cow's style, in general, is about—more realism. I may very likely go back to cartoonish someday. My approach to developing a character is to understand the background and characteristic style of the character. Knowing his or her personality. With that and, perhaps, some reference materials, you are ready to do a turn around shot and a few facial expressions. Of course, the design frequently changes and undergoes growth given the time to let the character emerge.

How long did it take for your style to mature to where it is today? Was it a conscious effort or did it evolve organically?

I guess that would be how long I've been in comics—since 1994. So that would be six years working in the studio with so many talented and wonderful artists. You couldn't help being influenced by one another more or less. So it was both conscious and organic.

What advice would you give to the new artist who wants to stand out from the pack?

Tough question! . . . Believe in yourself! . . . Draw the way you would draw with a well-equipped knowledge of pretty much everything around you—people, expressions, side views, down shots, perspective, buildings, nature, animals, anatomy, etc. Be very observant and imaginative; use reference whenever you need to and be a good storyteller.

Where do you think comics are headed today?

Hah! If I knew that, I'd be rich!

" *Believe in* *yourself!* "

Brian Denham

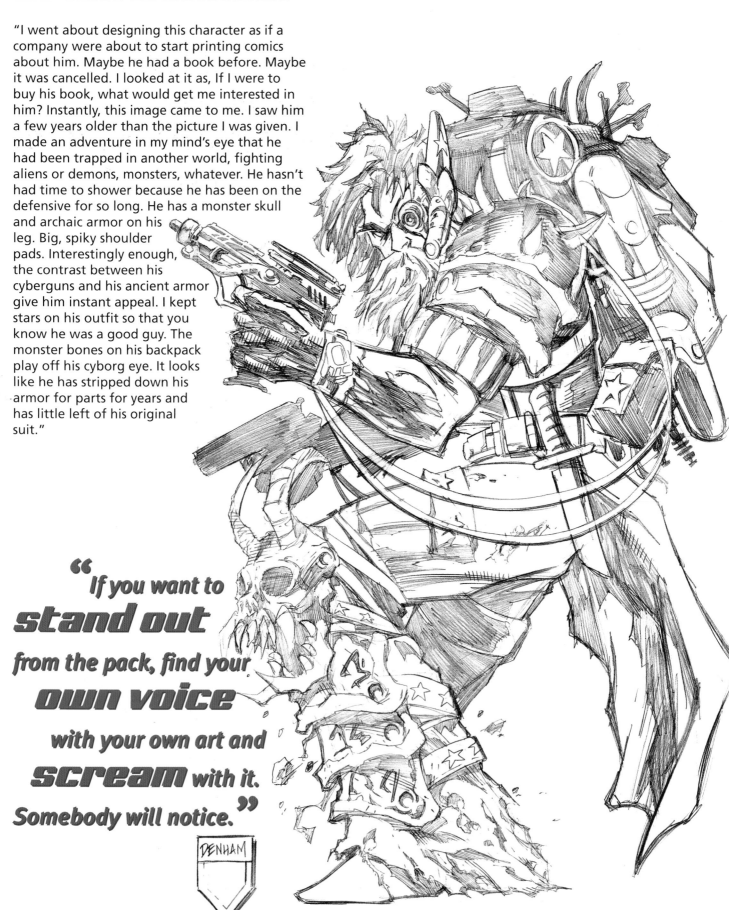

"I went about designing this character as if a company were about to start printing comics about him. Maybe he had a book before. Maybe it was cancelled. I looked at it as, If I were to buy his book, what would get me interested in him? Instantly, this image came to me. I saw him a few years older than the picture I was given. I made an adventure in my mind's eye that he had been trapped in another world, fighting aliens or demons, monsters, whatever. He hasn't had time to shower because he has been on the defensive for so long. He has a monster skull and archaic armor on his leg. Big, spiky shoulder pads. Interestingly enough, the contrast between his cyberguns and his ancient armor give him instant appeal. I kept stars on his outfit so that you know he was a good guy. The monster bones on his backpack play off his cyborg eye. It looks like he has stripped down his armor for parts for years and has little left of his original suit."

"**If you want to stand out** from the pack, find your **own voice** with your own art and **scream** with it. **Somebody will notice.**"

DENHAM

R.V. Valdez

"Personal style is a funny thing. It seems that every artist is in search of one to call his own. But almost every style has been used. So many of today's new artists look like derivatives of current artists or past artists. Personally, I try to look for realism, rather than [something] stylistic, which helps me stay true to myself. I attended art school at Art Center College of Design in Pasadena, California. So, I like to paint and use various media. I try to incorporate what I know from painting to help approach form and lighting. I also prefer to use pull-outs and cross hatching to distinguish my gray values. So, I guess I would say I try to push realism as much as possible while still blending some stylistic and dynamic qualities."

" Study, study, *study.* Keep looking for *artists you admire,* and study them."

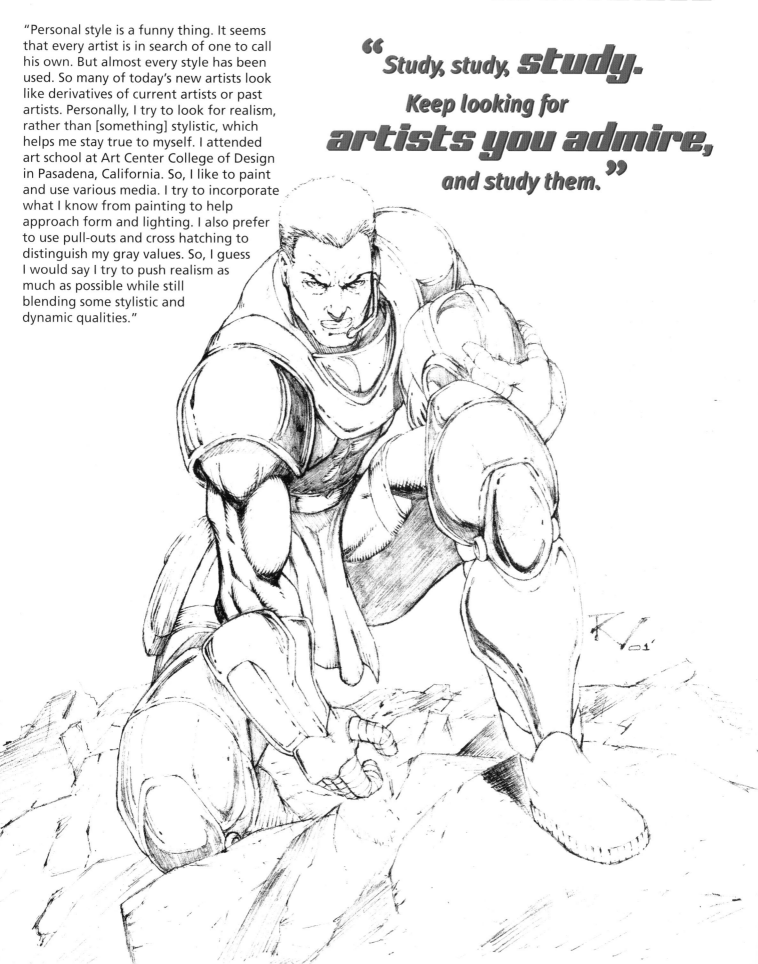

Talent Caldwell

"I started drawing as a tyke and haven't stopped since. After failing art in high school, I decided to piss away urging suggestions to join the military and press on to a job in comic books. Having saved up enough money from working "real" jobs, I made the move to Los Angeles, where after five months of playing video games, I got hired by industry heavyweight Michael Turner. From thence, we arrive at present.

"People draw from inspirations and absorb any and all that they consider interesting to help evolve their look into something even more pleasing. I like to have fun with the character. I try to give it a three-dimensional life beyond the two-dimensional art form. Taking a cue from movies, framing the figure is very important. How you do it, why you do it, where you do it, is all done to make the character look good. I describe my style as an exaggerated simplified-realism with surreal, photo-esque back-grounds; others would just call it cartoony."

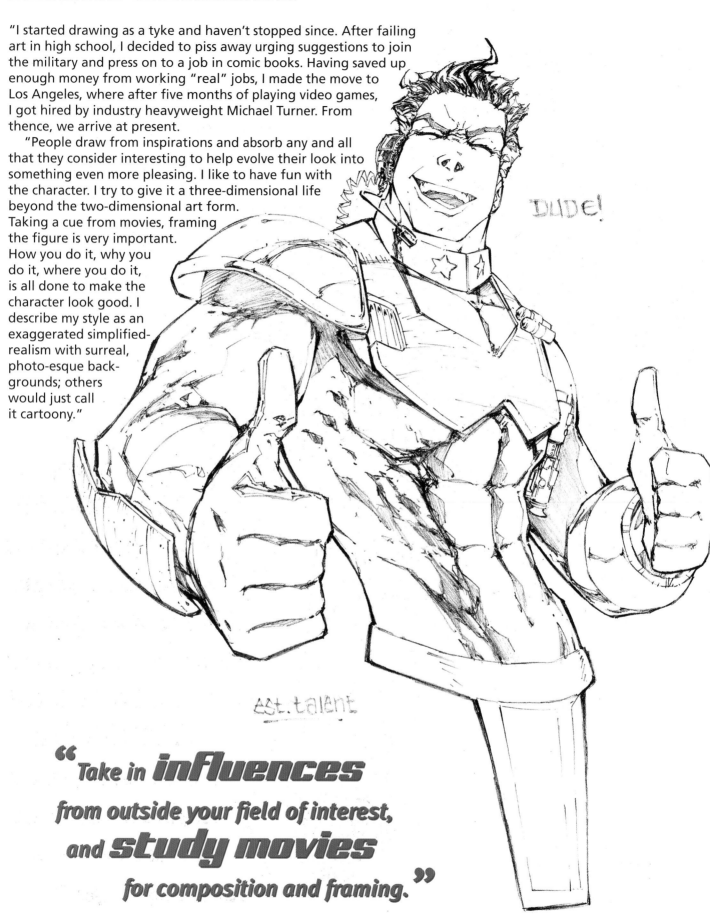

DUDE!

est. talent

" Take in **influences** from outside your field of interest, and **study movies** for composition and framing. "

Nate Van Dyke

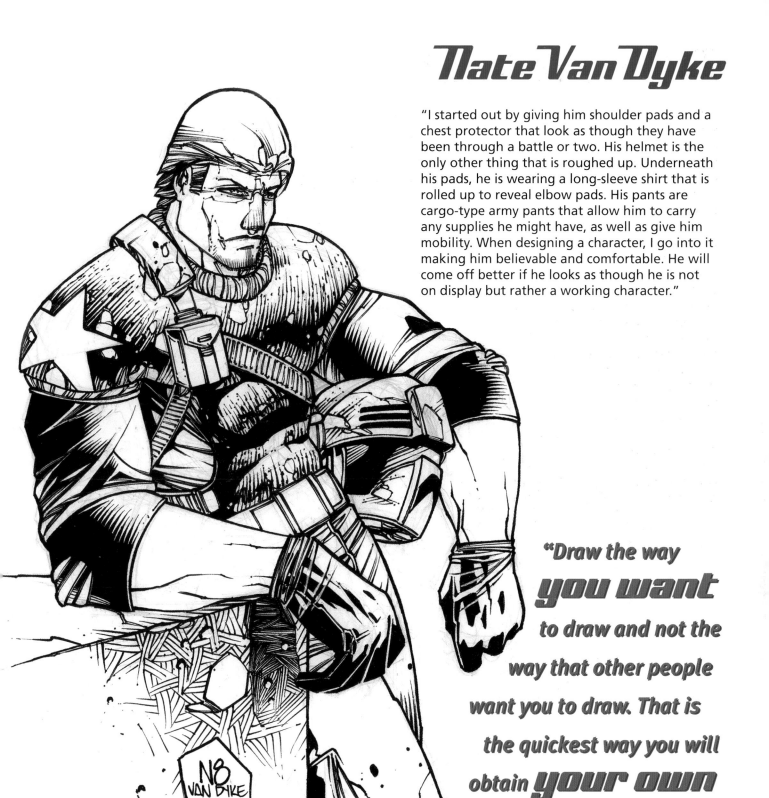

"I started out by giving him shoulder pads and a chest protector that look as though they have been through a battle or two. His helmet is the only other thing that is roughed up. Underneath his pads, he is wearing a long-sleeve shirt that is rolled up to reveal elbow pads. His pants are cargo-type army pants that allow him to carry any supplies he might have, as well as give him mobility. When designing a character, I go into it making him believable and comfortable. He will come off better if he looks as though he is not on display but rather a working character."

"Draw the way *you want* to draw and not the way that other people want you to draw. That is the quickest way you will obtain *your own identity*. Look at what's out there but put your own twist on it and you'll have something to offer."

Working with a Cutting-Edge Inker

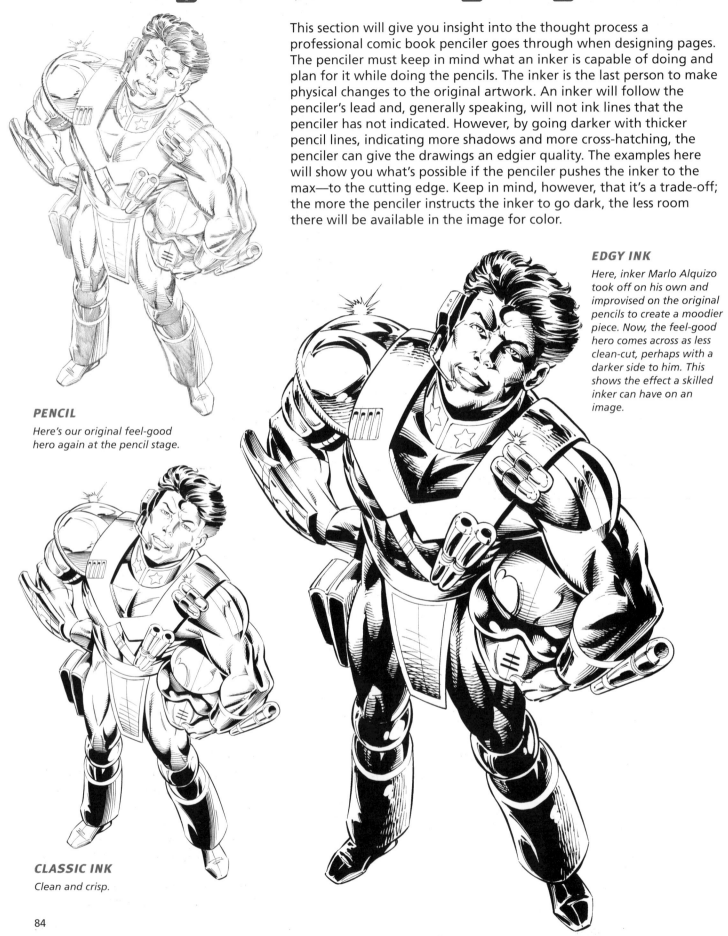

This section will give you insight into the thought process a professional comic book penciler goes through when designing pages. The penciler must keep in mind what an inker is capable of doing and plan for it while doing the pencils. The inker is the last person to make physical changes to the original artwork. An inker will follow the penciler's lead and, generally speaking, will not ink lines that the penciler has not indicated. However, by going darker with thicker pencil lines, indicating more shadows and more cross-hatching, the penciler can give the drawings an edgier quality. The examples here will show you what's possible if the penciler pushes the inker to the max—to the cutting edge. Keep in mind, however, that it's a trade-off; the more the penciler instructs the inker to go dark, the less room there will be available in the image for color.

EDGY INK

Here, inker Marlo Alquizo took off on his own and improvised on the original pencils to create a moodier piece. Now, the feel-good hero comes across as less clean-cut, perhaps with a darker side to him. This shows the effect a skilled inker can have on an image.

PENCIL

Here's our original feel-good hero again at the pencil stage.

CLASSIC INK

Clean and crisp.

84

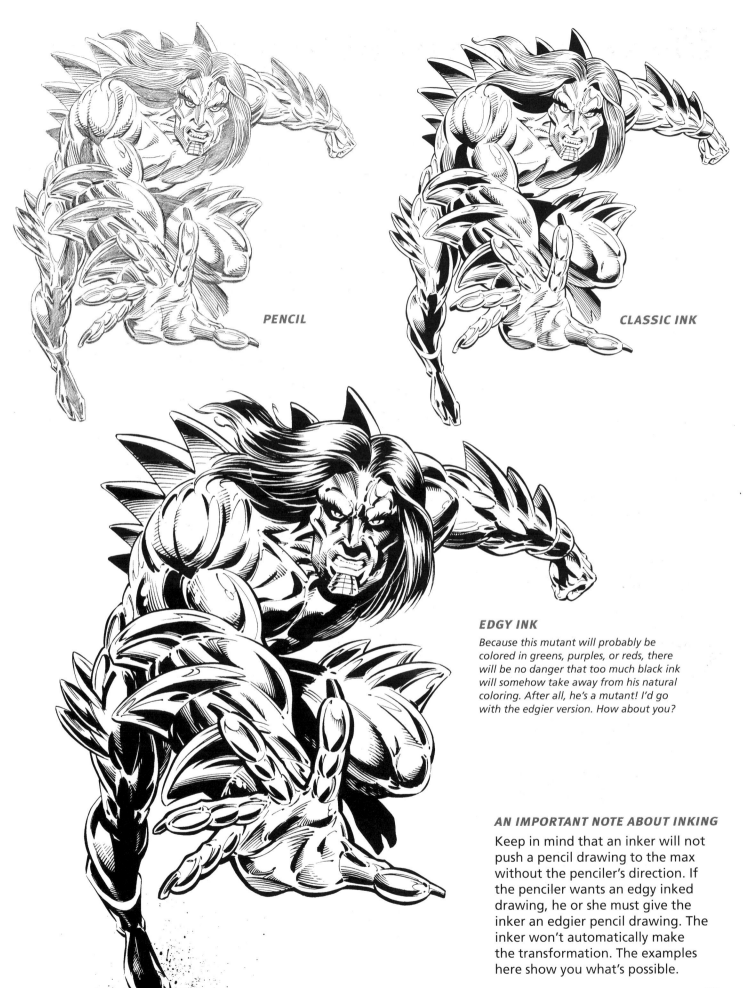

PENCIL

CLASSIC INK

EDGY INK

Because this mutant will probably be colored in greens, purples, or reds, there will be no danger that too much black ink will somehow take away from his natural coloring. After all, he's a mutant! I'd go with the edgier version. How about you?

AN IMPORTANT NOTE ABOUT INKING

Keep in mind that an inker will not push a pencil drawing to the max without the penciler's direction. If the penciler wants an edgy inked drawing, he or she must give the inker an edgier pencil drawing. The inker won't automatically make the transformation. The examples here show you what's possible.

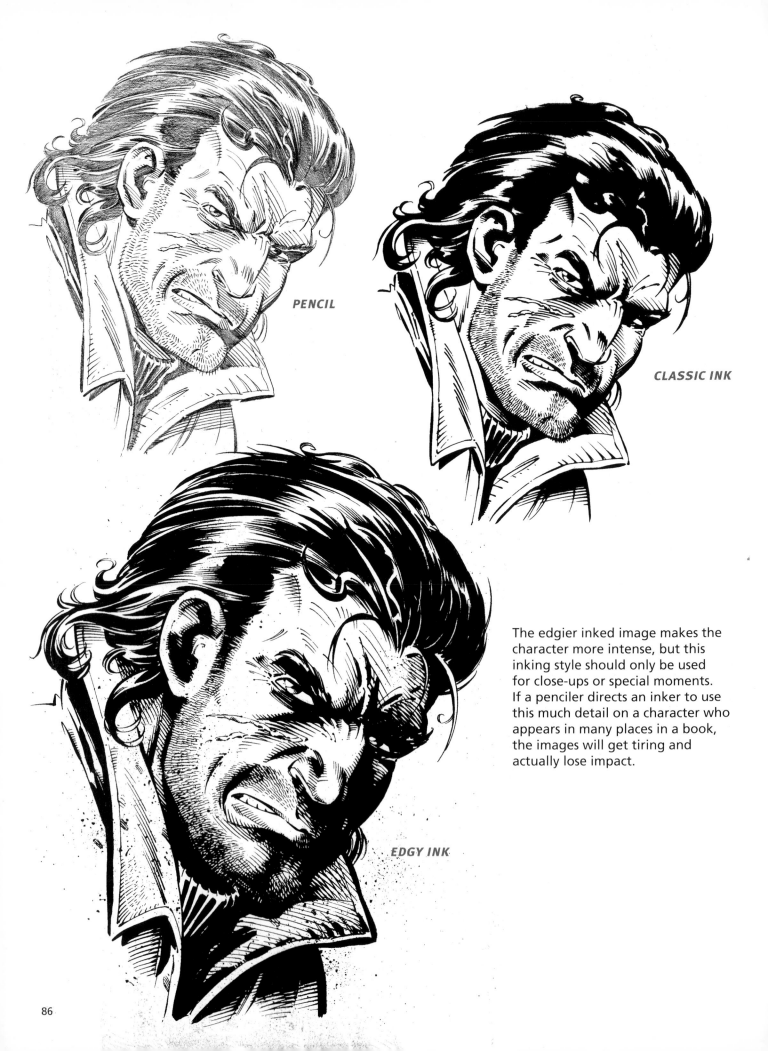

PENCIL

CLASSIC INK

EDGY INK

The edgier inked image makes the character more intense, but this inking style should only be used for close-ups or special moments. If a penciler directs an inker to use this much detail on a character who appears in many places in a book, the images will get tiring and actually lose impact.

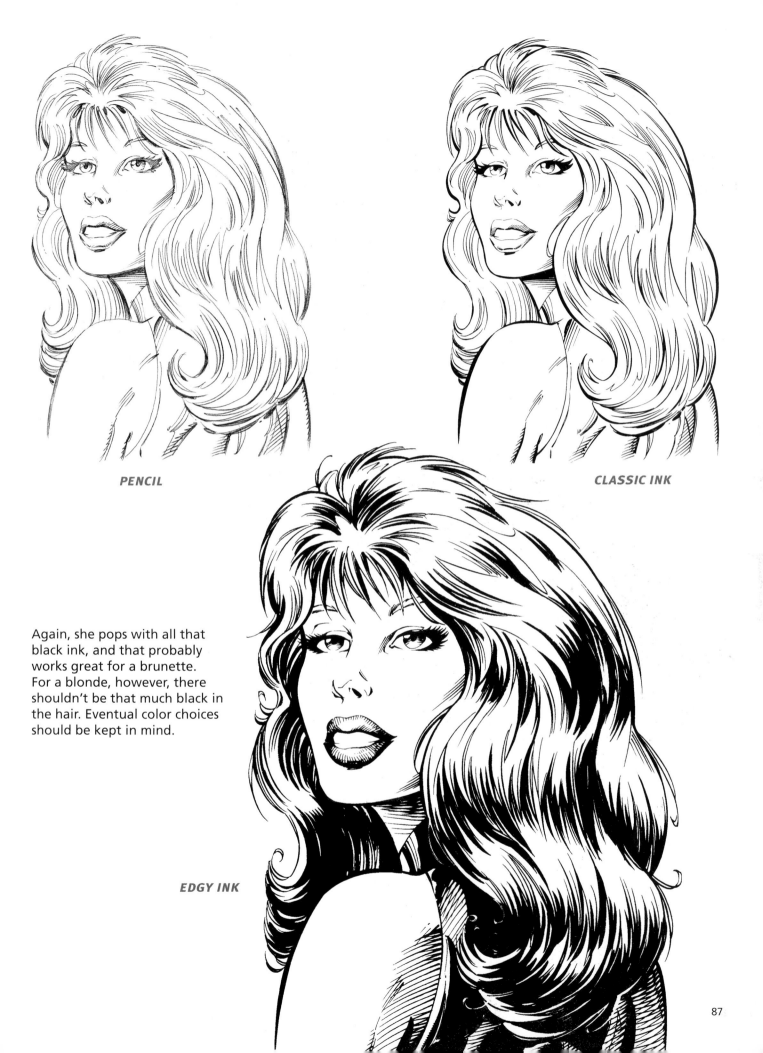

PENCIL

CLASSIC INK

Again, she pops with all that black ink, and that probably works great for a brunette. For a blonde, however, there shouldn't be that much black in the hair. Eventual color choices should be kept in mind.

EDGY INK

The thing the edgy ink style has going for it in this background scene is that it emphasizes the destruction around the characters. But again, it's a trade-off. The edgier ink loses the clearer sky. The penciler must decide how he or she wishes to handle it and which factor should be most emphasized.

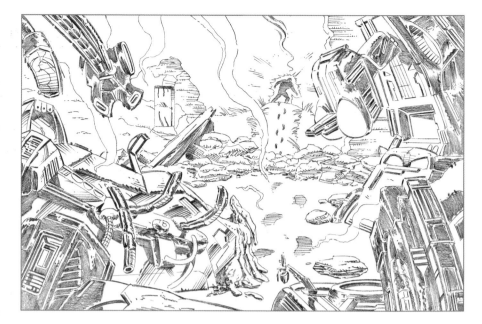

PENCIL

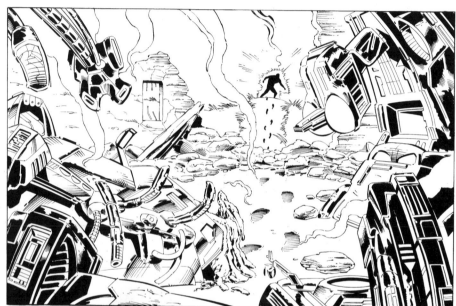

CLASSIC INK

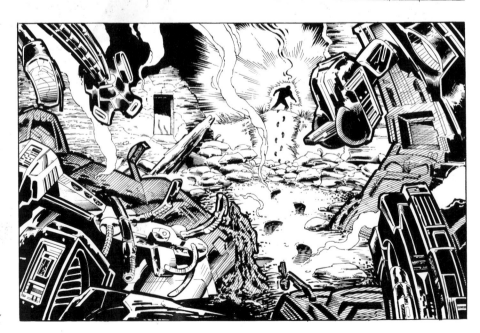

EDGY INK

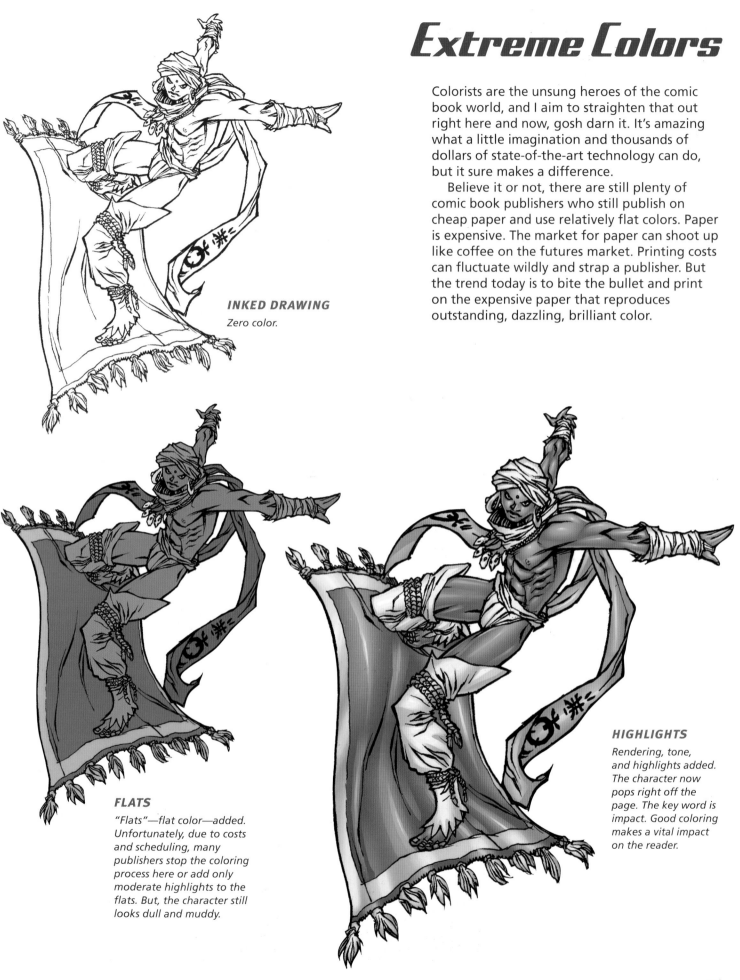

Extreme Colors

Colorists are the unsung heroes of the comic book world, and I aim to straighten that out right here and now, gosh darn it. It's amazing what a little imagination and thousands of dollars of state-of-the-art technology can do, but it sure makes a difference.

Believe it or not, there are still plenty of comic book publishers who still publish on cheap paper and use relatively flat colors. Paper is expensive. The market for paper can shoot up like coffee on the futures market. Printing costs can fluctuate wildly and strap a publisher. But the trend today is to bite the bullet and print on the expensive paper that reproduces outstanding, dazzling, brilliant color.

INKED DRAWING
Zero color.

FLATS

"Flats"—flat color—added. Unfortunately, due to costs and scheduling, many publishers stop the coloring process here or add only moderate highlights to the flats. But, the character still looks dull and muddy.

HIGHLIGHTS

Rendering, tone, and highlights added. The character now pops right off the page. The key word is impact. Good coloring makes a vital impact on the reader.

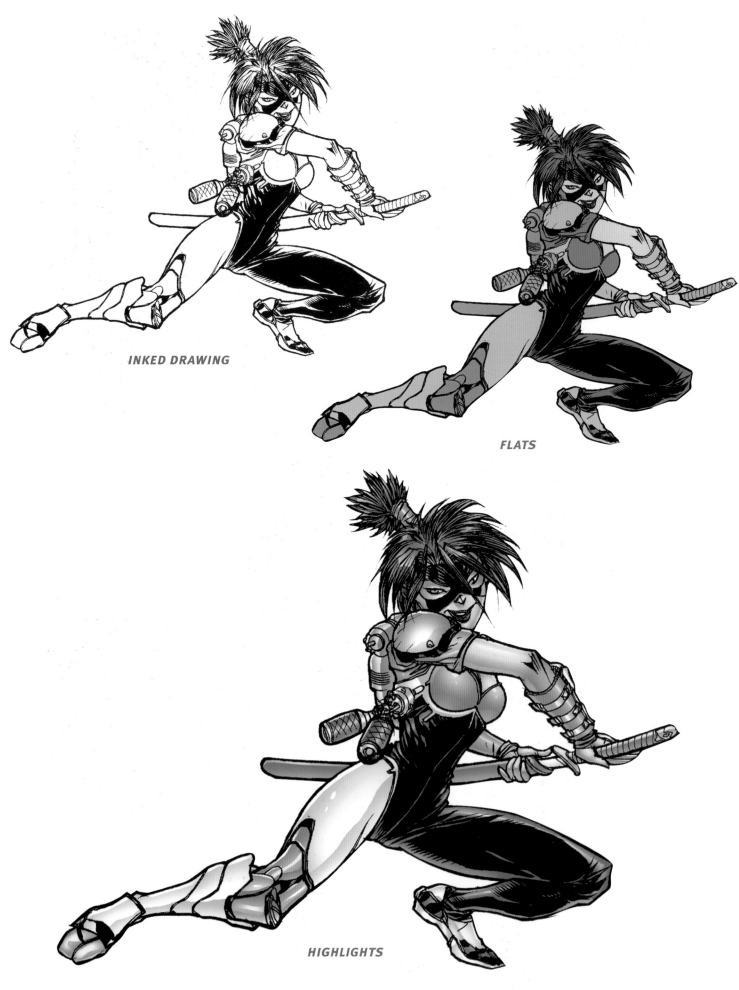

INKED DRAWING

FLATS

HIGHLIGHTS

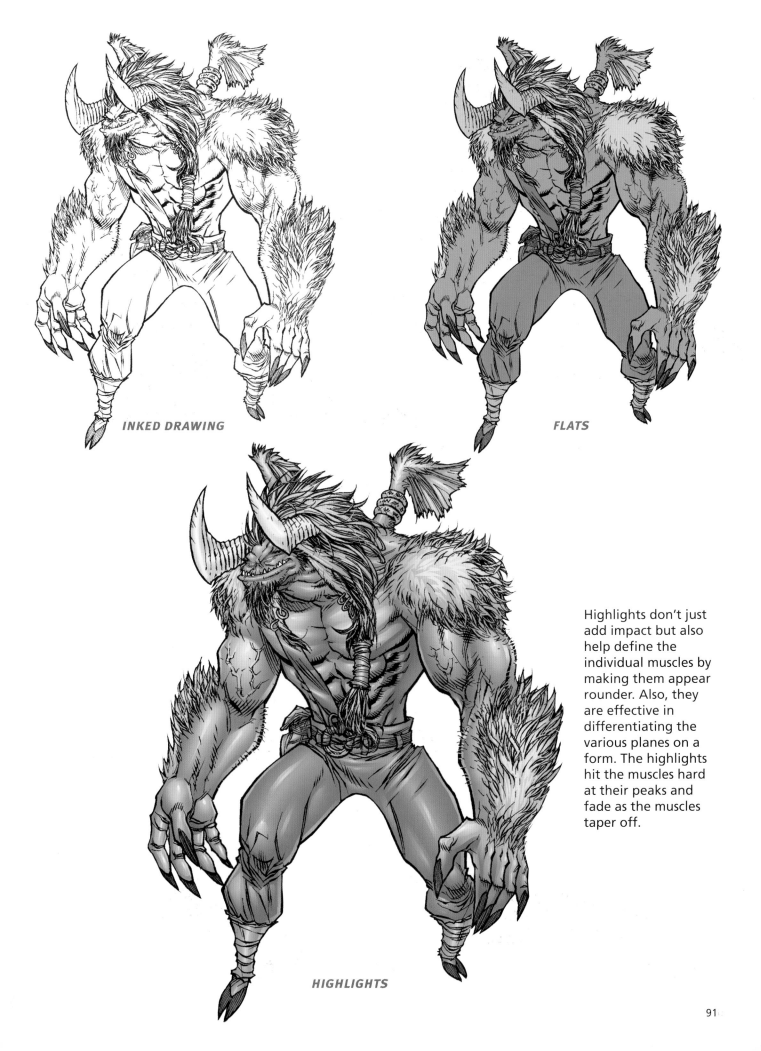

INKED DRAWING

FLATS

Highlights don't just add impact but also help define the individual muscles by making them appear rounder. Also, they are effective in differentiating the various planes on a form. The highlights hit the muscles hard at their peaks and fade as the muscles taper off.

HIGHLIGHTS

Wild Skin Colors

Maybe she's from another planet. Maybe she just tans weird. Either way, her coloring sure makes her an attention grabber. Different colors for both the skin and clothing create different effects. There's no limitation in comics. No need to be literal. Certain color schemes are more prevalent in certain types of comic book genres.

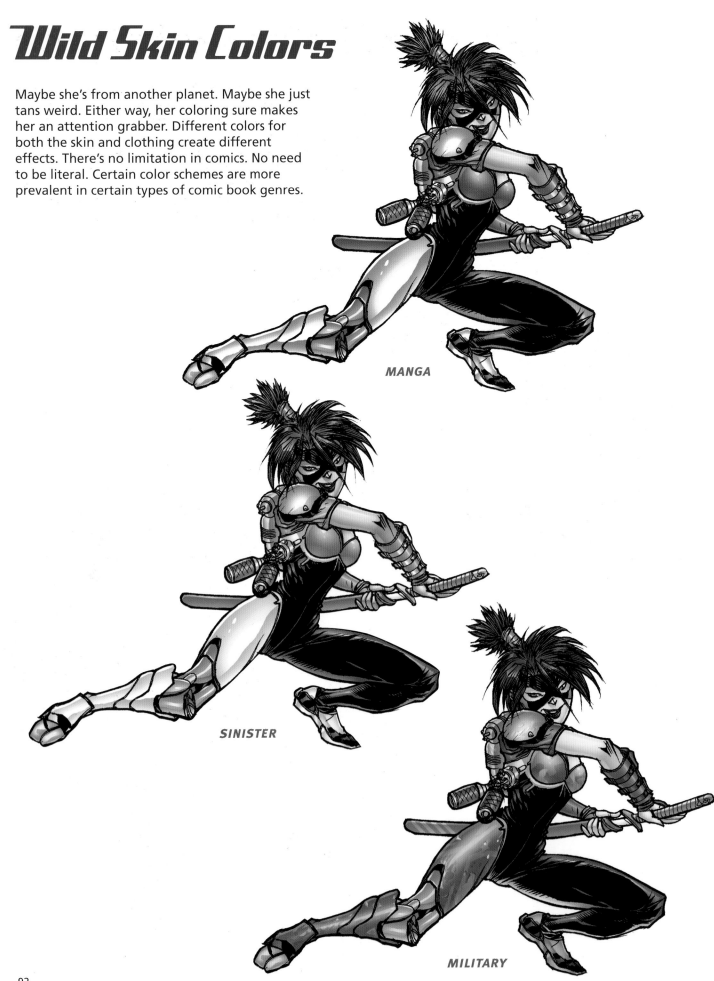

MANGA

SINISTER

MILITARY

Advanced Color Techniques

Some of the most effective techniques for creating luminous colors involve using what are called *knockouts* and *glows.* A knockout is when the line of the artwork that's usually in black is turned into a color line that matches the color of the character so that there is no break in the color. It adds a radiant quality to the character. *Glows* are effects that make characters seem to radiate heat, energy, or light. All of these techniques were done in Photoshop, which is extolled by many as a fantastic tool and the standard in the industry.

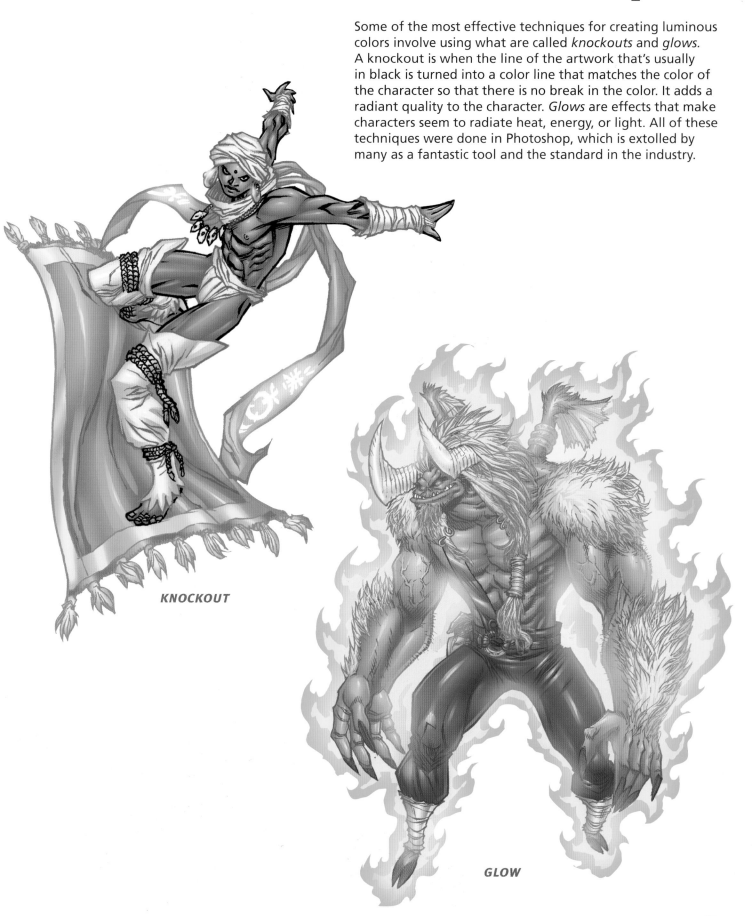

KNOCKOUT

GLOW

Combining Genres

There are some genres that are a bit tired. Oh great, another guy with a cape fighting a guy who wants to blow up the planet. You can always dig deeper and find a way to infuse any genre with new life and a fresh angle. But people still might shy away from the genre because of its familiarity. So, a really cool way to create excitement is to combine genres, creating something totally whacked-out, unexpected, and new. By putting two incongruous things together, you give the audience something completely nuts, and if you treat it seriously, the readers will eat it up! This approach to creating comic book genres is the latest thing. So, keep your eyeballs glued to the newest comics to find out what's current.

WESTERN + MANGA (JAPANESE COMICS)

This is a cool look, introducing manga characters into the old west. It also creates a younger look. As is common in many manga comics, you can add a fantasy sidekick, such as the one here.

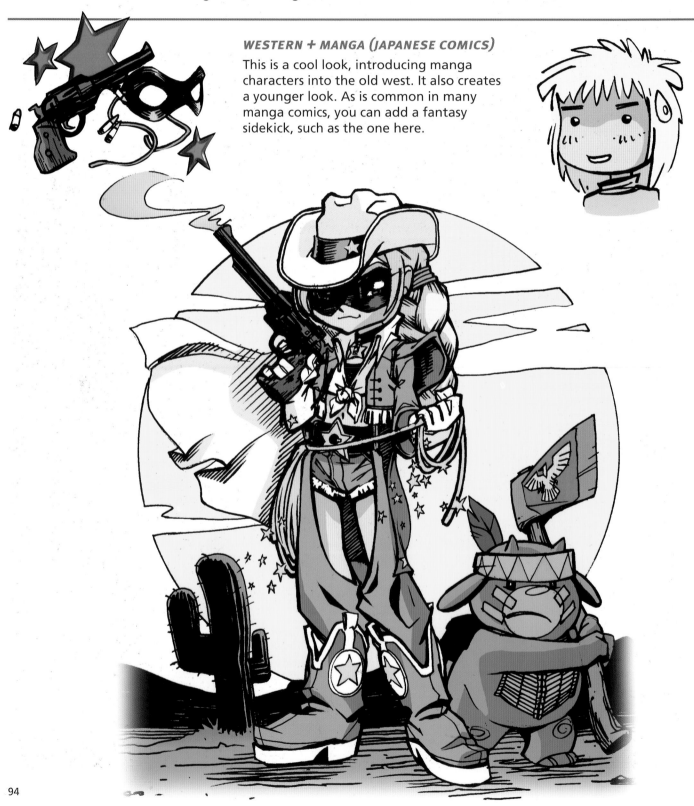

WESTERN + SCI-FI

By combining space aliens with the wild west, you get shoot 'em up cowboys on techno-horseback in gun battles with star cruisers. The incongruity of the images makes it curiously appealing. You want to hang out for a while to figure out what the heck is going on.

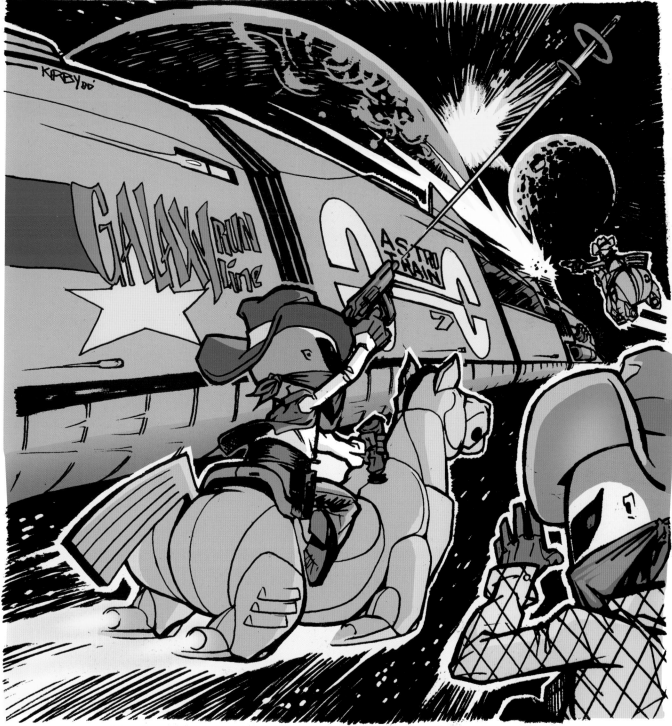

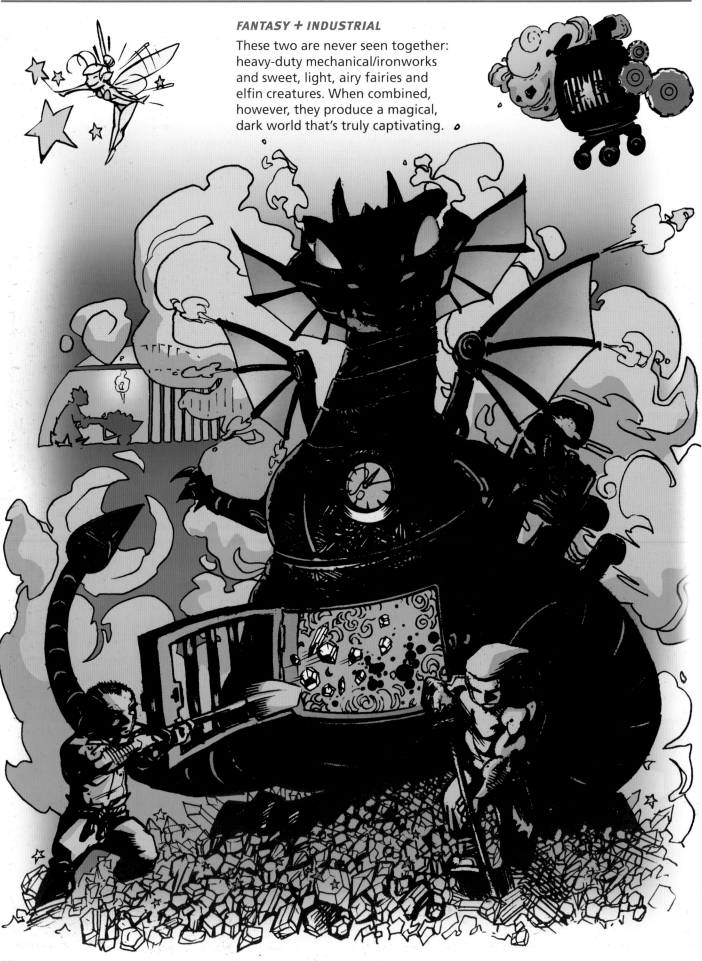

FANTASY + INDUSTRIAL

These two are never seen together: heavy-duty mechanical/ironworks and sweet, light, airy fairies and elfin creatures. When combined, however, they produce a magical, dark world that's truly captivating.

AQUATIC + TEAM HEROES

Sea-based creatures have always had their place in comic books, and although they've had some popularity, they've rarely attained the kind of sustained status of some of the better-known comic book characters. On the other hand, team heroes have always been extremely popular; comic book writers are always struggling to find new arenas in which to cast them. You can mine less popular genres for great settings without using their characters. Here, the underwater setting provides a cool landscape, while the team characters provide the interesting protagonists.

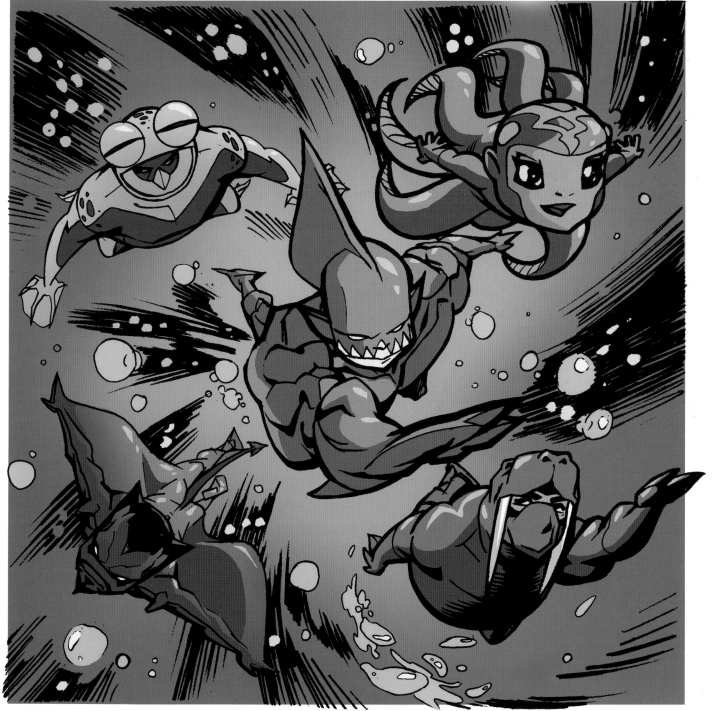

The Power of Perspective

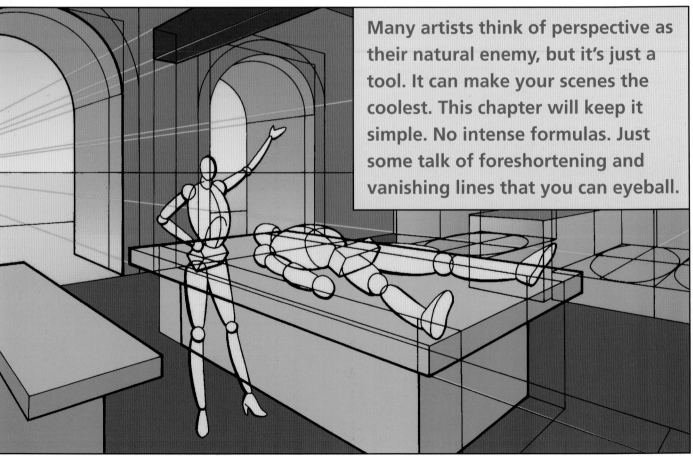

Many artists think of perspective as their natural enemy, but it's just a tool. It can make your scenes the coolest. This chapter will keep it simple. No intense formulas. Just some talk of foreshortening and vanishing lines that you can eyeball.

Foreshortening for Impact

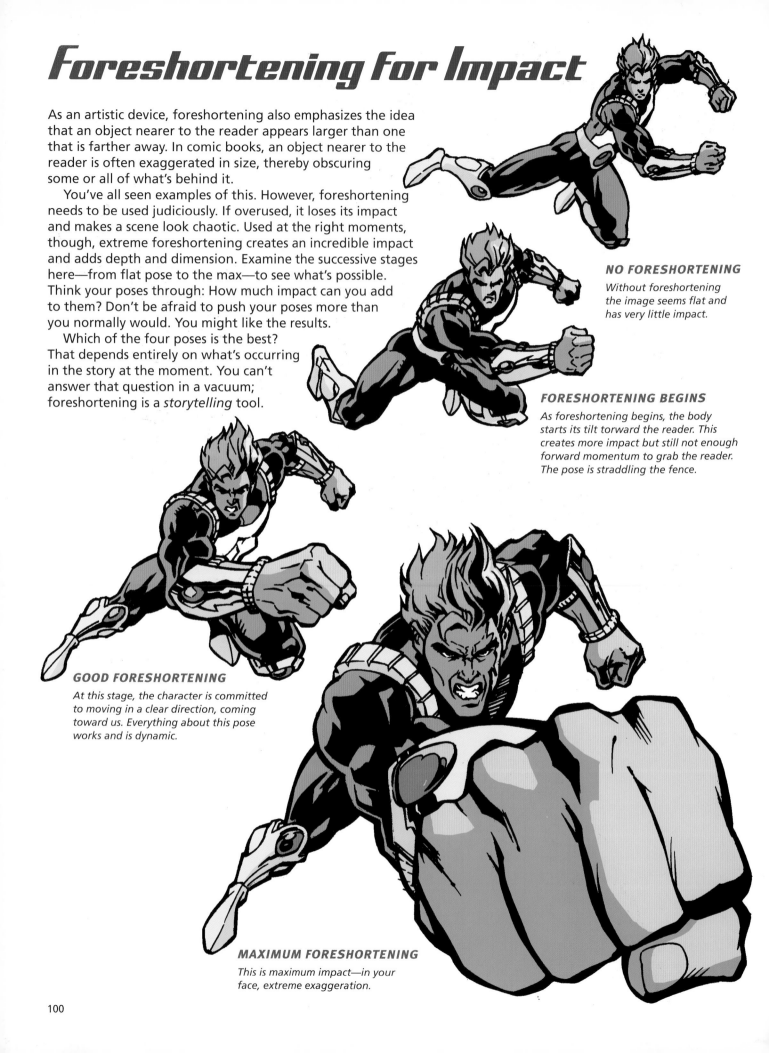

As an artistic device, foreshortening also emphasizes the idea that an object nearer to the reader appears larger than one that is farther away. In comic books, an object nearer to the reader is often exaggerated in size, thereby obscuring some or all of what's behind it.

You've all seen examples of this. However, foreshortening needs to be used judiciously. If overused, it loses its impact and makes a scene look chaotic. Used at the right moments, though, extreme foreshortening creates an incredible impact and adds depth and dimension. Examine the successive stages here—from flat pose to the max—to see what's possible. Think your poses through: How much impact can you add to them? Don't be afraid to push your poses more than you normally would. You might like the results.

Which of the four poses is the best? That depends entirely on what's occurring in the story at the moment. You can't answer that question in a vacuum; foreshortening is a *storytelling* tool.

NO FORESHORTENING

Without foreshortening the image seems flat and has very little impact.

FORESHORTENING BEGINS

As foreshortening begins, the body starts its tilt torward the reader. This creates more impact but still not enough forward momentum to grab the reader. The pose is straddling the fence.

GOOD FORESHORTENING

At this stage, the character is committed to moving in a clear direction, coming toward us. Everything about this pose works and is dynamic.

MAXIMUM FORESHORTENING

This is maximum impact—in your face, extreme exaggeration.

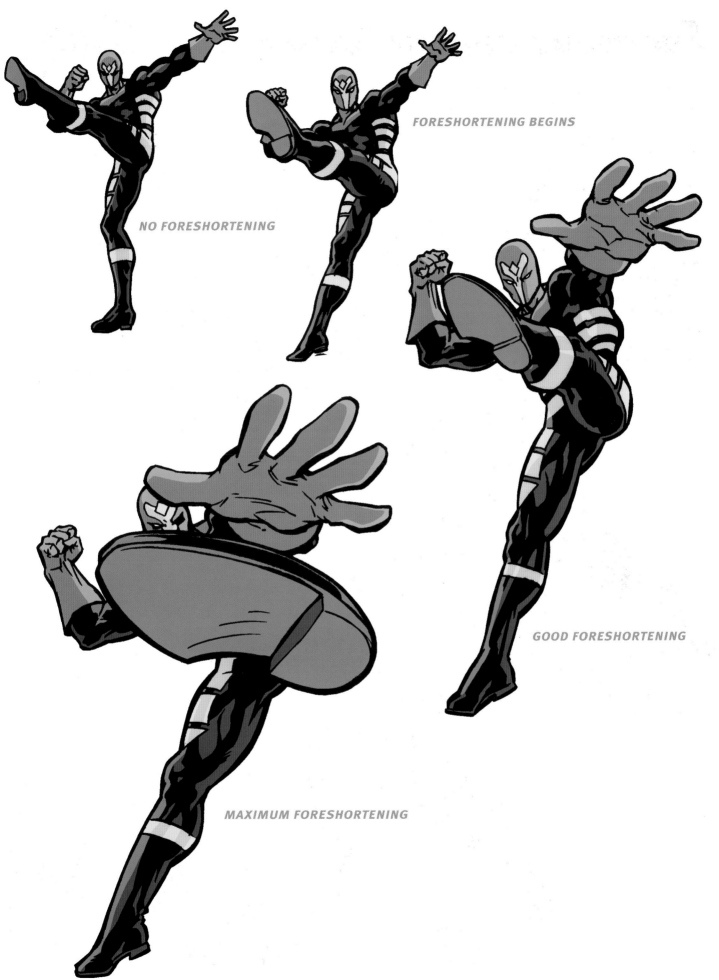

NO FORESHORTENING

FORESHORTENING BEGINS

GOOD FORESHORTENING

MAXIMUM FORESHORTENING

101

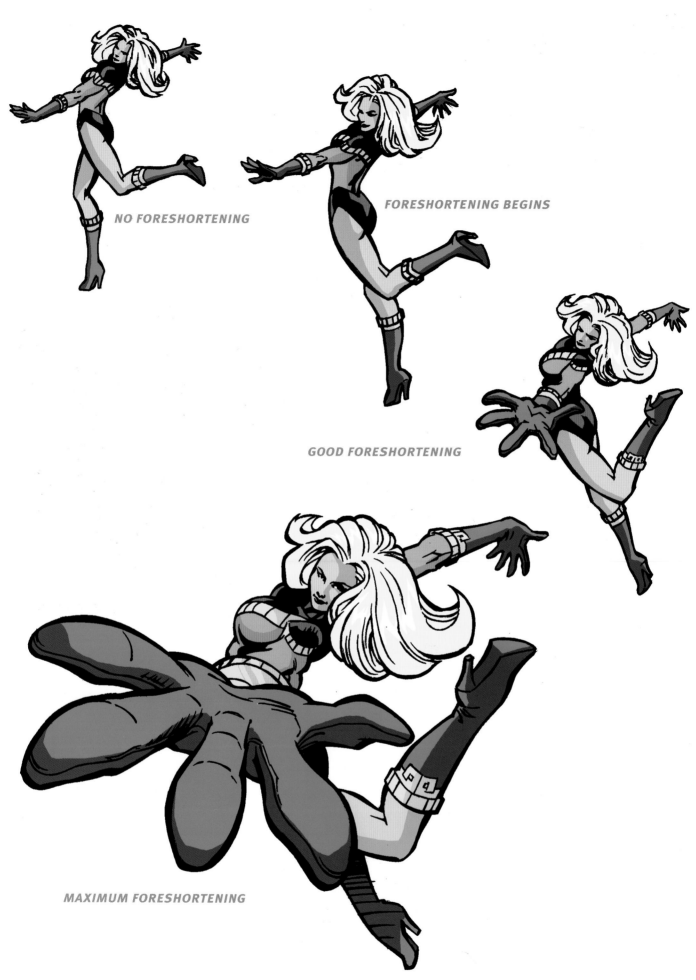

NO FORESHORTENING

FORESHORTENING BEGINS

GOOD FORESHORTENING

MAXIMUM FORESHORTENING

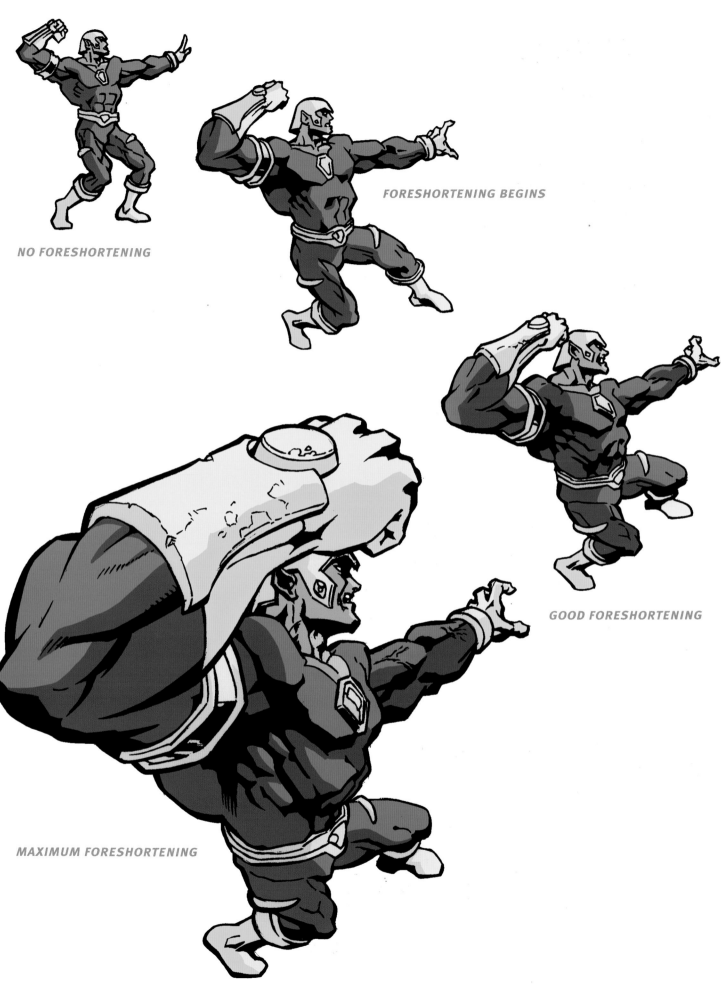

NO FORESHORTENING

FORESHORTENING BEGINS

GOOD FORESHORTENING

MAXIMUM FORESHORTENING

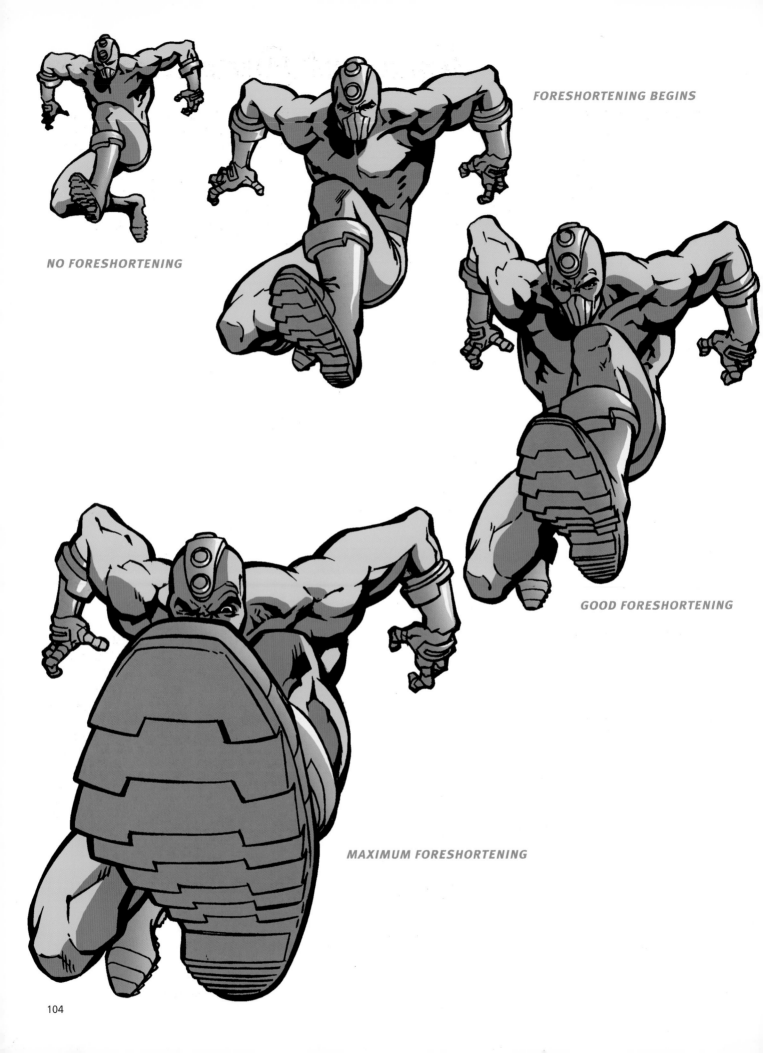

FORESHORTENING BEGINS

NO FORESHORTENING

GOOD FORESHORTENING

MAXIMUM FORESHORTENING

Types of Perspective

ONE-POINT PERSPECTIVE

One-point perspective is when all parallel lines that travel from the foreground to the background converge at a single point on the horizon. Many scenes are drawn this way. It's easy. It basically means that no corners are facing us. Everything is flat and head-on to the reader.

HORIZON LINE VANISHING POINT

Objects drawn in perspective get smaller as they recede into the distance away from the reader. There are three types of perspectives generally used in comics: one-point, two-point, and three-point perspective. Okay, we're done. Was that hard? Don't give me that bit about how you wish it were a bit more challenging. You were cringing a few sentences ago. Stick with me.

TWO-POINT PERSPECTIVE

Two-point perspective is when the vanishing lines converge at two points along the horizon line. The simplest version of two-point perspective places the corner of the subject facing the reader.

VANISHING POINT LEFT HORIZON LINE VANISHING POINT RIGHT

THREE-POINT PERSPECTIVE

Three-point perspective adds a third element, that of height. This exciting component gives comic book scenes more impact than other media, because of the degree to which comic book artists take artistic license and exaggerate it. You add a third vanishing point way up high and reduce the object not just from the sides, as in two-point perspective, but also from above. You've probably seen this in comic book cityscapes.

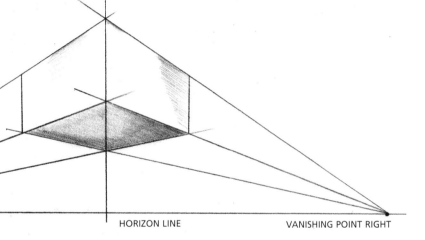

VANISHING POINT TOP

A WORD ABOUT VANISHING LINES

There are no such things as actual vanishing lines. They're just something artists made up as a guide for themselves to help indicate correct perspective. When positioned correctly, vanishing lines would all meet up at either one, two, or three vanishing points in the distance, depending on which type of perspective is used (one-point, two-point, or three-point). Placing the figures in your drawings on correctly positioned vanishing lines, ensures that your scenes are shown in proper perspective. The vanishing lines also indicate the rate at which things get smaller as they recede into the background.

VANISHING POINT LEFT HORIZON LINE VANISHING POINT RIGHT

Exterior One-Point Perspective

Complex as it may appear, this is in reality a very simple drawing, perspectivewise. Everything converges at a single vanishing point. Don't let the detail fool you.

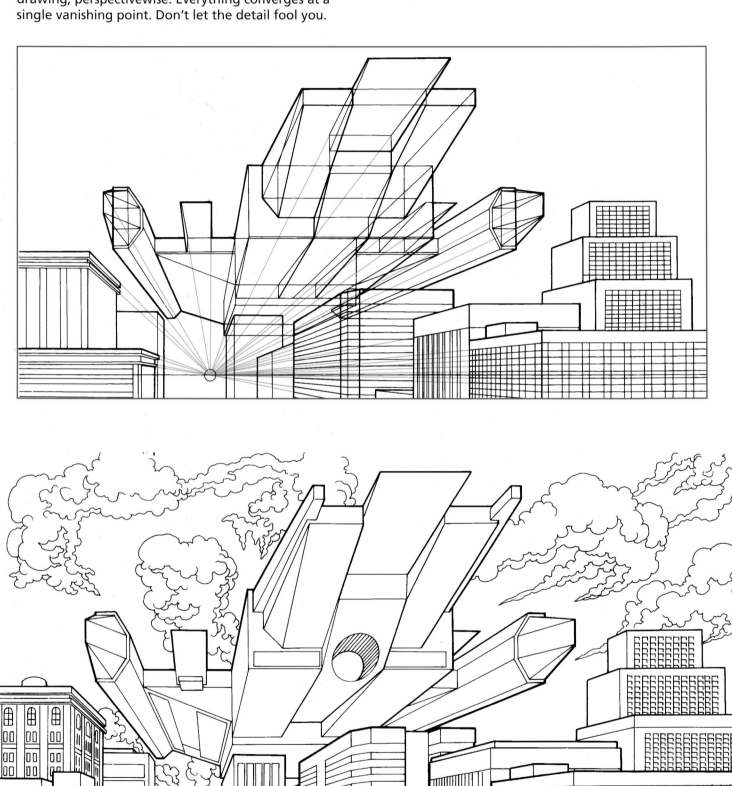

Interior One-Point Perspective

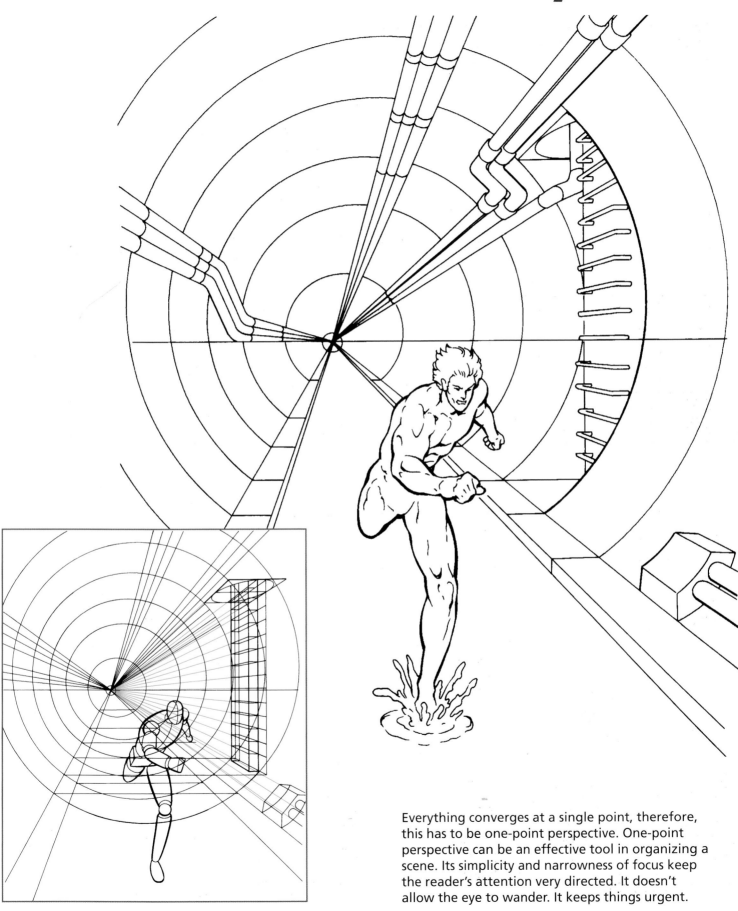

Everything converges at a single point, therefore, this has to be one-point perspective. One-point perspective can be an effective tool in organizing a scene. Its simplicity and narrowness of focus keep the reader's attention very directed. It doesn't allow the eye to wander. It keeps things urgent.

Exterior Two-Point Perspective

How can you tell that this is two-point perspective? Notice that the corner of the building on the right is pointed at you. You can't do that in one-point perspective. In the diagram step, it's even easier to tell because you can see the *two* vanishing points—one on the left and one on the right. A scene in two-point perspective spreads out and "breathes" more than a scene done in one-point perspective.

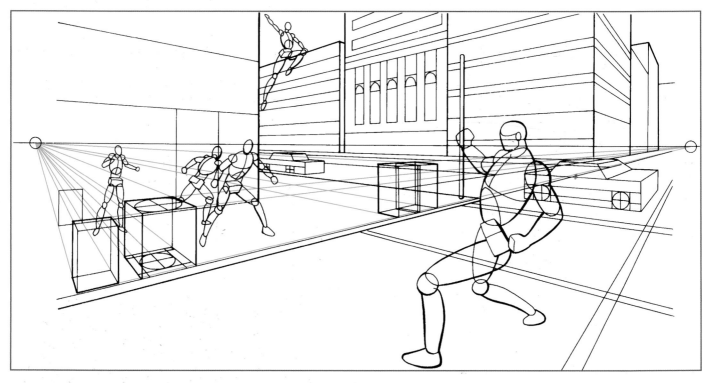

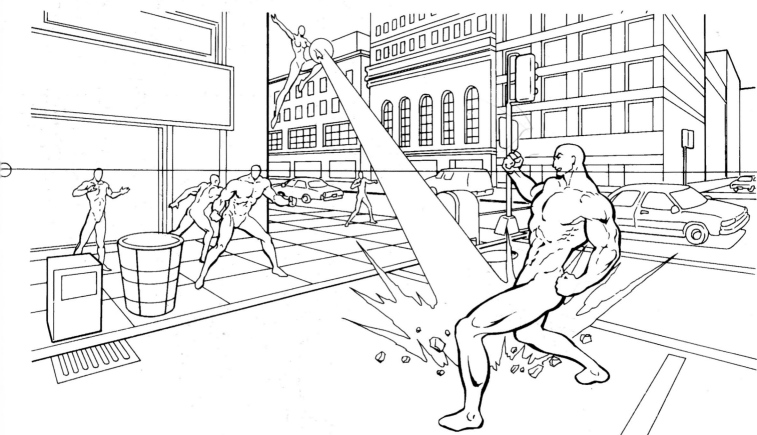

Distorted Exterior Two-Point Perspective

Moving the vanishing lines closer together in two-point perspective alters the look and feel of the scene. It makes it more compact, causing the buildings to look *distorted.* (The distortion will always be the greatest at the edges of the picture.) This contributes to making a scene that feels more unsettled, which may help underscore what's going on in the story.

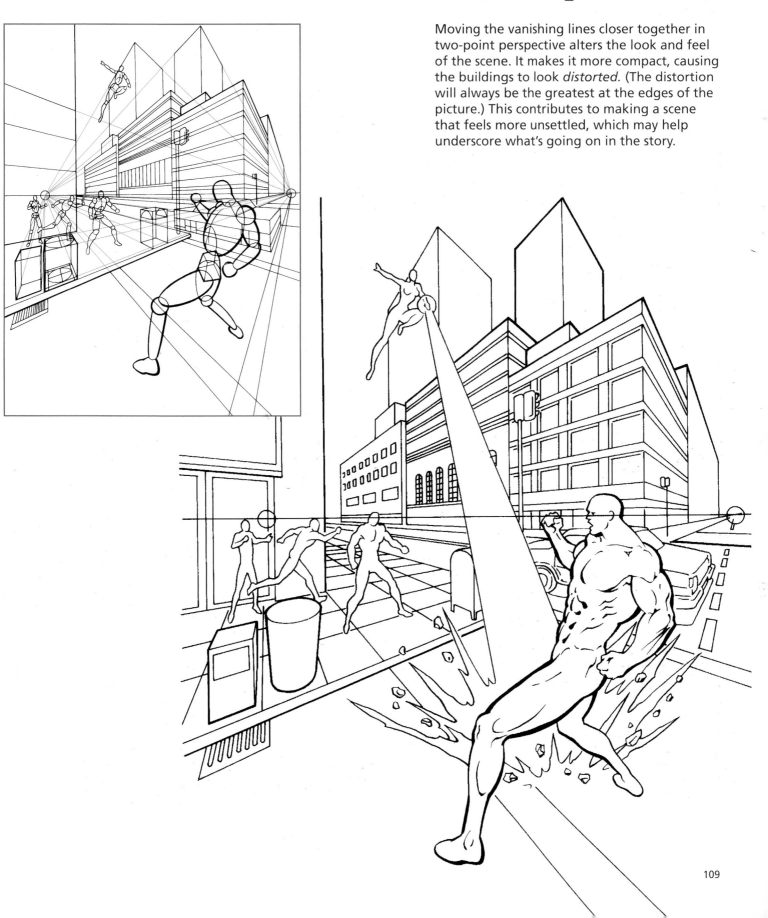

Interior Two-Point Perspective

You can tell that this is two-point perspective because there's a corner (of the operating table) facing us. Actually, it makes no difference whether the corner is coming toward us or facing away from us. In fact, the room itself has a recessed corner in it, which is an indication of two-point perspective. Either situation requires two vanishing points. Note how all the lines of the walls, tables, and floor tiles recede along the vanishing lines toward one of the two vanishing points in the scene.

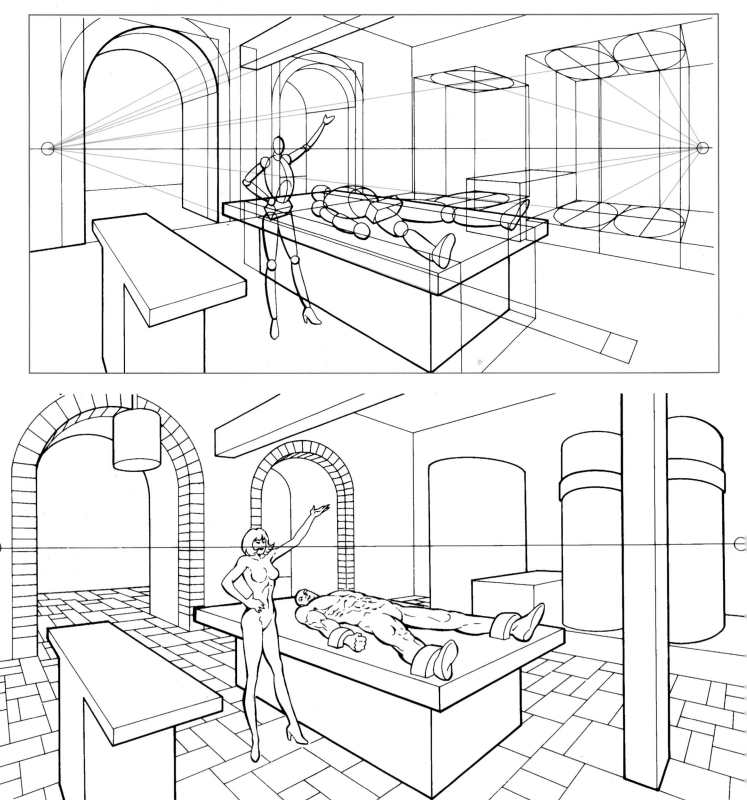

Distorted Interior Two-Point Perspective

Again, a big difference results when you nudge the vanishing points closer together. The tables and floor tiles become distorted, and this makes the scene seem surreal, almost like a dream sequence. The figures also decrease in size more rapidly.

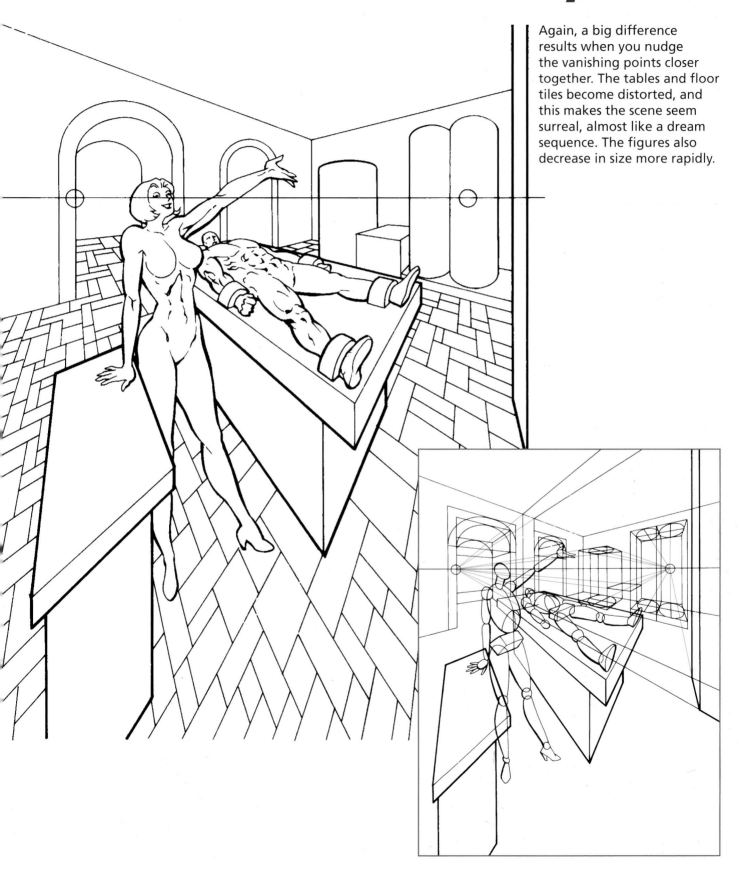

Exterior Three-Point Perspective

Adding a third vanishing point overhead can add heavy drama to a scene. The third vanishing point turns skyscrapers into towers, and as a result, that caped guy looms overhead with far more authority. The third vanishing point also gives the scene direction, leading the eye from the figure in the foreground up the page to the figure above. Without the third vanishing point, this scene would be flat.

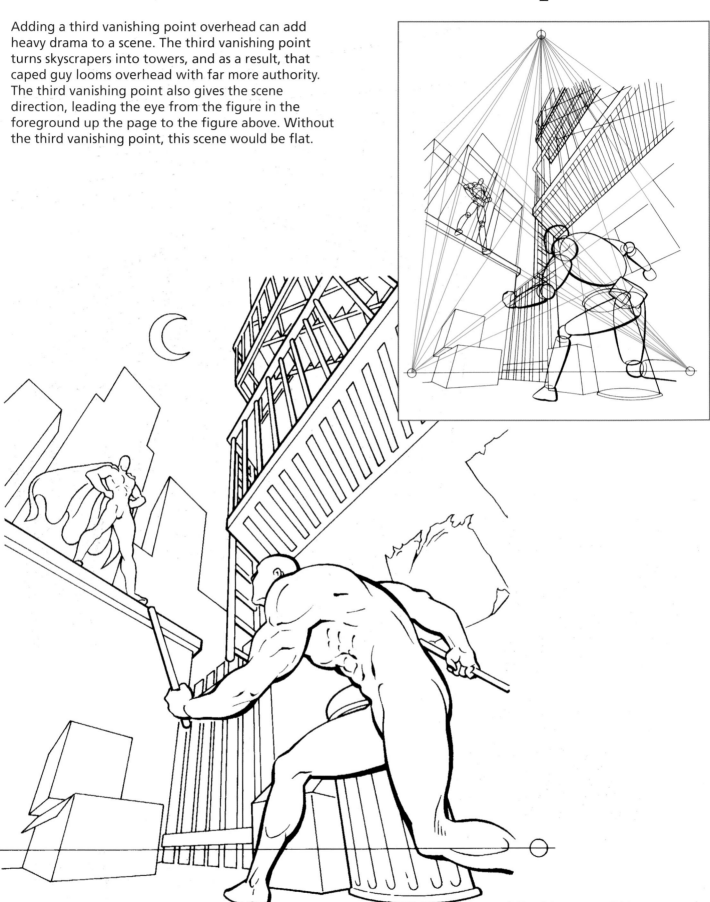

Interior Three-Point Perspective

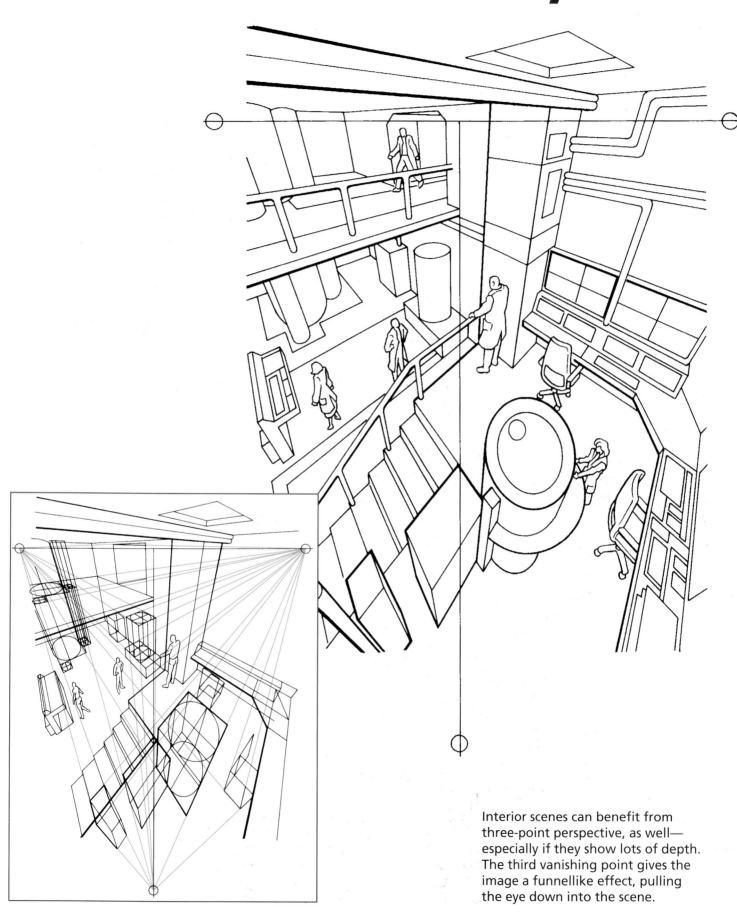

Interior scenes can benefit from three-point perspective, as well—especially if they show lots of depth. The third vanishing point gives the image a funnellike effect, pulling the eye down into the scene.

Designing the Page

This section is the bible for how to crank out amazing scene after scene. It'll teach you to think like a designer. Ask any comic book editor what separates an average artist from a great one. Most often, the answer is: The ability to tell compelling stories *visually.* All the great characters you draw won't get you ahead in this business if you can't keep your readers hanging on the edge of their seats from panel to panel. ■ There are, of course, the essential design techniques, such as timing, pacing, rhythm, spacing, repetition, symmetry, and angles. But there's also more—there's the stringing of all the techniques together in a manner that leads readers where you want them to go, emotionally. In addition, cutting-edge comics have broken loose from the look of more traditional comic book pages by reconfiguring the standard panels and inserts. It's a new world out there, so you're not going to want to miss this section.

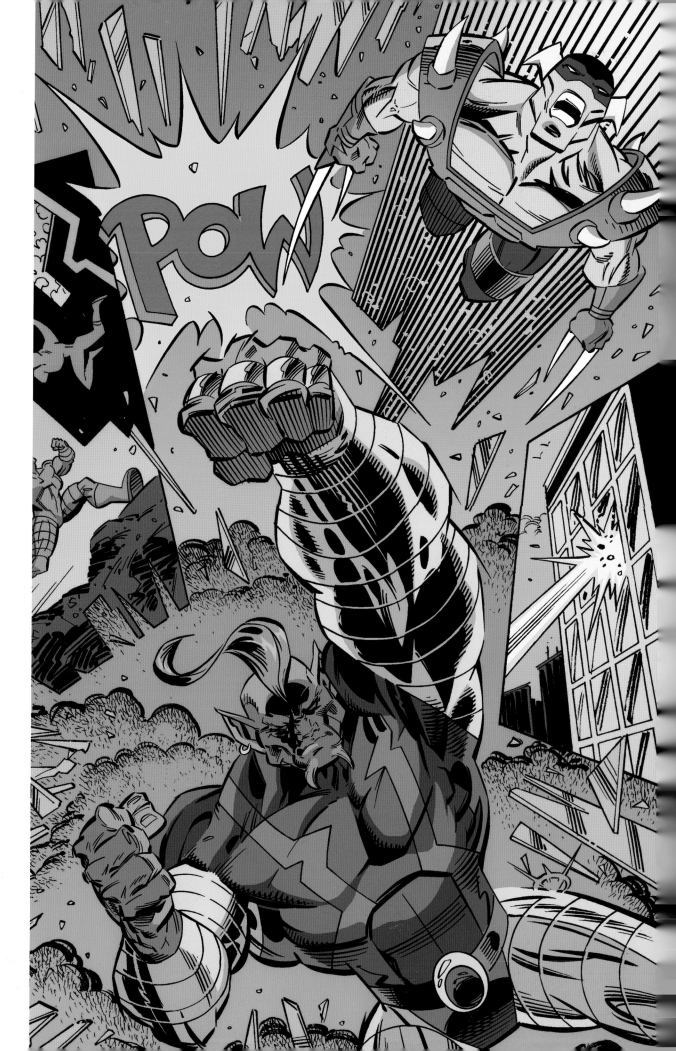

Using Your Eyes As a Camera

Up till now, you've been drawing characters. That involves one set of skills. Now, you've got to start thinking differently, because you're going to draw *stories,* and this takes an entirely new set of skills. Start thinking of your eyes as a camera lens. How do you see the scene in your mind's eye, *before* you draw? Are you looking up at the character? Down at the character?

Is the character in your face or way in the distance? If you place your characters in a room, where should you position them to make the scene as visually interesting as possible? Get into the habit of asking yourself these questions before you attack a scene. Take a look at the panels here, which compare traditionally laid out comic book scenes to more dynamic versions.

1. CENTERED
It's dull, uninvolving.

2. LOW ANGLE
The low angle creates dynamic angles.

3. CENTERED
The straight-on shot of the monster attack has no impact or attitude.

4. CLOSE-UP
The close-up creates tension, urgency.

5. FLAT STAGING
Everyone in the scene is located at about the same distance from the reader. There's no composition happening here.

6. VARIED STAGING
When the distances of the different characters to the reader are staggered, tension erupts in the scene.

7. AWKWARD CROPPING
The panel frame cuts off the hero's body at the legs. It's not an impressive shot.

8. EFFECTIVE CROPPING
Moving in close, the panel frames the villain looming overhead and creates a sense of immediate danger.

9. FLAT POINT OF VIEW
Viewing the scene from directly in front of the running subject, doesn't result in a feeling of danger.

10. DRAMATIC POINT OF VIEW
Viewing the scene from above and behind the running subject, from the viewpoint of the pursuing airborne vehicle, greatly enhances the sense of danger to the man. .

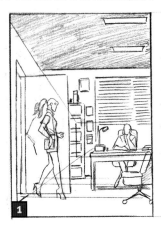
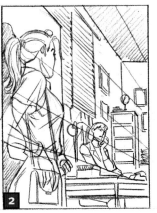
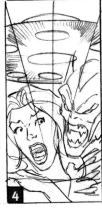
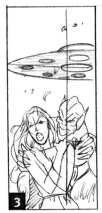
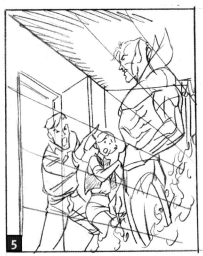
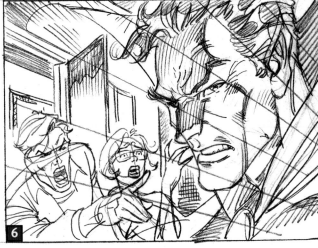
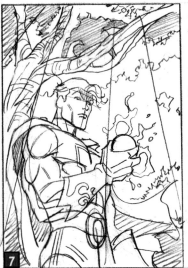

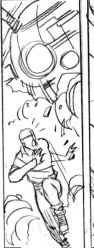

Using Distance As a Dramatic Tool

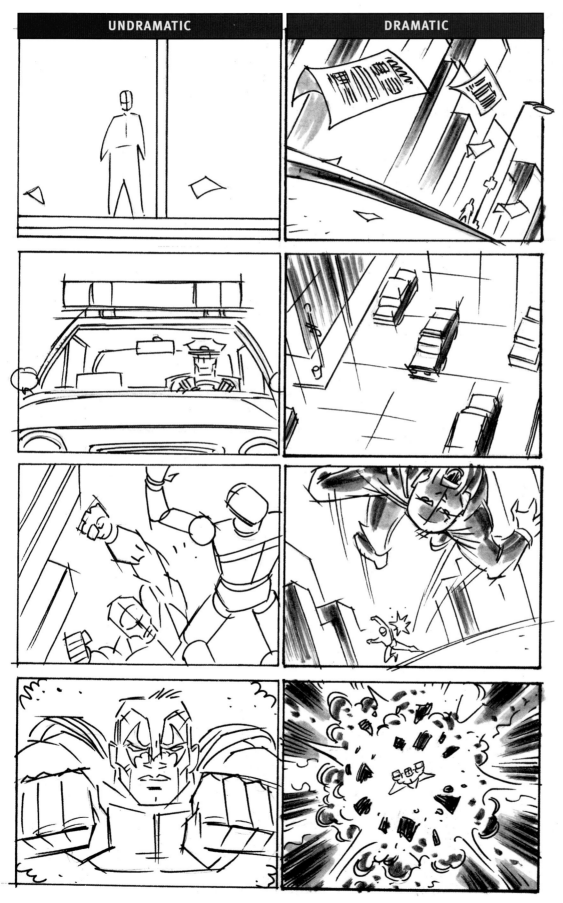

UNDRAMATIC

DRAMATIC

It may seem counter-intuitive, but by pulling *away* from a scene, you can actually *increase* the impact on the reader. The column on the left shows average scenes; nothing wrong with 'em, but they lack impact. The column on the right shows the effect of increased distance.

The Extreme Close-Up

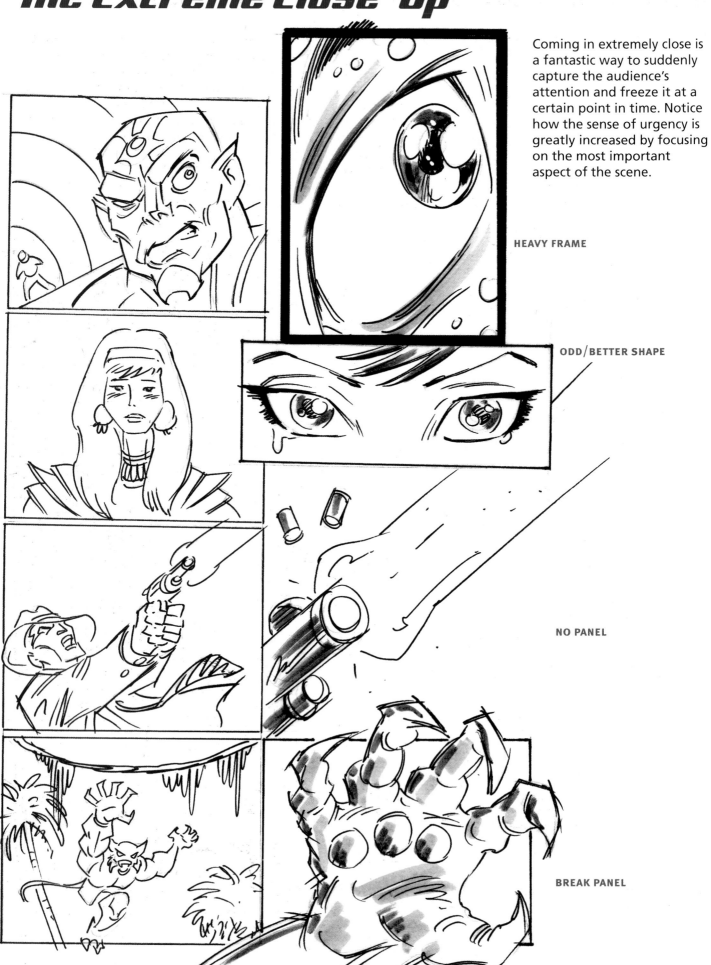

Coming in extremely close is a fantastic way to suddenly capture the audience's attention and freeze it at a certain point in time. Notice how the sense of urgency is greatly increased by focusing on the most important aspect of the scene.

HEAVY FRAME

ODD/BETTER SHAPE

NO PANEL

BREAK PANEL

Low Impact vs. High Impact Panels

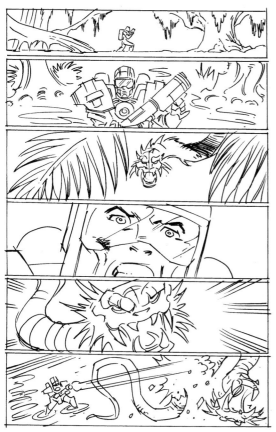

This layout is clear, but it's so predictable. This is the way you draw a scene when you don't give it a moment's forethought. It's just one nice image after another without much suspense, tension, or surprise. It's not bad—in fact, it's kind of typical. But it's not cutting edge. The climax (the shooting of the swamp snake) is almost an afterthought—no more important than any other panel. It doesn't make sense, does it? If you were telling someone this story, you'd put more emphasis on the part where the hero shoots the swamp snake, right? Also, take note of the panel designs. They're all horizontals. You know how people like to stare at a beautiful horizon? That's because it's so peaceful. Horizontals are calming. Great for vacations. Bad for comic book pages.

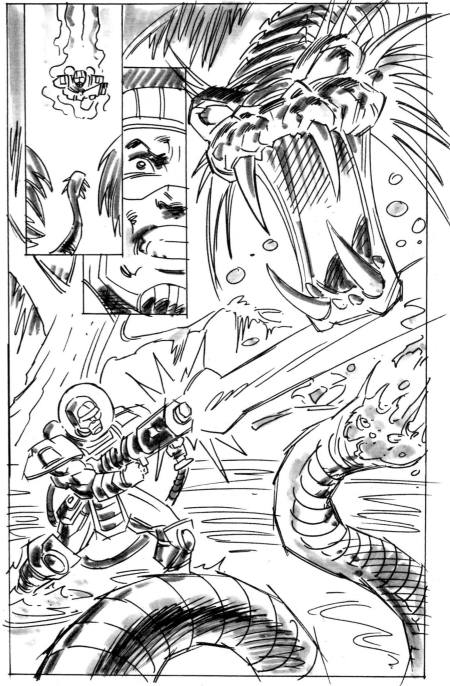

Here, some changes have been made. Gone is the symmetry. Some panels are given less weight, while others get much more. Surprisingly, creating high-impact layouts often means *simplifying* the page rather than complicating it. Good design gets right to the point. This main panel on the revamped page joins the scene already in progress, in the middle of the swamp. The insert panels swiftly set up the story: The swamp snake is advancing on our hero, who must make a decision—and quickly! The laser beam blast severs the snake's head from its body, and the beam also serves to tie in the man on the lower left to the snake's head on the upper right. Staggered, energized vertical panels replace the soothing horizontals of the previous version, adding urgency to the scene.

Flat vs. Dramatic Panels

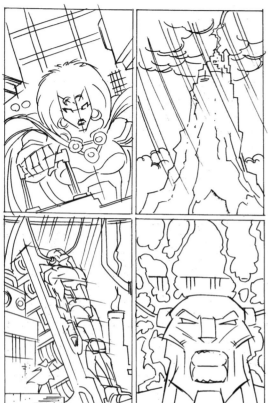

Here's a typical four-panel design. The pacing is completely steady. The shot of the Mistress of the Castle is flat. It has no attitude and reveals nothing about its subject matter. The shot of the castle is also flat—there's no foreground to give the panel depth. The monster is on a diagonal, but the scene is shown from a completely neutral angle. The final close-up has no impact, because nothing in the preceding panels has led up to it.

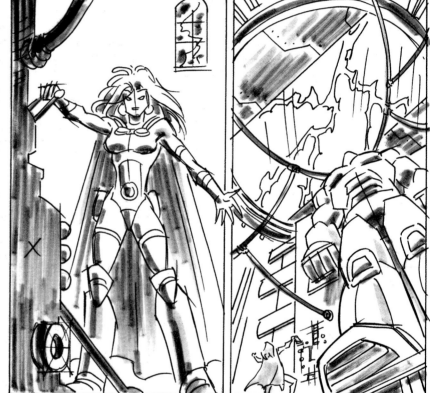

Here, the page starts with an up-shot of the Mistress of the Castle. She's big, bad, and sexy. The next panel cuts right to the important stuff—the monster. Note the high-tech roof opening up to reveal the dramatic stormy clouds overhead; this kind of shot eliminates any need to cut away from the action to show an exterior shot of the castle. Combining the exterior and interior elements into one panel also makes the scene more dramatic, and simplifies the page. Now there's room for a really dramatic close-up of the monster, and the penciler is able to go nuts with the special effects because of the extra room gained by eliminating a panel.

Variety Isn't Always More Exciting

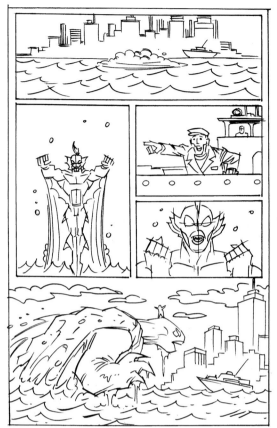

Here's a great example of the mistaken assumption that mixing up different sizes of comic book panels will generate more excitement. Not necessarily so. There's no foreshortening here. It doesn't matter how nifty your panel design looks if everything inside the panels is flat and centrally located. Nothing is on a diagonal. Nothing is coming at the reader.

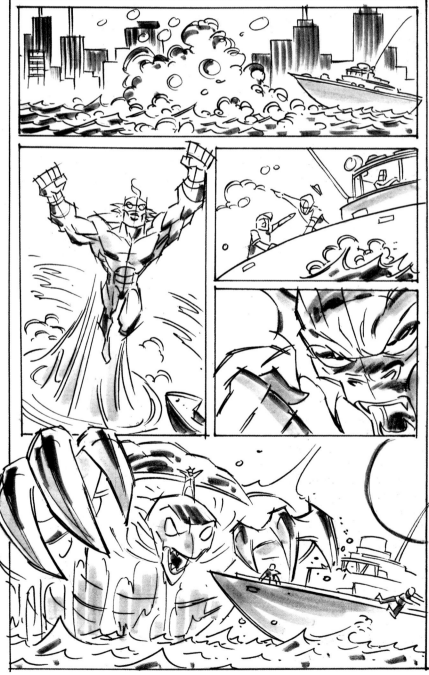

With the exception of the opening panel, which is a typical establishing shot (establishing the setting), all of the other panels show people or creatures moving toward the reader. There's implied movement all over the place.

Trying to Do Too Much

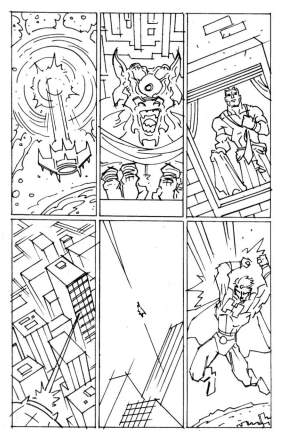

This is another typical problem that you may encounter. You may be very ambitious. You may want to show your editor and readers that you're going to attack every panel from every conceivable angle. Here, all the panels are cool, but they all have equal weight. Too many points of interest create a weak page. Nothing stands out as more important than anything else, and with a cruel irony, the page becomes less interesting even though you're working harder.

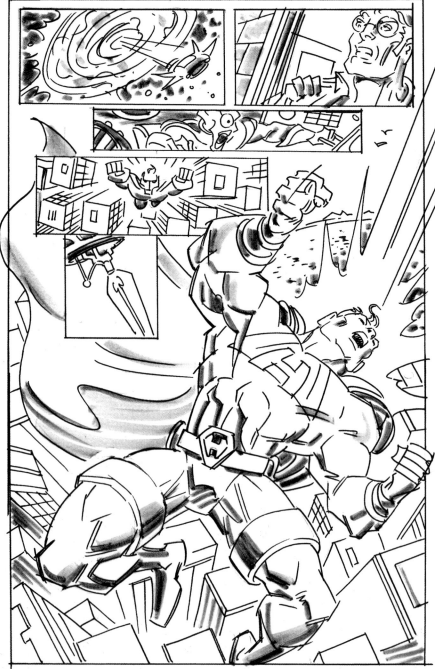

This page sacrifices all the back story for a big, splashy payoff—but it works big-time. The hero being frozen in a beam over the city is a dramatic moment that cries out for special treatment.

Designing a Dramatic Fight Scene

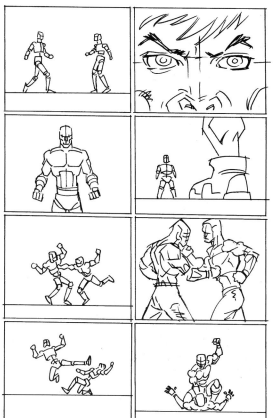

Here's a situation you're going to run into. It's a fight scene. You might assume that a fight provides enough action, so much so that if you were to add heavily dramatic design elements to it, the result would be too chaotic. But today's reader has grown up watching television shows and commercials with cuts that last mere fractions of a second. We're training an entire generation to acquire attention deficit disorder. Everything has to be fast and furious, or we're bored. As a result of our conditioning, this page suffers from its stagnant, symmetrical panel design. The shots are all centered (dull and stable), flat (with no foreshortening), too distant (with no foreground/background elements) and tired medium shots—the kind used back in the golden age of comics.

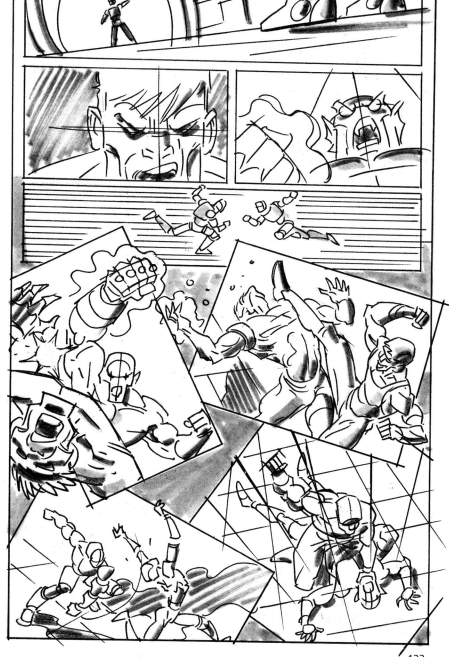

Now the page has a solid theme. It's not about "the big punch"; it's about the battle. It's a play in three acts: the preparation, the confrontation, and the fight. Instead of having the horizontal panels create a calming force, they function as small beats, separating the first act (the preparation) from the third act (the fight). As the two fighters race toward each other, the panels suddenly explode into a tilting, cascading avalanche of violent shots. The panel design not only mirrors the raucous energy but heightens it and takes it to the next level.

Finding a Unifying Theme

There's nothing wrong with this page. It's a good, average comic book page. Some interesting angles, shows skill and variety. But there's no unifying theme. I don't get the sense, as a reader, that I'm being directed toward a moment. If you want your work to stand out from the crowd, you've got to dig a little deeper.

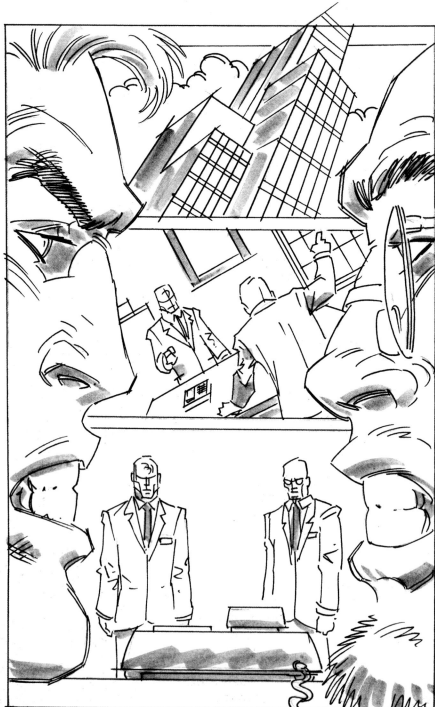

By comparison, the tension is evident from the moment you look at this page. The two profiles frame the scene, compressing the action, and never let up. Note the tilted buildings and figures (inside some of the horizontal panels) which reflect the severe emotional instability in the scene.

Symmetry vs. Asymmetry

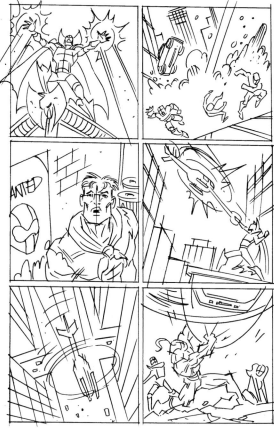

This page again shows the tiredness of the symmetrical panel setup. All the angles are good. They show us important, urgent moments. But somehow, these moments don't add up to anything, because they're laid out in such a bland grid.

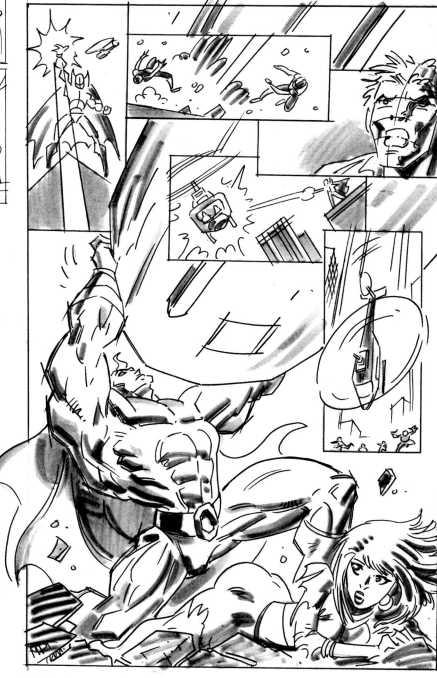

Here, the urgent moments are interjected violently onto the climax of the page; they're almost disjointed due to their intensity. The image of struggle at the bottom of the page dominates all the others and is the cliff-hanger that makes the reader want to turn the page to see what happens next. The bottom of a panel or page can always support a heavier image than the top. Designwise, you want to avoid getting too top-heavy.

Crossing Over to Television Animation

Television is like a hungry beast, always needing to be fed. It needs properties (licensed characters) as its basis for animated television shows. One of the most successful sources of licensed characters for animated shows is comic books. As a result, comic book illustrators are uniquely qualified to get hired as animation character designers and storyboard artists. ■ However, because of animation's unique requirements, artists must redesign comic book characters for this medium. The intricate linework, pools of inked shading, and cross-hatching must be eliminated. It's just not possible for a crew of animators to reproduce every individual line on a comic book character. It would take too long—it takes twelve drawings to create just one second of animation. The characters must be simplified. But to simply *dumb down* a character would leave it a mere shadow of its former self. So, heavy stylizing makes up for any simplification. And this results in a very cool look.

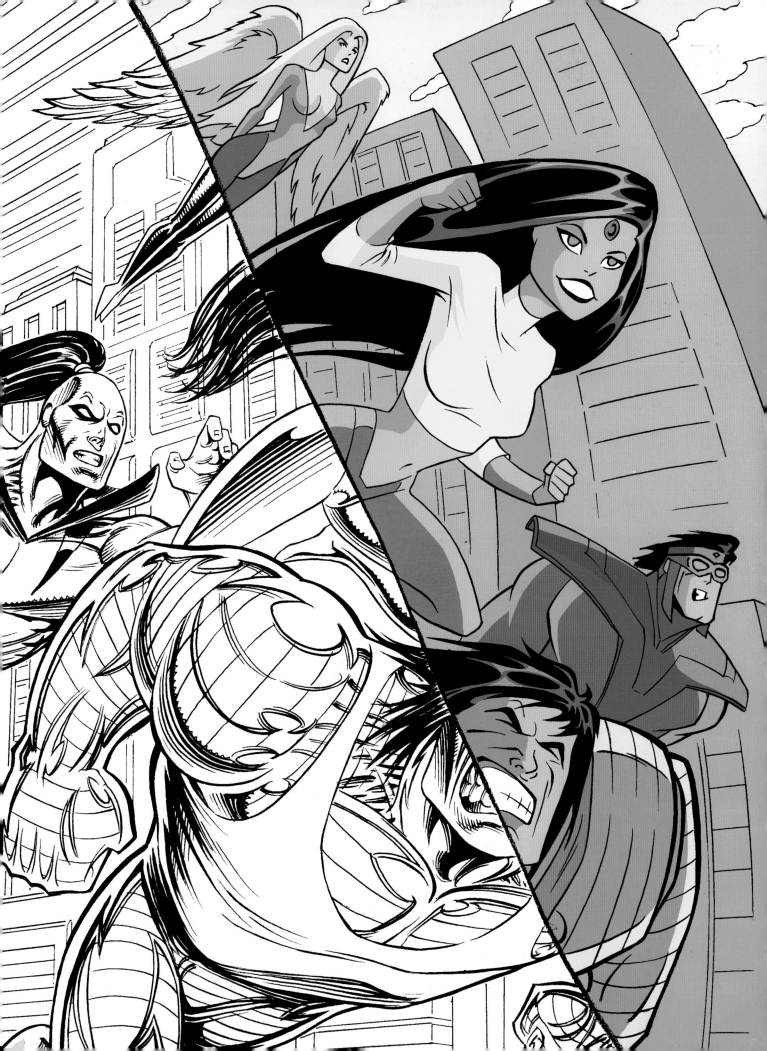

The Animated Style

Animated heroes (in blue) are less rugged and grungy than those in comic books (in black). They don't look as though they've been through a war. Although heroines are attractive, they aren't as overtly sexy, because the average animation viewer is younger than the average comic book reader—and the characters must be age-appropriate. Still, animated shows make up for this with clever linework and imagery. Just look at the impressive designwork in the *Batman Beyond* series .

ANIMATION: AN OPTION FOR YOU?

Industries operate in a cyclical way; when some doors shut, others open. Animation provides good opportunities for comic book artists to use their talents and make professional contacts. Plus, animation isn't relegated to television anymore. It includes all sorts of computer and internet applications. It's also a good strategic career move to have several sources of income. Sometimes, the producers of an animated show or webcast will be in a scheduling panic and will pay handsomely to get character designs done quickly. This is because they can't begin production until the characters are locked in place. Often, they'll look to comic book artists to create these designs, hiring animators later on to do the actual animating. These gigs are often short-term but pay quite well.

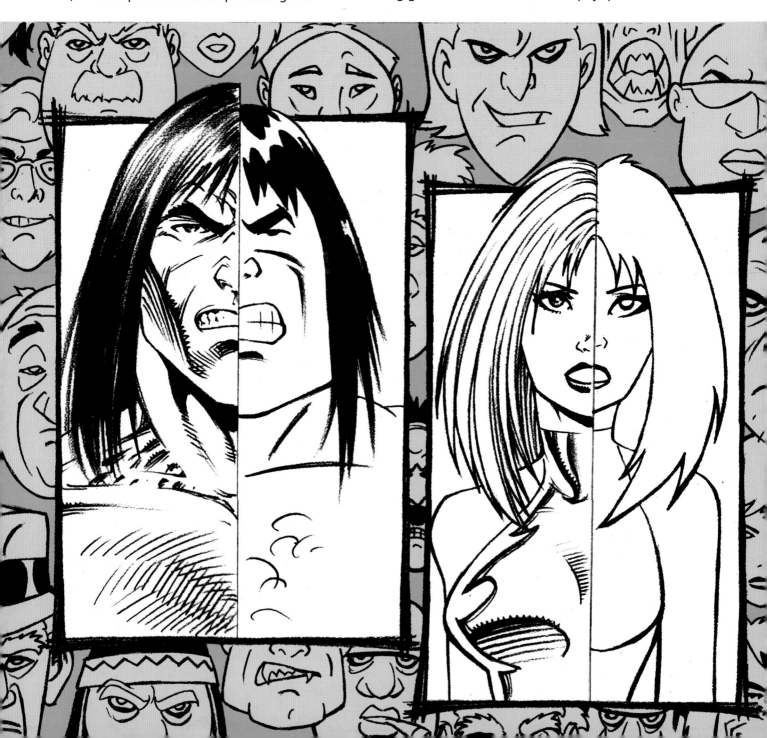

Clean Lines and Angles

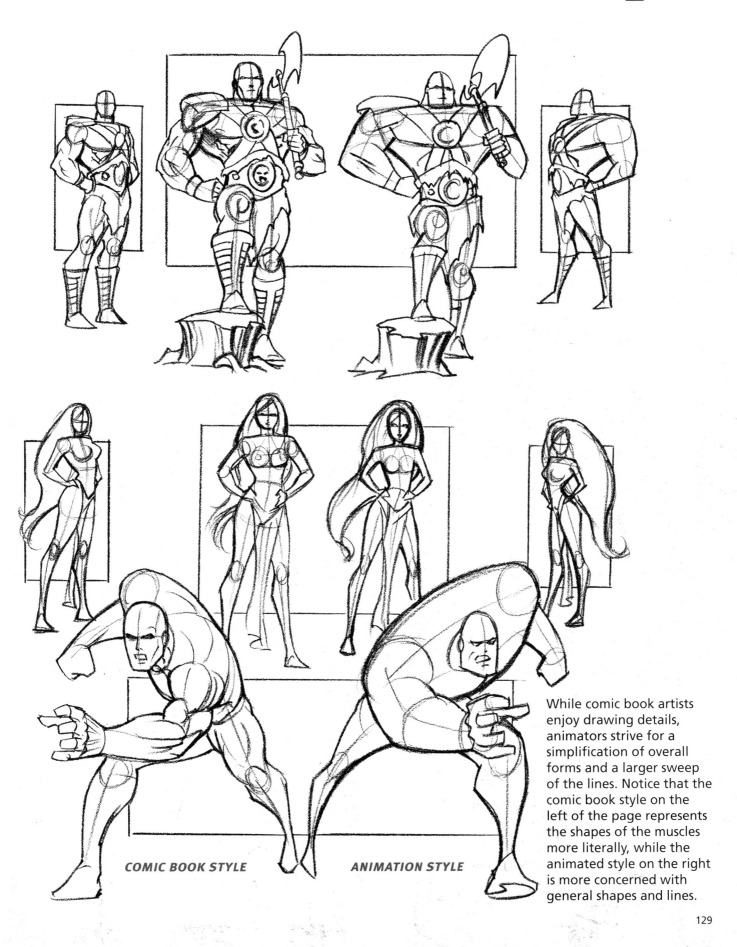

COMIC BOOK STYLE

ANIMATION STYLE

While comic book artists enjoy drawing details, animators strive for a simplification of overall forms and a larger sweep of the lines. Notice that the comic book style on the left of the page represents the shapes of the muscles more literally, while the animated style on the right is more concerned with general shapes and lines.

Simplifiying the Head

For animated shows, characters derived from comic books are simplified and their shading is removed. They still manage to retain their personality, though. In fact, they gain something in the form of humor. Most animated shows, even those based on dramatic comic books, have characters infused with a bit of tongue-in-cheek humor. If they didn't, audiences might expect a more serious treatment of the characters, which would require staying true to the original models, which are too intricate for animation.

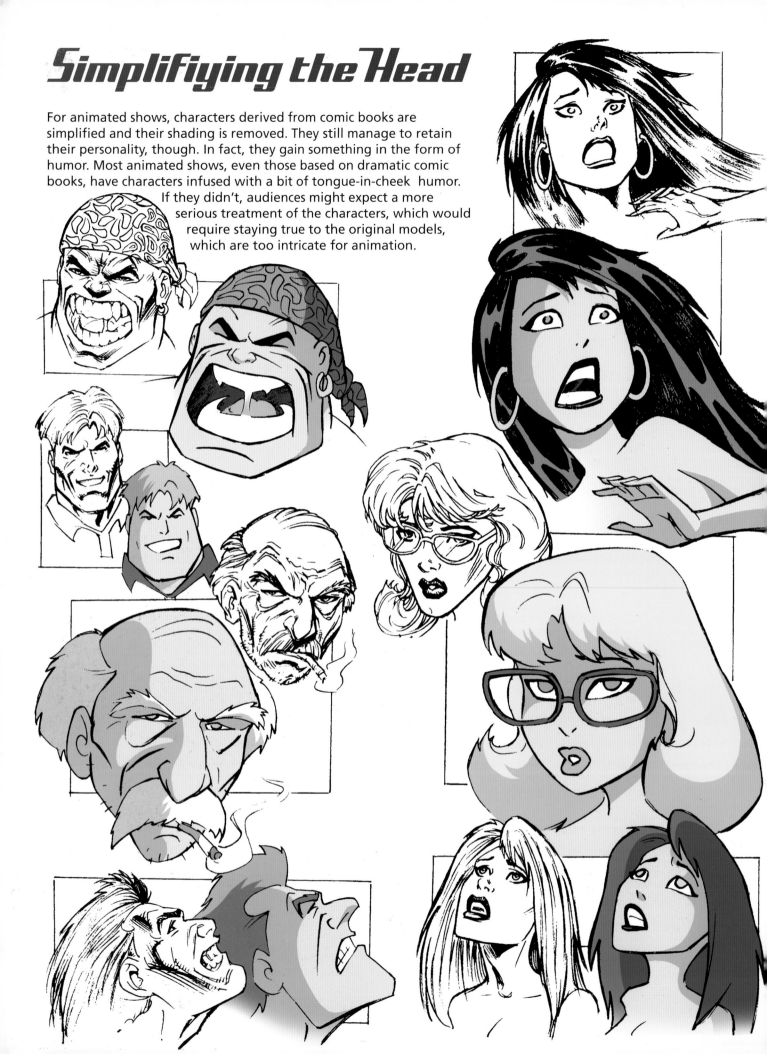

Simplifiying the Body

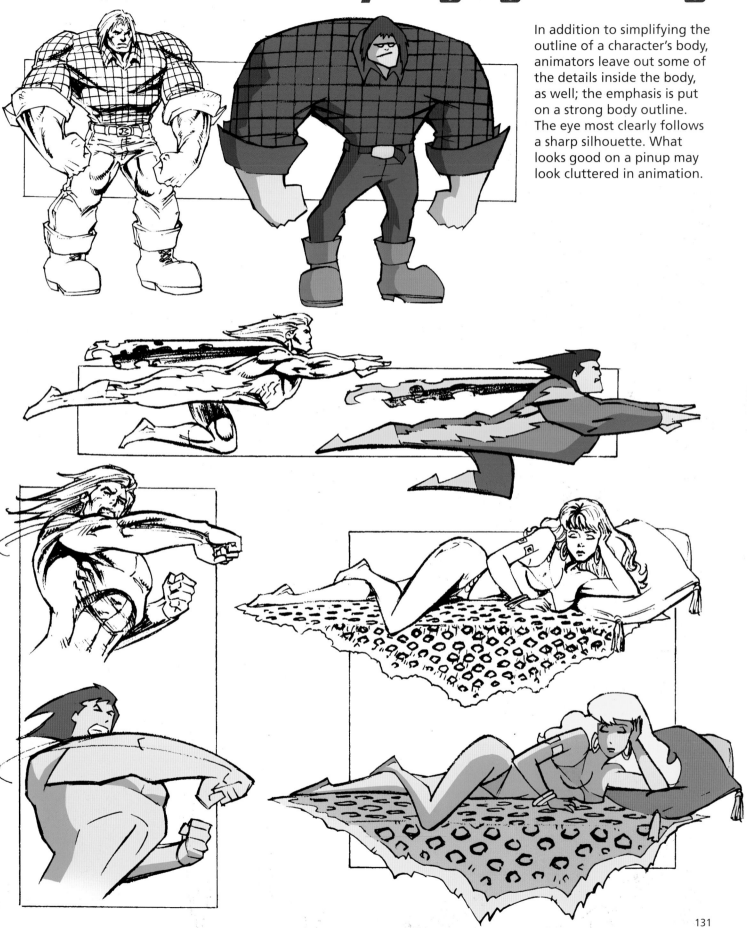

In addition to simplifying the outline of a character's body, animators leave out some of the details inside the body, as well; the emphasis is put on a strong body outline. The eye most clearly follows a sharp silhouette. What looks good on a pinup may look cluttered in animation.

The Weird and Unexplained

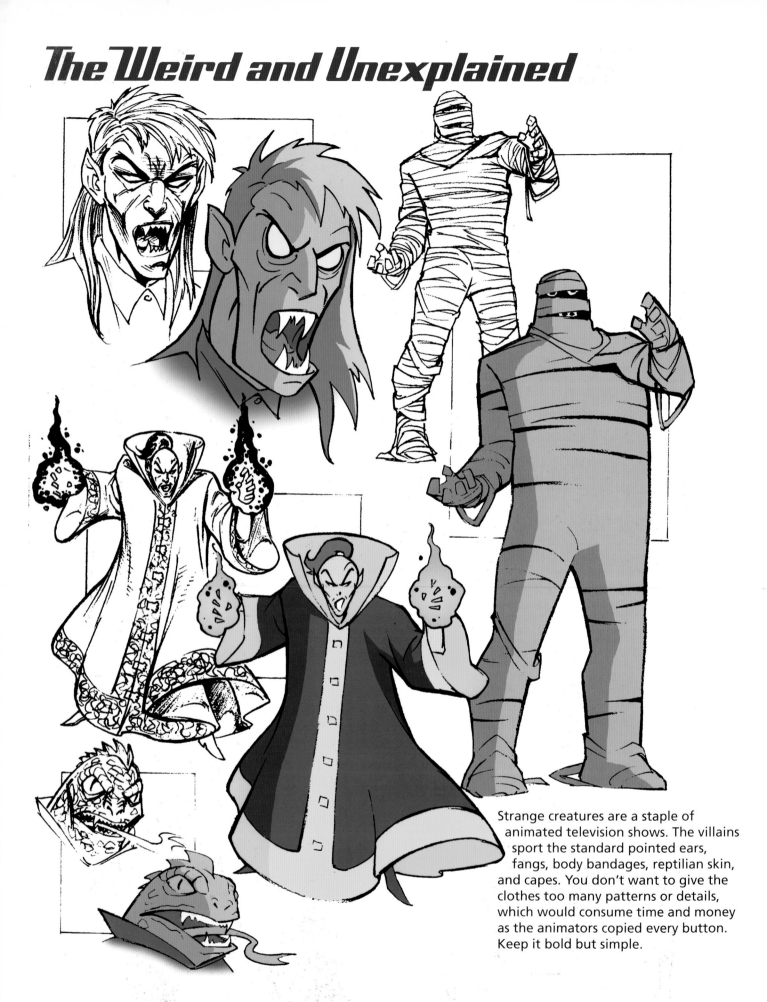

Strange creatures are a staple of animated television shows. The villains sport the standard pointed ears, fangs, body bandages, reptilian skin, and capes. You don't want to give the clothes too many patterns or details, which would consume time and money as the animators copied every button. Keep it bold but simple.

Realistic vs. Stylized Animals

Dinosaurs, lions, and other big cats, beasts, and carnivores have all played great roles as antagonists in comic books, where they're rendered in a realistic manner. In order for the animal's threat to seem real, its appearance cannot be cartoony. That would destroy the suspense of the story. And too much realistic detail won't work in animation. So instead, go for a designy, stylish look while keeping the basic form and structure of the creatures realistic. Note that the outlines of the drawings are basically the same in both styles; it's the interior rendering that changes from the comic book style to the animated style.

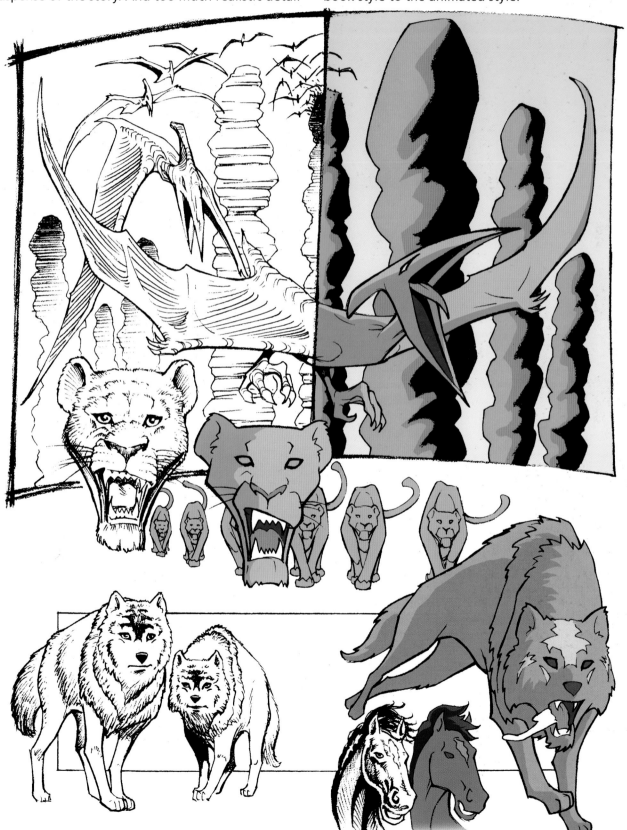

Stylized Backgrounds

Backgrounds in comic books are very linear. Part of the reason for this is that comic book panels, which are rectangles, are an integral part of the design of most comic book scenes; strong verticals and horizontals are built into the fabric of every page. This establishes a linear framework.

In animated shows, curved lines may also be employed so that the entire scene seems to bend, whereas a curving, rubbery background is at odds with the straight, structured panel design of comic books. Therefore, animation artists are free to use curved lines to add style to their backgrounds.

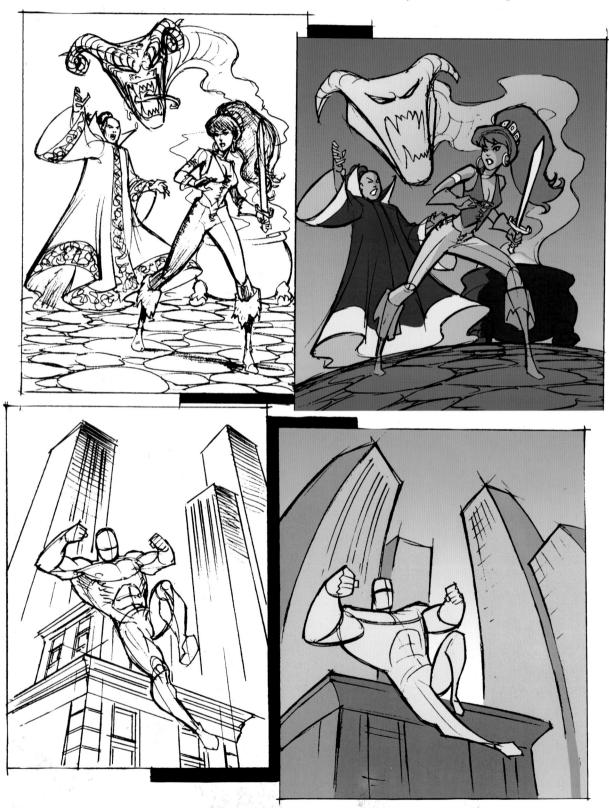

Special Effects

Pow! Zap! Ka-Blam! Comic book special effects are hard to beat. But if you tried to reproduce them slavishly in animation, you'd drive yourself crazy. You'd be required to draw every little dot and line over and over. Instead of dots and lines, think in terms of beams for animated special effects. Beams are simple outlines that are bold and, when in motion, easier for the eye to follow than lots of delicate lines and bursts. Beams have a clean interior space that works well when filled with color.

Remember, a reader has time to pour over a comic book page, but a television viewer only gets 1/12 of a second to view each animation drawing, so excess linework only gets in the way of the overall thrust.

Getting an Agent to Rep Your Work

It's often said of creative fields that a lot of the work is *looking* for work. It's not like a job in corporate banking where you just show up at the office every day. When you finish one assignment, you've got to find the next one. There are people whose business it is to find those assignments for you. They do everything from finding the jobs to negotiating the contracts to collecting the fees to offering career guidance. This saves artists time that can be better spent developing their talents and increasing their output, resulting in a higher income.

And let's face it, even artists are capitalists at heart. ■ The artist's agent, or "rep," is probably better at networking than the artist. Of course, some artists are good at making contacts. Some artists live in cities where there are a lot of publishers or comic book conventions. Others are already hooked up with a publisher and doing fine. You may not need an agent, or you may not need one *at this point* in your career. Agents take a healthy cut of your salary, in the range of 10 to 25 percent. It's not for nothin' that they do all this work.

Six Good Reasons to Get an Agent

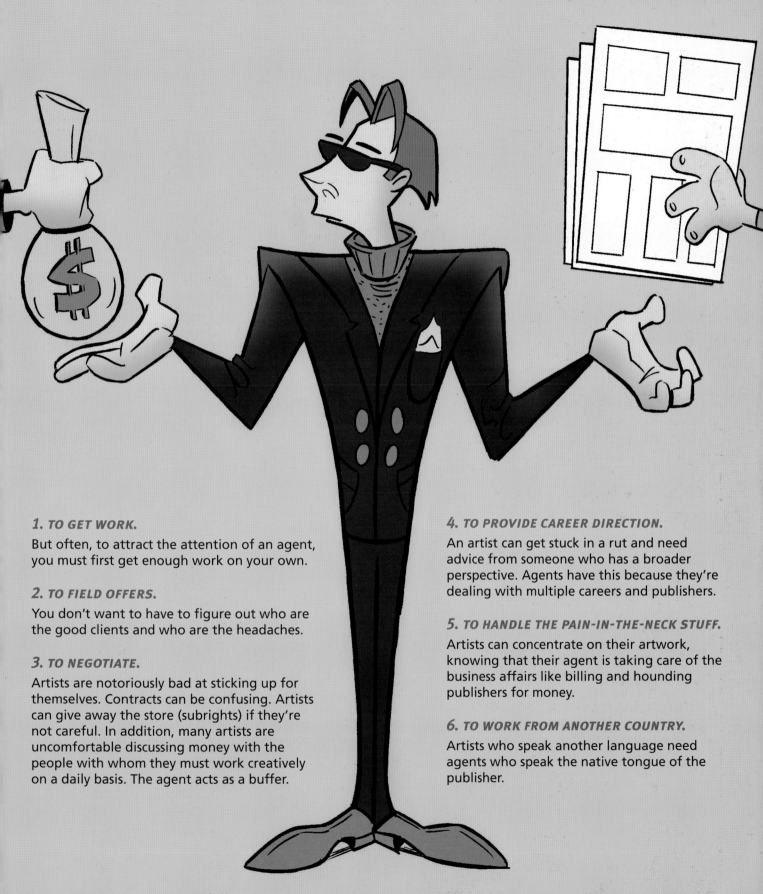

1. TO GET WORK.

But often, to attract the attention of an agent, you must first get enough work on your own.

2. TO FIELD OFFERS.

You don't want to have to figure out who are the good clients and who are the headaches.

3. TO NEGOTIATE.

Artists are notoriously bad at sticking up for themselves. Contracts can be confusing. Artists can give away the store (subrights) if they're not careful. In addition, many artists are uncomfortable discussing money with the people with whom they must work creatively on a daily basis. The agent acts as a buffer.

4. TO PROVIDE CAREER DIRECTION.

An artist can get stuck in a rut and need advice from someone who has a broader perspective. Agents have this because they're dealing with multiple careers and publishers.

5. TO HANDLE THE PAIN-IN-THE-NECK STUFF.

Artists can concentrate on their artwork, knowing that their agent is taking care of the business affairs like billing and hounding publishers for money.

6. TO WORK FROM ANOTHER COUNTRY.

Artists who speak another language need agents who speak the native tongue of the publisher.

An Interview with Doug Miers

Doug Miers of Studio 3 represents some of the comic book world's top artists, both nationally and internationally. Here's what he had to say on agents and the world of comics.

Chris Hart: What can an agent do for a comic book illustrator's career?

Doug Miers: An agent can get the work seen by the editors who make the decisions. Mailing submissions is fine, but few real breaks are made from the slush pile [unsolicited submissions, for the most part, ignored by editors]. An editor has to be pretty desperate to go down to the mailroom and start digging through the submissions, which are otherwise routinely rejected by secretaries. Artists would have better luck talking to editors at conventions or finding slick agents to do the same.

CH: How does an artist go about getting an agent?

DM: A number of good agents are lurking around out there, like Spitfire Services, Dogg Works, StarReach, and Glass House. Find them at conventions or mail direct. Submit your work as you would to an editor, with clearly rendered layouts that convey stories with dynamic art.

CH: What should an artist include in a submission package of samples when trying to obtain an agent?

DM: I like to see at least seven consecutive pages of continuous storyline that relate a story using pictures. I've made editorial decisions based on only three pages, but they must be sequential art— lone pinups and sketches don't cut it.

CH: How often should artists phone their agents to see how things are going? What's a good amount to keep in touch and what's too much?

DM: I would touch base every couple of weeks, although a lot depends on the artist/agent relationship and the current

How often should artists phone their agents?

workload status. Calling day and night might be upsetting to the agent with no news to give, but calling occasionally might help keep the artist "in mind" as new jobs come through.

CH: When selling an original comic book idea to a movie or television studio, what rights does the original comic book creator get to hold onto?

DM: That depends entirely on the circumstances of development. If the work was done as work-for-hire, then theoretically the artist is entitled to little, if anything, although the studios will often attach the artist as a consultant or

Selling a comic book idea to a movie studio.

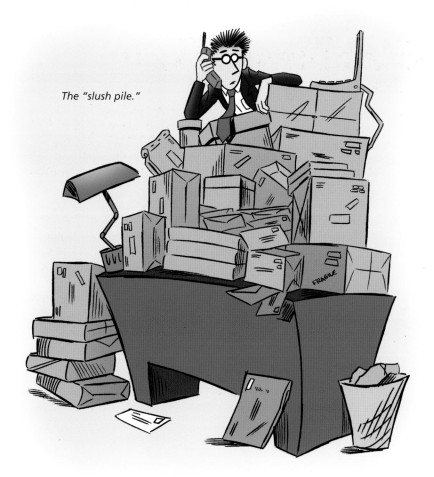

The "slush pile."

(if lucky) a producer. If the artist created and still owns the property, he can make his own deal with the studio for whatever he thinks he can get.

CH: On selling movie rights, would you recommend that an artist get a literary agent to negotiate a movie deal?
DM: Movie agents are a great way to get serious consideration, but when it comes to options [typically, deals in which a studio, producer, or production company pays for the exclusive right to hold the property for a limited amount of time while it tries to set up the film and if it does, the option is exercised, and the artist receives a big cash bonus], the studios have this notion that any newcomer is simply not going to get the same deal an insider would, and I think this is regardless of whether you have an agent. (The agents are pretty savvy to the way things are and adopt the same attitude).

CH: Can an artist work for more than one publisher at a time?

DM: There is the matter of artists defecting from one publisher to another. Sometimes editors can get very competitive (and very petty) when pursuing a particularly hot artist. It's easy to burn bridges by jumping around too much. The best an artist can do if he's lucky enough to find a particular niche is to stick with it.

CH: What steps can an artist take to make the jump from being published by a few minor publications to becoming established with the major comic book publishers?
DM: Always continue to improve. It's easy to open a comic and say, "I'm this good." But that's not going to get you the job. You have to be *better* than the competition, and there is a lot of competition. You have to be reliable, dedicated, and able to meet a deadline. Some of our best artists can't do monthly books because they can't manage a monthly schedule, so they're stuck in mini-series hell. When you do get work, that doesn't mean you've made it; it means you're just getting started, and you have to produce artwork even better than your samples. If the series ends or if the editor gets tired of missed deadlines, you're right back where you started, and a couple of credits on an obscure series are no great help.

Artists defect from one publisher to another.

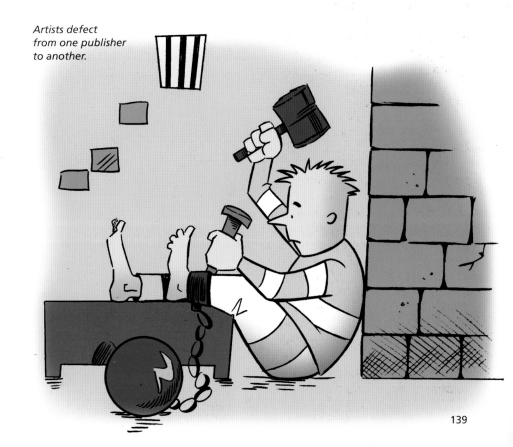

Riding the Edge: An Interview with Brian Pulido

Comics are a tough business. There's an amazing amount of competition. The roads are littered with the corpses of independent publishers who thought they had a new angle but failed to capture enough readers to support their print runs. Since this is a book about cutting-edge comics, my eyes kept darting back to a select group of comic books every time I visited the comic book stores—those in which the women were sexy, the stories were dark, and the art was cool. The publisher was Chaos! Comics. ■ Rather than try and do a little bit of everything, Chaos! started out by doing one thing—dark and evil comics—spectacularly well. It seized a niche and its audience, and never let go. The characters, such as Evil Ernie and Lady Death, are legendary. From there, Chaos! branched out but never lost sight of its roots. Chaos! Comics is a publisher with bite. Here president and writer Brian Pulido shares his thoughts on getting to the top, staying there, and where the industry is heading.

Chris Hart: Chaos! Comics consistently maintains a cutting-edge look. What do you do to stay on top of the industry?

Brian Pulido: It's not always intentional. We look at pop culture, see what's happening, and mirror it or take it to the next level. When we're really doing our jobs, we forecast what's coming up; for example, in the case of Lady Death, my most famous character, I felt a need to do a strong-willed woman who wouldn't take crap from anybody. It seemed natural to me, because I was mostly raised by my mom and sister. I was used to women in charge. It turned out, I forecasted a powerful trend in comics—what is now referred to as "Bad Girls."

We also stay on the edge by consuming movies and magazines. We compare stuff to other forms of entertainment.

CH: How did you discover your personal style?

BP: In my case, you're referring to my writing style. I actually design my characters and do the first drawings, but I hire pros to do the books. I'm a writer by trade. I gravitated toward dark material early on. I recall writing a story for my high school yearbook that was about lunatics getting loose at a USO, stealing a bundle of Santa costumes then going on a murder spree. Sadly, it was rejected. Since then, I've cultivated other interests, but the dark stuff seems very natural to me.

CH: Of all of your characters, which one surprised you by becoming as popular as it did?

BP: Lady Death. She became a cultural archetype. I simply wanted to tell the tale of a girl named Hope, but she became so much bigger than that.

CH: How did Chaos! corner the horror comics market?

BP: By providing horror fans with something they never got before: great-quality stories and art in a high-end package. We were there first in the early '90s and have had a strange hold on it since. Also, we actually love the stuff and you see our passion in our finest work.

CH: Where do you see comics and the internet heading?

BP: Good question. It's early to tell because no company has yet created a simple and compelling delivery system online, but it is just a matter of time. Do I see this replacing print comics? No, I don't; however, it will be a new channel to get out stories across.

The Chaos logo.

CH: What are some business models that make sense for comics and the internet?

BP: A subscriber service, where a customer pays a fee to read a book once. Another scenario is providing the content free and having advertising as a way to generate revenue.

CH: Most aspiring comic book artists only think about drawing, but in this new, entrepreneurial, high-tech world, what else should they consider?

BP: We should all be thinking out of the box. That's where the path of most success lies. What else

to consider? Business training. Financial training. Marketing training. Sales training. You can't get there without a little marketing. Make that a lot of marketing.

CH: Are you developing any projects for film or television, either animated, computer generated, or live action?

BP: We are doing a Lady Death animated feature with AD Films. We are producing a live action Evil Ernie movie with Gene Simmons of KISS, and we have Brigade Entertainment, producers of Detroit Rock City, producing Chastity.

CH: What advice would you give to those considering self-publishing?

BP: Don't do it unless you are insane. It's a dangerous market out there. It's like gambling every day. If you have the guts, the savvy, the drive, the *vision,* then do it. Otherwise, get a publisher.

Look, most people get into self-publishing because they want people to see their work, but you learn *very* quickly that making the book is only about 10 percent of the job. Running the business is the other 90 percent.

CH: What is the market for graphic novels, as opposed to comic books?

BP: Short term, print runs are not high. However, trades are a good revenue stream. Diamond Comics Distribution noted that trades are their number two growth area.

CH: What are some areas that you'd like to see Chaos! Comics explore as you look toward the future?

BP: We will further explore the internet and new forms of entertainment on the internet. We will explore television and film. Like anyone else willing to play the game, we are after global domination.

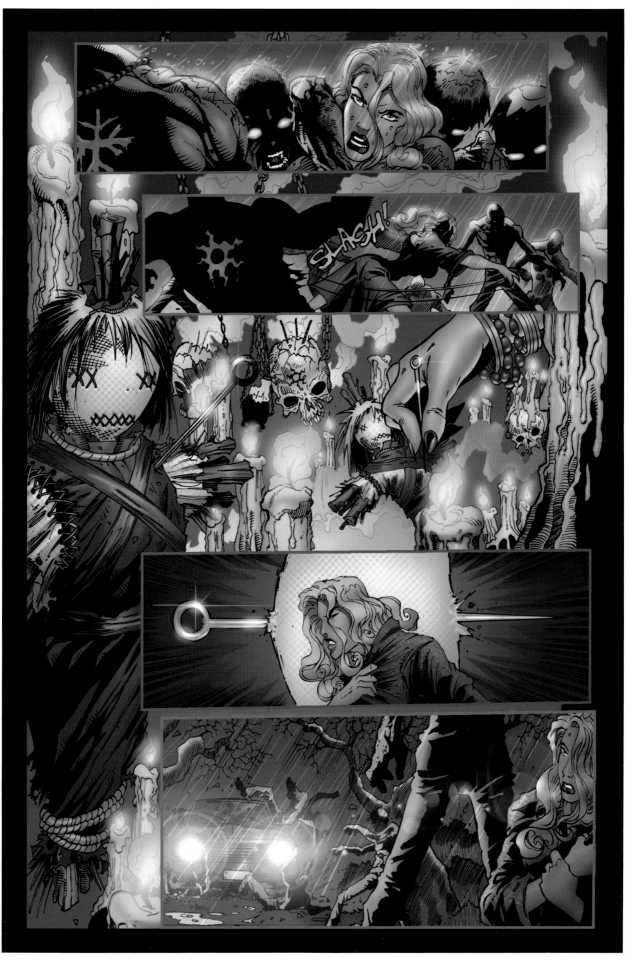

SLASH!

Index

abdomen, 28, 36, 39, 44, 48, 49
agents, 136–139
allure, extreme, 52–61
Alquizo, Marlo, 84
anatomy, 24–41
angle(s)
 body, 34
 clean, 129
 head, 14, 15, 16
 low, 116
angular face, 67
animals, 50, 51, 74
animation, television, 126–135
ankle, 22, 23
aquatic genre, 97
arm muscles, overlooked, 33
arms, 28, 29, 32, 35, 38, 44
Arnold, Curtis, 4
attitude, basics with, 8–23

back, 30–31, 32, 35, 38, 48, 49
 female, 40
backgrounds, 88, 134
backstory, 48
Bad Kitty, 1, 4
baldness, 69
basics, with attitude, 8–23
Batista, Adriano, 4
big guys, 42–51
body
 animation, 131
 big guy, 42
 center line of, 39
 classic, 18, 19
 female vs. male, 35
 in profile, 32, 38
 tough guy, 28
 upper, 32, 36, 37
body language, 58–59, 60–61
break panel, 118

Caldwell, Talent, 82
calves, 28, 41, 44
camera, eyes as, 116
careers, 128, 136–139
Centered panels, 116
center line, 39
Chaos! Comics, 4, 7, 140, 142
characters, extreme, 62–75
character types, 68–75
Chastity, 2, 4
cheekbones, 12, 14, 26
chest, 28, 44, 48, 49
chin, 10, 11, 12, 14, 26, 67
classic body, 18, 19
classic ink, 84, 85, 86–87, 88
claws, 50
close-up, 86, 116, 118
clothing, 58–59, 60–61, 132
collar bone, 35
colors, 89–91, 92, 93
combining genres, 94–97
comic book style, animated vs.,
 128, 129
contour line(s), 41
 of female face, 26
 upper body, 37
contracting, 48, 49
costume. see clothing
creatures, strange, 46–47, 132
cropping, 116
crown, 27
crystal dude, 70

Denham, Brian, 80
design
 extreme character, 62–75
 fight scene, 123
 page, 114–125
distance, and drama, 117
distorted perspective, 109, 113
drama, 116, 117, 120, 123
dramatic twisting, 39
Drew, 4

ears, 10, 50, 55, 132
edgy ink, 84, 85, 86, 87, 88
expanded face, 67
expressions, 17
exterior perspective, 106, 108,
 109, 112
extreme allure, 52–61
extreme character design, 62–75
extreme close-up, 118
extreme colors, 89–91
extreme veins, 44–45
eye/nose faceplate, 66
eyes, 10, 12, 27, 54, 57, 59, 64, 65,
 72, 75
 as camera, 116

face, 14, 15, 26, 56, 65, 67, 72
 muscles of, 26, 27
faceplate, eye/nose, 66
fangs, 132
fantasy, 94, 96
feet, 22–23
female arm, 33
female back, 40
female body, in profile, 38
female eyes, 64
female face, contour lines of, 26
female form, 35
female hands, 21
female head, 12–13, 15
fight scene, 123
fingers, 20, 21, 35
flat panels, vs. dramatic, 120
flats, 89, 90, 91
flexed back, 31
forehead, 12, 13, 26, 27, 67
foreshortening, for impact,
 100–104
freaks, muscle-bound, 48–49
fur, 50

gathered face, 67
genres, combining of, 94–97
glows, 93
glutes, 41
goop, 75

hair, 15, 57, 59, 65, 72, 75, 87
hands, 20–21
head, 27, 42, 57, 59, 66, 67, 75
 animation, 130
 modern, 10–11, 12–13
 tilts and turns of, 14–15, 16
 tough guy's, 26
heavy frame, 118
hero body, 18
heroes, team, 97
heroine body, 19
"hidden" muscles, 29
high impact, low vs., 119
highlights, 89, 90, 91
hips, 19, 28, 35, 38, 39, 40, 41, 44

impact
 foreshortening for, 100–104
 low vs. high, 119
industrial genre, 96
inked drawing,

before color, 89, 90, 91
inker, 84–88
insects, 50, 75
intensity, 17
interior perspective, 107, 110,
 111, 113
irresistible lips, 55

Japanese comics. see manga
jaw, 10, 11, 12, 26, 27
Jensen, Kason, 4

knee, 28, 38
knockouts, 93
Koslowski, Richard, 4

Lady Death, 6, 7, 142
layering of muscle groups, 29
legs, 19, 28, 32, 35, 38, 41
line(s)
 center, 39
 clean, 129
 contour, 26, 37
 straight, and angles, 34
 vanishing, 105
lips, 10, 12, 13, 26, 55, 65, 67
"love handles," 29
low impact, vs. high, 119

male eyes, 64
male hands, 20
male head, 10–11, 14
manga, 4, 92, 94
Miehm, Grant, 78
Miers, Doug, 7, 138–139
military skin, 92
modern head, 10–11, 12–13
moments, 17, 86
mouth, 11, 55, 57
muscle-bound freaks, 48–49
muscles, 19, 28, 32, 35, 36, 39, 40,
 41, 50, 91
 arm, overlooked, 33
 of face, 26, 27
 "hidden," 29
mutant, 74, 85

neck, 19, 28, 30, 44
ninja spy girl, 73
nose, 10, 12, 13, 55, 65, 66, 67

odd frame, 118
one-point perspective, 105, 106,
 107
overall design, 67

page, designing of, 114–125
panels
 and close-ups, 118
 flat vs. dramatic, 120
 low-impact vs. high-impact, 119
paper, 89
pencil, 84, 85, 86, 87, 88
personal style, 76–97
perspective, 98–113
Photoshop, 93
planes of face, 14, 15
point of view, 116
pretty, into sexy, 57
pretty face, not just, 56
profile, 26
 body in, 32
Pulido, Brian, 7, 140–143

realistic animals, 133
regular woman, into seductress,
 58–59
Reis, Ivan, 7

ribs, 29, 35, 38, 44
rotation, upper body, 36

sci-fi, 95
sexy, pretty into, 57
sexy clothes and costumes, 60–61
sexy eyes, 54
shoulders, 19, 28, 30, 40, 44, 48,
 57, 58, 59
sidekick, fantasy, 94
sinister skin, 92
skin, 50, 70, 92, 132
skull, 10, 12
special effects, 72, 135
spine, curve of, 30, 40
spine of the scapula, 30–31
staging, 116
starting point, 78
storytelling, 100
straight lines, and angles, 34
strange creatures, 46–47, 132
stretching, 48, 49
style
 animated, 128, 129
 comic book, 129
 personal, 76–97
stylized animals, 133
stylized backgrounds, 134
superarticulation, 46
super disgusto, 75
symmetry vs. asymmetry, 125

tails, 50
Tan, Billy, 79
team heroes, 97
teeth, 11, 27, 50, 72, 132
television animation, 126–135
theme, unifying, 124
thighs, 35, 41, 44
three-point perspective, 105, 112,
 113
tilts and turns, of head, 14–15, 16
toes, 22, 23
Top Cow Productions, 7, 78, 79
torso, 32, 36, 37, 38, 39, 48, 49
tough guy
 body of, 28
 head of, 26
transformation, into seductress,
 58–59
tweaked face, 65
twisting, dramatic, 39
two-point perspective, 105, 108,
 109, 110, 111
types, character, 68–75

underlying form, of head, 26
unexplained creatures, 132
unifying theme, 124
upper body, 32, 36
 contour lines on, 37

Valdez, R. V., 81
vampire chick, 71
Van Dyke, Nate, 83
vanishing lines, 105
variations, Top Cow, 78
variety, and excitement, 121
veins, 44–45, 75

warlock, 72
weird creatures, 132
western genre, 94, 95
wild skin colors, 92
wild things, 50–51
woman, regular, into seductress,
 58–59

Young, Roy, 7